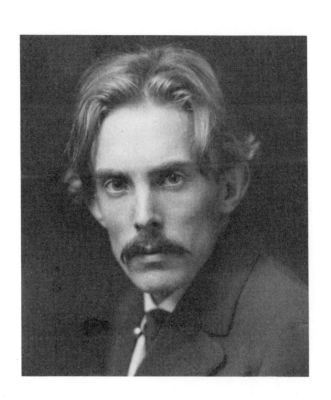

HELEN LAIRD

CARL OSCAR BORG

AND THE

MAGIC REGION

Artist of the American West

Gibbs M. Smith, Inc.
Peregrine Smith Books

First edition.

Library of Congress Cataloging in Publication Data

Laird, Helen, 1933-
 Carl Oscar Borg and the Magic Region.
 Bibliography: p.
 Includes index.
 1. Borg, Carl Oscar, 1879-1947. 2. West (U.S.)
in art. 3. Indians of North America—Pictorial –
works. 4. Artists—United States—Biography.
I. Title.
N6537.B634L35 1985 760'.092'4 [B] 84-26428
ISBN 0-87905-180-9

Book design by M. Clane Graves

Printed and bound in Japan

Cover photograph of Carl Oscar Borg by W. Edwin Gledhill.

TABLE OF CONTENTS

BLACK AND WHITE ILLUSTRATIONS

LIST OF COLOR PLATES

FOREWORD

I can't help observing the many similarities between Carl Oscar Borg's life and mine. We both came from Scandinavia, he from Sweden and I from Denmark. As young men, we were so eager to be Americans that we jumped ship to enter this country. Carl did it twice—at Norfolk, Virginia, in 1901 and in San Francisco in 1904. I sneaked off a Danish steamer docked in Hoboken, New Jersey, on December 31, 1918.

Both of us were self-taught artists. We fell in love with the U.S. Southwest (the "Magic Region") as it was before it became overmechanized. We shared an abiding respect for this land's original inhabitants, the American Indians. We studied these noble people firsthand. Like Borg, I was always a stickler for authentic details.

We both got roped into the movie industry. Carl designed Hollywood sets for Douglas Fairbanks, Sam Goldwyn, and Cecil B. de Mille. As a kid, I performed trick riding for the Great Northern Film Company in Denmark. Much later, I had bit parts in two John Wayne westerns, *McClintock* (United Artists, 1963) and *El Dorado* (Paramount, 1966). Titles for the latter film were superimposed on my paintings.

It's a sad fact that the highest fees Carl ever earned for his considerable talent, by his own account, came from his "industrial" work. He also painted western illustrations to attract tourist trade for the Santa Fe Railroad.

Borg's artistic versatility seemed limitless. He was adept in oil painting, watercolors, gouache, wood carving and engraving, drypoint copper etching, and monotype printing. He was also an expert photographer and photo retoucher. Futhermore, he was an art teacher and poet.

Although Carl achieved international fame for his American West art, his subjects were, by no means, limited to that locale. He left the United States several times to live and work abroad. He traveled to Central and South America, North Africa, Italy, Spain, and France. Before World War I, his art exhibitions drew rave reviews in the principal capitals of Europe.

He sat out World War II in Sweden. In June 1945, he received a medal from the Royal Swedish Academy of Science in recognition of his gifts to his homeland (art, historical artifacts, and poetry).

Something of a mystic, always restless, and frequently despondent, Borg roamed four continents seeking fulfillment. Toward the end of his life, he felt he was a failure. How ironic! His friends and benefactors had included some

of the most famous and influential people of his time.

Helen Laird has written an accurate and complete biography of Carl Oscar Borg. Mrs. Laird has researched her subject thoroughly, and her book is interesting and informative. She tells Carl's life sensitively, yet objectively, without editorializing.

For me, this statement from Mrs. Laird's book reveals the core of Carl's talent: "Borg had an extraordinary gift for seeing, for sensing the spirit of the place where he was, the thing he looked at . . . the full sweep of an Arizona sky, or the essence of a flower in his native province."

Borg deserves a niche among the foremost painters of the American West. Like Catlin, Bodmer, Bierstadt, Remington, and Russell, he has left a vivid record of western history for future generations to enjoy.

OLAF WIEGHORST

PREFACE

Carl Oscar Borg (1879-1947), protegé of Phoebe Apperson Hearst, friend of Thomas Moran, Ed Borein, Charles Russell, and Charles Lummis, was one of California's best-known artists in the early decades of the century. His subsequent neglect by the American public and American art historians is attributable to several factors. Borg was a Swedish American and many of the written records he left documenting his life and time were written in Swedish. He settled in California in 1903, but his identification with the American West came to an abrupt halt in 1938 when he returned to Sweden where he remained until 1945. Although the majority of Borg's paintings are found in private and museum collections in the United States, a good number are in European collections. The paintings are in strong hands and rarely appear in galleries or at auction. The task of carrying Borg's life to the future fell to Borg's second wife, Lilly, a Swede whom Borg married in 1938. She had not shared his years of flourishing and fame in the American West. She arrived in California forty-two years after Borg had first settled there, and only a year and a half before his death.

After his death, Lilly Borg, who was not yet an American citizen, returned periodically to Sweden. She helped arrange a Memorial Exhibition in Gothenburg in 1949, the year she married Martin O.Elmberg, a Swedish engineer, and in the early fifties she released Borg's autobiographical fragment and materials she had compiled from Borg's scrapbooks and manuscripts to Albin Widén, a distinguished pioneer in Swedish American Studies. Widén's *Carl Oscar Borg, ett konstnärsöde,* a biography based largely on the two sources, was published in Stockholm in 1954. Mrs.Elmberg's English language text, "Carl Oscar Borg, the Wanderer," was never published. Twenty years elapsed before Mrs.Elmberg released to this author the source materials that made a new biography possible.

Borg's neglect is partially explained by his dual nationality, and partially by the fact that he located and thrived in Southern California. In Taos and Santa Fe, social development has been evolutionary, fostering an uninterrupted, well-documented tradition of fine art. Santa Barbara and Los Angeles also flourished briefly as fine arts centers in the early decades of the century, but no strong or continuous tradition survived in Southern California. The tenor of the times changed too abruptly. Like molten lava, a vast new population spread across Southern California carrying new impulses and a new culture, burying the gentler past and earlier traditions nearly instantaneously.

Had Borg lived in Taos or Santa Fe, it is likely that his life and work as a painter of the Navajo, the Hopi, and the Southwest would long ago have been recognized and documented. In the annals of American art history, Borg belongs to that group of artists (including Victor Higgens, Walter Ufer, E. Martin Hennings, Ernest Blumenschein, Joseph Sharp, and Frank Tenney Johnson) whom Peter Hassrick links together in *The Way West* in his aptly titled chapter, "Quiet Passing." They sought spiritual truth in their subdued and gentle subjects and in the richly varied land.

Borg belongs also to another group of less celebrated, less well-known American artists, those landscape artists including, among many others, William Wendt, Jean Mannheim, Elmer and Marion Kavanaugh Wachtel, Hanson Puthuff, who came to Southern California at the turn of the century and there briefly discovered their Mecca. The existence of these artists and their achievements, long buried under what Southern California became and is—a highly charged, mutational state, oriented toward the future—are beginning to be recognized. Carl Oscar Borg takes his place among them as an American regionalist.

ACKNOWLEDGMENTS

I am indebted to Carl Oscar Borg's widow, Lilly Borg Elmberg, now deceased, who asked me to write this book. She gave me the autobiography Borg wrote in Swedish covering the years 1879-1908, and her own brief summary in English of the years 1908-1947, the two major sources on which the only published life of Borg, Albin Widén's *Carl Oscar Borg, ett konstnärsöde* (Stockholm, 1953) was based. Later, Mrs.Elmberg gave me the primary source materials which made this biography possible: Borg's poems, letters, notebooks, and essays. I drew heavily upon these primary sources, translating from the Swedish or French as necessary. They provided the nucleus from which to launch an inquiry into the historical context against which the artist's life was played. Whatever success I have had in melding the individual life and the Zeitgeist I owe to the institutions and libraries whose collections of published and manuscript materials were made available to me, and to the individuals who gave so generously of their knowledge.

I wish to express my thanks to the Huntington Library; the Bancroft Library; the Stanford University Library; the Hoover Institution; the Hearst Free Library, Anaconda, Montana; the Los Angeles and Pasadena public libraries; the Research Library of the Motion Picture Academy of Arts and Sciences; the Library of Congress; the Smithsonian Institution; Gothenburg's Art Museum; Gothenburg's Ethnological Museum; the Southwest Museum; the Friday Morning Club; the Salmagundi Club; the Santa Barbara, San Marino, and Pasadena historical societies. To the Huntington Library, San Marino, California, on whose resources in art history as well as western Americana I drew most heavily, I owe the greatest debt, not only for the privilege of working with rare books, magazine, and manuscript collections, but for the friendship of staff and scholars.

I have the pleasure of acknowledging the contributions of individuals: Glen Dawson, Jules and Vivian Delwich, John Dominique, Gunnel Elfwing Menn, Helmut Erickson, Sven-Eric Isacsson, Frank Norick, Keith Gledhill, Katherine Haley, Blanche Judson, Melvin R. Laird, Raymond Lindgren, Thomas McNeil, Bob Schlosser, Martin Ridge, Mrs. M. K. Swingle, Elsa Villadsen, John Villadsen, Kathy Weaver, and Howard Woodruff.

I owe an especial debt of thanks to my husband, David Laird, whose interests have so often sparked my own, and who has been supportive of this project over many years; to Richard Lillard who read the first "final" draft carefully and took the time and trouble to make the kind and incisive suggestions that

encourage and instruct; to H. Arnold Barton and Edwin Carpenter for reading the revised manuscript, flagging a multitude of spelling errors and raising pertinent questions; to Carole Osborne Cole for assistance in preparing the final manuscript for publication; to Saimi Lorenzen, my wise, great spirited friend whose lively reminiscences did so much to bring this book to life; to my parents, John and Thora Lauritzen, immigrants from Aalborg, Denmark, who gave me the language.

Finally, I am grateful to those who contributed photographs of the artist's work, to those who contributed financial assistance, and to Gallery 29 and the Southwest Museum for the sponsorship that helped make publication possible.

For David and Vanessa

Moorings

1879-1900

Carl Oscar Borg was born into a poor family in Dals-Grinstad, Sweden, on March 3, 1879. His ancestors had heard "every tree in the forest preach resignation and patience." His father, Gustaf, one of the last of the career soldiers to be given a small cottage in exchange for military service, was on duty away from home for long periods of time. His mother, Kristina Olsdotter Borg, who had children one after another, patiently waited for the father's return; she faced frightening storms alone, and managed as best she could when there was little to eat.

Frost and poverty inhabited Borg's childhood and youth. Demonstrations of affection, which might have rendered a harsh life less severe, were few. Dalslanders were ashamed to show affection in those days. They were not unfeeling; on the contrary. But life had always been hard and had knocked the demonstrativeness out of them.

Borg sometimes complained that he had had no real childhood, but he also thought that his childhood, like all childhoods, had been a marvelous fairyland full of wonder and adventure. He had the gift of every child, perhaps to a greater extent than most, the power of imagination that could recreate the world and make the poor boy a hero, a knight, a "Saint Göran who shall slay the dragon."

Shortly before his death, Borg began to write his autobiography. In it he "went back to that world which is a child's world, there where each of us has his beginnings and becomings," and described his first memory.

> My father carried me on his back; he was on the way to my mother's father's house. The path lay over new fallen snow. It was Christmas day 1881 or 1882. Now when I look back, I can still see everything; the flat and empty landscape, the small cottages, the black and white magpies that hopped on the snow, the sharp winter air over everything. The sun was bright and I watched the shadow which followed us, and I still hear the frost which cracked under my father's footsteps on the hard snow. There was a burning cold over my face, and I looked bewildered and wonderingly at the white matter which came out of my mouth and drifted up into the sky.

Another "real picture" from childhood remained as clear at the end of his life "as if it were yesterday." On another Christmas, when he was four years old, the family gathered in the living room of his mother's parents' house. The grandmother tended the Christmas porridge while the grandfather "read in the Bible about the Christ child who was born so long ago." Borg played on the floor which was scrubbed clean and strewn with bits of spruce. He heard his

grandfather's voice, but didn't understand what he was reading.

> There was nothing there to interest me anyway, because I had caught sight of a little white horse which was dragging a carriage by me and under the big bed which stood against the wall. It was dark under the bed, and I was afraid of the dark, but when the horse didn't come back, I crawled under the bed after him. But he had disappeared in the dark and I began to cry. I began really to howl. Grandfather put his Bible down and came to see what had happened. He wanted me to come out, but I only cried and said that I wanted the white horse and carriage. So he had to get down on his knees and take hold of me. I couldn't be consoled.

When, in answer to their questions, he told them what he had seen, the old people looked at each other and his grandmother murmured something about the "trolls." Dalslanders were superstitious. They respected troll power and believed in omens; the child's vision portended something.

Life was full of wonder and hardship, pain and moments of high abandon when happiness swept the room in which they all lived, sleeping four or five to a bed, head to toe. Borg remembered the celebrations when his father returned from duty, the aquavit and black bread he brought with him, the gathering of the aunts and uncles and grandparents, the dancing to the concertina his father played, the fighting that sometimes broke out. He remembered the first books he looked at: a child's picture book, "the world's most fascinating book," with pictures of golden hens and red cows from which his grandfather taught him to read, and an old Bible with yellowing etchings. He remembered the only picture that hung in the cottage, a portrait of King Charles XV astride his horse. These few sources gave the child his first glimpse of the artist's power of recreation.

As soon as he could hold a pencil, he wanted to draw. He copied the King on his horse many times, in spite of the teasing and scolding of his father and his father's father, "a real tramp, clad in rags and almost never sober," who called him "harkeskräcken," a meaningless and terrifying name. They accused him of wasting his time drawing his gubbar* and predicted that he would never amount to anything. Later, in school, he "could never curb his inclination to draw on his slate." His teacher, Lars Norén, did not scold. "Good indeed, really 'bra' " he said, an expression reserved for things he particularly liked. Old Norén,

*"Old men." in Swedish the word has two meanings: old men, and sketches or drawings. Borg used the word in quotes, emphasizing the double significance.

who sang and preached at funerals and also bled and vaccinated people, kept a bottle of gin or cognac in his desk. He didn't fool his students when "he bent behind the shelter of his desk as though looking for something. Several times [they] had to stretch him out on the floor and go home." Norén had taught Borg's mother and grandmother.

Borg took care of younger siblings, his brothers Johan, August, and Eric; he played in the fields with the bugs, insects, and frogs that his grandmother said resembled the "dogturks" who, part human, part animal, were heathen and lived in distant lands. He played with his godmother's children, and he played alone. He taught himself to make figures from clay he scooped from the ground, and to paint them with flower colors. One figure was that of the sexton, an old soldier named Ode, complete with uniform and collection plate. He set Ode on a stone and, not having the courage to come out, hid in a birch grove and watched from a distance as his teacher came down the road. Norén stopped to examine the statue and when he moved on again, the boy discovered three coins in the sexton's plate. They "provided matter for discussion in the village for a long time."

As soon as he was old enough, he was sent off in the late spring and summer to earn a little money herding cows and goats, "walking barefoot over the ground white with frost to the barren fields where one could scarcely find a blade of grass." He received his room and board, but any wages went to the "poor family where there were always more mouths to feed." One of the farmers for whom he worked gave him a pocketknife, and he began to carve shapes: people and animals and boats.

In the evening, he read what books he could borrow, Esaias Tegnér's *Frithiof's Saga* or Hans Christian Andersen's tales, or listened to the news the itinerant shoe repairman brought or the "wonderful stories" told late into the night by the wandering tailor who sewed clothes for the wealthier farmers. The tailor spun tales of "ghosts and spirits and people who could not rest in their graves" for those who kept him company as he worked. The shoeman brought news; the tailor stories; and "Tittskåpsqubben" (old man peepshow), Mr. Snår, the salesman who sold "songs and little books, thread, buttons, needles . . . to the women in town," brought pictures. "He went around the town with his peep show on his back. There one saw King Oscar the Second, whole armies, foreign places, shipwrecks, trainwrecks . . . everything imaginable, every place in the world."

Grinstad was a small, stable community, its social lines clearly marked. A herd boy might tend the cattle and work the farm; he might sit with the shoe-

man and the tailor and admire the pictures in the salesman's peepshow; he did not mingle with the rich or the educated. But one educated man in Grinstad, a newcomer, the minister, A. Magnus Nilman, took an interest in the boy. He had watched him build a boat, observed its successful launching, and listened as Borg explained he was trying to design a boat like the one he had read about in *Frithiof's Saga*. Nilman recognized the boy's talents and need, praised his accomplishment, and reached out in friendship toward him.

Borg was fourteen when his public schooling ended. He then attended the religious classes at Grinstad church that prepared him for his confirmation, a grave ceremony marking the transition from childhood to adulthood. Pastor Nilman was his teacher. The tall, gentle, erudite minister who treated the ragged, neglected child with a kindness and courtesy to which he was not at all accustomed, seemed almost a god to Borg. He listened to the minister's magnificent voice, learned his lessons easily and well, and decided that he would ask the pastor if he could work for him. But he was a shy boy, and he had not done so when the confirmation day arrived.

Acutely sensitive to his family's poverty and lack of distinction, three aspects of the important event impressed him. He thought the wealthy farmers must think it strange that the poor soldier's son could answer so many difficult questions when their sons, heirs of large properties, could not. He thought he must be a terrible sinner, a child of Cain, whom God could not want, because he alone was not weeping as he took his first communion. He remembered that he was the only child to be confirmed without his parents present to bear witness and be proud. The father was away, and it was impossible for his mother to come. Borg stood, uncomfortably, in his mother's only pair of leather shoes. One did not wear wooden shoes to church.

The day was not a happy one for Borg, but soon a "golden age" opened for him. He gathered his courage and went to the pastor's office to ask if he could work for him, groom his horse, and keep his beautiful red carriage spotless. Pastor Nilman was surprised. He liked the boy who had evidenced talent and intelligence, but he was not a rich man. Still, the boy clearly could use his help and would benefit from his guidance. He thought over his request and then called out to his wife to come into his office. They talked a few minutes while Borg stood aside, anxiously twisting his cap in his hands. When Mrs. Nilman took him into the kitchen for something to eat, he knew he had his place.

The Nilmans were a decisive factor in Borg's life and destiny. They gave him a sense of personal worth, and in their home he experienced the happiest days of his youth. The work was not hard; he had no worries to distract him,

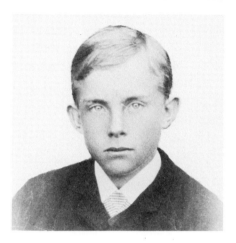

Borg at age 14.

and he had access to the minister's extensive library. He "did his work, read omnivorously and drew." The Nilmans encouraged his interest in books and art. They gave him his first set of paints, and his ambition to become a great artist began to take shape. He learned about Raphael and saw pictures that inspired his awe and wonder. He found it difficult to talk with the Lutheran minister about the artist celebrated by the Catholic Church, but a vision of the artist's gift and power developed.

Borg's profound respect for art, his feeling that it was a "kind of religion, the worship of the beauty in nature," his sense of the artist's mission and calling took root in his childhood. During that harsh first chapter of life in Grinstad, the seed of a mystic sense of overriding beauty and wonder had been planted. Transmitted to him through the Bible stories his grandfather read aloud, it was confirmed and reinforced when, as a slightly older child, he read the sagas, marvelled at the paintings of Raphael, and began to grasp the notion of the ideal.

From the time of his boyhood, the artist, for Borg, was a Raphael, a DaVinci, a Rembrandt, a Dürer; someone able to see and render the deeper patterns that lay beyond the drab and ordinary—the intemperance of nature, the callousness of man. He sensed a profound dignity in the mysterious unity of artist, beholder and created artifact. From the days of his childhood and throughout his life, the artist-poet's calling was a high one for him.

The boy in Grinstad had neither the vocabulary nor concepts to articulate a philosophy, but he yearned to be a great artist. Books, art, and religion, all integral aspects of life with the Nilmans interwove in the deep layers of his psyche.

As Borg approached his fifteenth year, Pastor Nilman recognized a responsibility for his future. He had been able to help Carl Oscar by giving him shelter and support at a crucial period of his life, but he had no financial resources to help him further. Borg needed a craft. Because his talents and interests lay in painting, Nilman sought and found an apprenticeship for him with a master house painter in neighboring Vänersborg, the "little Paris" of Västergötland.

By foot, horse, and train Borg traveled to Vänersborg where he was given a cold, rat-infested room off the master's storeroom. The cold and the noise of the hungry rats made the nights long and difficult. The days were better. There was food enough, and music too. One of the painters, Kalle Björn, had a beautiful, strong singing voice and sang all the while he worked.

From the master painter, Fröberg, a teetotaler who preached endlessly against drunkenness, and the two journeymen who worked with him, Borg learned his craft. He learned to mix colors, to paint houses inside and out, to apply decorative motifs. An adept and willing pupil, he was soon considered, if not the best, at least one of the most capable painters in Vänersborg.

While mastering his craft, Borg continued to pursue his interest in "real" art, sketching whenever he could, picking up suggestions offered by other house painters who could also paint pictures. He learned a good deal from a counterfeiter who had once been jailed for practicing his skills. From professional artists who visited Vänersborg during the summers, Borg learned about Stockholm and the opportunities afforded in the capital where there were museums, galleries, and art schools.

In October 1898, Borg, who had "performed his work . . . to absolute satisfaction," completed his four years' apprenticeship. He was a qualified master painter, free to consider a move to Stockholm where he began to think his future lay. He returned to Grinstad to see his parents and to talk over his plans with Pastor Nilman. His mother's health had begun to fail, and he lingered in Grinstad through the winter, painting and papering in the village to add to the meager income his father brought in as the fastest roof thatcher in the county. He spent as much time as he could with the Nilmans enjoying friendship, congenial surroundings, beautiful furniture, pictures, books—things he "really needed." He was "most at home" there and relished the "freedom of exchanging views on many things." Nilman encouraged him to try his luck in the capital. After all, the "only important thing was to become an artist."

Borg finally borrowed money for the trip from the Bank of Vänersborg—an uncle guaranteed the loan—and "one frosty morning in April 1899," a month after his twentieth birthday, "with much good advice and warnings to take along

on the trip,'' he was ready for ''the real adventure.'' The morning was raw, the sky a heavy blue-grey with only a stripe of lighter grey near the horizon. It was ''blowing cold over the monotonous fields,'' but his mother walked with him down the frost-covered road. Finally she had to go back and they shook hands goodbye, not speaking their feelings. Borg watched his mother's retreating figure, watched as she turned and waved. ''The wind blew her thin clothes about her and . . . her shawl flew out like large black wings.'' He never saw her again.

Borg lived as a paying guest with relatives in Stockholm and looked for work. But it was not easy to find work in Sweden in 1899 even if one had a trade. After weeks of fruitless searching, Borg was grateful to locate a job in his mother's cousin's ship-painting firm. He was one of several painters at work on the *Örnen* when the ice broke and it was scheduled to sail for Dunkirk. As the youngest and only worker without family responsibilities, Borg was asked to sail along and finish the job at sea. It didn't take long to think this over. He ''decided to travel.''

When Borg sailed from Stockholm in the spring of '99, he expected to return. Ordinarily courteous and restrained, Borg rarely lost his temper, and then only when ''the devil flew up'' in him. One of those rare moments occurred while the ship was anchored in Dunkirk. The captain, hung over and mean after a night ashore gambling and losing, offended Borg, who abruptly told him to ''be so good to give me my money and I'll get off your damn wooden shoe of a ship.'' When the ship sailed again, Borg remained behind in Dunkirk with a few possessions and a French vocabulary of two words: ''café'' and ''cognac.'' He had cut himself off from his past; he did not reach out for it again until he had wandered some thirty years and experienced both victory and defeat.

In 1934, when Borg returned to Sweden, he had achieved his goal; he was the great painter he had dreamt of becoming; he was also a sick and deeply lonely, disillusioned man who had ''travelled many years on the earth and was dead tired of it.'' He had the crushing sense then that his efforts had been in fulfillment of a merely egotistical wish and not worth much. But the twenty-year-old who stood alone in Dunkirk in 1899 was a strong, resilient, proud, determined dreamer ready to embark on a worthy quest.

LOOKING FOR WORK

1900-1904

His trials began almost immediately. He was unable to find work in Dunkirk. "It was hopeless for someone who didn't know the language." Advised by a seamen's pastor to do so, he moved on to Calais, a larger city. He had no luck there either. Encouraged by Nathan Söderblom, the seamen's pastor in that city who later became Sweden's archbishop, he sailed for England where, if worse came to worse, he could get passage on a ship to Sweden or to America.

He made his way to London where the little money he had was soon lifted from him by savvy cockneys. Without friends or relatives to help him, unable to communicate with anyone, he ran into "criminals and saints"—mostly criminals at first. He was beaten by a gang of toughs, "knocked senseless by a blow to the jaw," robbed of his coat, jacket, hat, and watch. For months he lived as one of the world's down-and-outs, holding out his hand to beg, searching the garbage cans for something that "at least looked edible," sleeping on doorsteps or under park benches.

Now I was one of the poor who always live on the streets, in this, the world's largest and richest city. Even now, they probably don't have it much better. Remarkably enough, there was a kind of camaraderie among the poor. When one was just as shabby as the others, then one was left in peace, and there was always someone who, in spite of the fact that I was a "bloody foreigner," showed that he had a heart and shared what he had been lucky enough to find. It went slowly, but I learned to understand words and phrases in English. It was a good thing that it was summer, or I would have frozen to death.

Finally his luck turned. He was "afraid of the police, and afraid of the many pubs where there was always shouting and fighting," but he was sometimes drawn there in the hopes of being offered an ale by some drunk. One night a Finnish agent, looking for workers to unload a ship just arrived from the West Indies with a cargo of coconuts, offered not only ale, but food, space on his floor to sleep, and a job.

For two shillings a day Borg worked with other impoverished, desperate men, all foreigners, who could be gotten for "less than the worst stick of an Englishman," loading green, gaseous coconuts into nets. His hands were cut by the fibers and "all bloody," but "it was so much better than sleeping on steps and under park benches and one got something to eat." The work was brutal, but it led to other contacts.

A distinguished looking gentleman appeared on board one day wanting to

know if any Swedes were working on the ship. When Borg was brought to him, Einar Malmsjö gave him his card and invited him to come along to the "Baroness of Limehouse." The "Baroness," Emma Leijonhjelm, was "a little, humble person with almost a bird face." A widow whose husband had been a sea captain, Mrs. Leijonhjelm ran a mission in East London and spent her days helping homeless seamen. Borg became "one of her boys." His isolation and deprivation were over. He lived in her home, met "a whole other class of people," improved his English, began to get work "here and there," and made friends among the seamen, whom he sometimes accompanied to their wooden freighters and "entertained with sketches and portraits of themselves."

The pencil sketches drawn on wrapping paper led Borg to his first opportunity to earn money through his talent. A "picture agent" who took orders from the sailors for portraits and seascapes was shown Borg's work. He introduced Borg to his employer, George Johansen, a "vigorous gentleman with a brown Van Dyke beard, a big knotted tie and a velvet jacket," known among the Scandinavian seamen as the "Sweetheart Painter." The artist-entrepreneur liked Borg's sketches, the manner in which he responded to questions about himself, the way he set about a request to repaint a "big sign in the shape of a lifebuoy" which announced "George Johansen, Portrait and Marine Painter." Borg painted it as though he were "painting an altar piece." He offered Borg a job at a beginning salary of a pound a week plus room and board.

In Johansen's studio "six girls worked coloring sweetheart photographs with transparent oil colors" which were "sold to sailors as real oil paintings." Borg learned to color portraits also and to paint seascapes. At first Johansen did the drawings and Borg the coloring in watercolor and oil, but after a few trips to the docks with Johansen who drew the newly arrived, fully rigged ships, Borg was able "to do everything" himself. He was given a private room in which to work, encouraged to paint as much as he wanted, and paid more. He began to visit museums and other "interesting places," and to teach himself to read English. His first book, Ainsworth's *Tower of London,* took a long time.

Expectant, interested, energetic, Borg no sooner mastered one field than he attempted another. He left Johansen's briefly to paint sets at Drury Lane where Sir Henry Irving and Ellen Terry were performing. Although "it was very interesting," Borg soon realized that his "interests did not lie in scene painting." When Johansen offered to increase his salary, he went back to seascapes and portraiture. He rented a room from a German couple, the Strumfens, whose little humpback daughter had "a beautiful singing voice and sang old German songs so that [he] began to learn German." He thought the language much eas-

ier than English and used it in conversation with the Strumfens who never spoke English.

In a short time he had climbed many figurative mountains; he had moved, within two years, from destitution to financial security, from painting real ships to painting pictures of them, yet he was not content. "In spite of the fact that everything was going so well, it was not the future [he] had dreamt of." Judging that he could go no further with his work for Johansen, he "decided to go to America where so many of [his] countrymen had gone." In April 1901, Johansen gave him a reference: "For close to two years, Mr. Carl Borg has been employed at my studio as an all around assistant painter and I can confidently recommend him to brother professionals as a clever and reliable hand." A Norwegian captain sailing for Norfolk, Virginia, agreed to give Borg free passage in exchange for the paintings that Borg would execute on the walls of his cabin. Like so many others, Borg entered America illegally, hidden in the propeller shaft while port officials cleared the ship.

Borg could understand and speak English now, and at twenty-two was a painter of considerable experience with references to prove it. He had no trouble finding work in Norfolk, but for the first and only time in his life, he was fired from a job before his own needs impelled him on. He knew very little about America, and nothing about the union he had been obliged to join to work as a decorator. Carrying habits and standards which had earned him praise as a "good and reliable" worker in Europe, he worked as he thought one should painting cupids and flowers on a rich German brewer's bedroom ceiling. He was surprised at the end of the day by the supervisor's "What the hell do you think you're doing?" He had "accomplished in a day what should have taken a week." Borg was expelled from the union and "blackballed."

He made a few unsuccessful starts at working as a painter on his own. He was hired to paint a yacht, but cheated out of his salary—he had no written contract—by his employer, a lawyer. He met Jim Smith, a former railroad worker who "got an idea they could make money on." They would go into the country; Borg would paint the old plantations, and Smith would handle the advertisement and sales. But Jim Smith fell critically ill. Soon in spite of all his efforts to find something to do, Borg was penniless again.

The Negro in charge of the boarding house where he lived took pity and allowed him to stay rent free in an empty room, when there was one, and when there was none, he "got to sleep down in the cellar where she herself lived." She was a kind and generous woman, but with "her snuff chewing and frequent spittings into the rags where she lay," her fondness for gin and her loud snor-

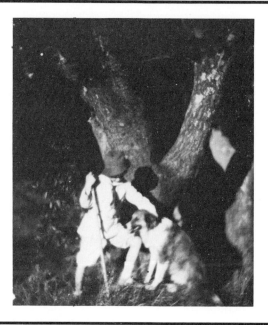

Keith and Gypsy, 1921, glass plate photograph by W. Edwin Gledhill.

ing, Borg thought "that was almost worse than being out on the streets."

He finally accepted the offer of a rail ticket to Canada and a job painting the summer home of a friend of the Scandinavian Consul Officer, Mr. Klover. The work completed, he lingered on in Toronto where he found a job with the Dominion Portrait Company, doing very much the same, not entirely satisfying, work he had done in London. In Toronto and in neighboring villages, the company's proprietor, Mr. Gurley, rented empty buildings; Borg sat on a chair in the window and worked at his easel. People gathered to watch and "sometimes there were many orders," completed later in Toronto and "sent out."

Photography had made portraiture available to men of modest means and opened a new industry for artists who handcolored enlarged photographic portraits—panchromatic plates were not available until 1906—or painted from photographs. As a result of Borg's early experience in the sweetheart portrait studios, he developed skills on which he drew throughout his life. He learned how to work with cameras, how to "see" a photograph; he became equally adept at painting from photographs or from sketches, and he learned how to work quickly. But working on an assembly line of sweetheart portrait painters was no more the future Borg had dreamt for himself in Toronto than it had been in London. In the spring of 1902, he returned to the United States, stopping

Keith and Gypsy, 1921, oil, 86.4 x 76.2 cm. Privately owned.

briefly in New York where he worked at the "sweetheart portraits all over again!" and then travelled to Philadelphia while he "still had a little money put aside."

At first "things did not go well there." He was down to his last loaf of rye bread and his last salt herring; he had no money left to pay rent and little likelihood of finding work. One Sunday afternoon he walked down to the harbor, then into the seaman's church to rest. After the service, a member of the congregation asked if he had work. When Borg answered in the negative, he introduced himself as Ole Nilson, cabinetmaker, and asked if Borg could carve wood. Borg replied that only modesty prevented him from letting on how he had discovered the art. Mrs. Nilson saw that Borg was starving. She invited him for dinner, and the next day, he began his new job carving "antique" furniture. (The "antiques" were purchased by a New York firm which shipped them to England and then reimported them to America, thus commanding a much better price.) After carving a few "monsters," Borg learned how to manage the tools; he became a skilled carver, and his salary was raised from six to ten dollars a week.

It was still not the life he had dreamt for himself. Scandinavian seamen he had known in London urged him to join them as an able-bodied seaman aboard the *S.S. Arizonan* sailing for California. He was tempted. He was no able-bodied seaman, but he hadn't been a furniture carver either and he had quickly be-

come one. He had long ago "come to the conclusion that one should be able to do anything." As for California, even as a boy in Grinstad, he had heard about the "big land of the West which seemed to be a place of refuge and good fortune for people who had little hope or chance in their reduced circumstances." He had spent almost two years trying to make his way in the East and he hadn't gotten very far. Encouraged by his comrades and his employer, who wished he were free to go along, Borg decided to try his luck again.

The voyage was stormy. "The ship rolled and strained in the high seas like a dying monster." Borg, who, on the death of the officers' mess boy, had been chosen to replace him, almost perished too. As they crossed the Straits of Magellan, a hurricane caught up with them. It was cold, and "the sky was fiery red with heavy black clouds which chased each other." Borg heard every timber creak and saw the rivets move in the deck plates as he waited with his tray loaded with the evening meal to make a run down the long, slippery deck to the officers' mess:

> In the calm between two big waves, I dashed out with the tray secure in both hands, but when I had almost reached the mess hall the whole freighter rose up, then in lightning speed lay down on its side. The tray went high up in the air and everything went overboard and I followed. There was just a thin iron railing around the sides. A big wave spilled over everything and took me with it and I thought then that was the end. But it was probably not supposed to be because somehow I managed to get my legs around each side of one of the strong iron posts and I held on for dear life. Others hurried over to me and dragged me from the sea's greedy desire. And it was high time because as soon as they got a hold of me I fainted.

On September 29, 1903, a bright sunlit day, in calm water, the *S. S. Arizonan* steamed into Santa Monica harbor and docked at the long wooden pier. The *Los Angeles Times* heralded the ship's arrival with a front page story: The *Arizonan* was the "second largest steamship ever built for the Pacific trade and the largest freighter ever in a Southern California port." She carried a cargo of steel rails for Huntington, general merchandise and whiskey for Spreckels, and a crew overjoyed at the prospect of shore leave.

"Masses of people came out by rail to see the *Arizonan*," among them a Swede by the name of Swanson with whom Borg struck up a conversation. Swanson extolled life in Los Angeles, the climate, the opportunities, the people. He

A Knight of the West, 1924, oil.

urged Borg to return and gave him his card, promising he could always have a room in his house.

The next day Borg made his way by foot and trolley into the city. He climbed the Santa Monica hills, took in the purple-blue mountains in the distance, the "tall trees and towering palms," and then something "far more interesting came into view":

> There was a man on a horse riding towards me. He was middle-aged, somewhat grey, but he looked straight and wiry as he sat on his silver-trimmed saddle. He wore an enormous, broad-rimmed hat which shaded

his sunburnt face. He had no coat, only a grey and black chequered shirt, around his neck a red scarf, a belt with a revolver holster, and on his legs wide leather chaps with big silver buttons along the sides. He had elegantly stitched boots with large spurs on his feet. In short, he looked like the film cowboy of a later time, William S. Hart. I didn't understand that this was a friendly "ranchero" or cowboy. To me, he looked like a knight from an age long past.

Borg felt "a spark of adventure" at the sight of him.

When Borg reached Los Angeles, he wandered into Central Park—now Pershing Square—sat on a bench, and was soon conversing with a number of people eager to know where he had come from and what his plans were. Los Angeles was a friendly city of 100,000 people in 1903. It possessed, as Swedish sculptor David Edström put it, "a background of romance, faith and spiritual vision that grips and holds one."[1] Borg felt that attraction. He had only a day's shore leave. He would sail with his ship, but he had made up his mind to "come back to La Reina de Los Angeles as they said the town was really called." The easy, outgoing character of the strangers he spoke with, the "tall trees and towering palms," the form and color of the majestic mountains, the "knight" that had crossed his path, the people, and the land, held promise for the aspiring artist.

Borg sailed with the *Arizonan* to San Francisco and Hawaii. When the *Arizonan* returned to San Francisco with a cargo of sugar, he jumped ship, taking only the bare necessities and a few small sketches. Afraid that he would be found and forced to return, Borg hid in a remote, inconspicuous boardinghouse until he was certain the *Arizonan* had pulled out of the harbor. Only then did he begin the long walk, "apostle like," to Los Angeles, following the railroad tracks.

Cypress Point, Carmel, watercolor, 36.8 x 57.2 cm. Collection Mr. and Mrs. Barney Goldberg.

GARVANZA

The walk took forty-nine easy, pleasant days. He slept out of doors, stopped at fruit farms to work for his food and a little pocket money, and "learned a lot about California" from the transients he met along the way. Borg spent his first night in Los Angeles at the Salvation Army Center and then rented a room at Swanson's house and began to look for work. He had no luck at first, only an occasional job washing dishes or laying parquet floors. He "seemed to be getting nowhere" until one day, a Danish photographer, Christian Pedersen, into whose shop on Fifth Street Borg had wandered, startled Borg by asking him to be his partner.

Later he was told the reason for the mysterious offer. Pedersen was a mystic; his eighteen-year-old son, whose hand had automatically traced the message on a paint order that morning, told Pedersen two things: first, that a stranger would enter the shop to whom he should "be good," and that his (Pedersen's) mother had died in Denmark. Borg was the stranger whom destiny had clearly sent into the shop, and Pedersen's mother had indeed died.

The two men worked well together, and when their work was finished, they sat in Central Park reading, exchanging ideas, discussing world religions and California. Through Pedersen, Borg became acquainted with the Theosophical movement in Los Angeles. "Anyone who was anyone attended Theosophical meetings in those days." Borg had been from the days of his childhood, and continued to be throughout his life, sensitive to signs and portents, cognizant of a world of mystery beyond appearances. Inexplicable, mysterious things did seem to happen to him. Most of his friendships were among mystics. He left Swanson's home and roomed for a while with Dr. Grove, a Rosicrucian, and later with Dr. Max Heindel, the Theosophist. He painted portraits of Christ, Buddha, and Mohammed, and signed them with a triangle. He restored the portrait of Mme. Blavatsky in the Theosophical Society headquarters in Los Angeles.

As if by miracle, the days spent in fruitless searching for work had ended. From the moment that Pedersen offered Borg a partnership, Borg's prospects in Los Angeles brightened, and Pedersen's did too. Once the small community of photographers and commercial artists in Los Angeles became aware of his talents and capacity for hard work, Borg was offered almost more work than he could handle. Like a boy stepping from stone to stone over a stream, he stepped from job to job hoping each time to move nearer his goal.

He had a card printed: "Carl Oscar Borg makes artistic photograph portraits. No sittings given except in one's own home." He was a photographer, and he did everything he could with paint in Los Angeles during the years 1904-1905. He decorated the Giraldi hotel in Pasadena; he painted signs; he was the first,

or one of the first, to advertise the new movie industry with his scenes of the movies at Talley's on Broadway; he painted the sets for the Unique Theater between Sixth and Seventh Streets and for the Casino Theater on Spring Street. He was pleased when Otheman Stevens of the *Los Angeles Examiner* hailed his efforts in *The Belle of New York* as "the best thing in the entire performance."

He continued to work on "real" pictures too. He submitted one of these early paintings, a watercolor entitled *In Fog,* to the Ruskin Art Club. It was accepted by Everett C. Maxwell, the curator, for the club's fourth annual exhibit, May 29-June 10, 1905. *In Fog* marked Borg's entrance into the Los Angeles art world. He had just turned twenty-six. His pictures hung with those of established California artists including Marian Kavanaugh, William Keith, Hanson Puthuff, Elmer Wachtel, Granville Redmond, Norman St. Clair, and Fernand Lungren. He had not met any of them.

In the spring of 1905, Borg was still outside the real artistic and cultural community of Los Angeles, but he was drawing closer. Borg often stared at the pictures in the window of an art gallery across from the Casino Theater. One day he "screwed up enough courage to go in" and introduced himself to the owner, William H. Cole, and showed him some of his work. Cole liked the young Swede and thought well enough of his talent to introduce him to Antony Anderson, the art critic for the *Los Angeles Times*. A lifelong friendship began in 1905 between the Norwegian-American critic, himself an amateur poet and painter, and the young Swedish artist. Cole and Anderson, both educated men born in the Midwest, did what they could to help Borg.

Although Borg had begun to make some small headway in the world of "real" art, he had too recently been among the down-and-outs of the world not to leap at an opportunity to make money. Offered the chance to become half-owner of the Casino Theater, he eagerly accepted. He put his hard work and all his savings, $5,000, into the partnership. He was enthusiastic and confident that he could meet any task. But when his partner's legs were crushed by a trolley and Borg had to take on his work and worries as well as his own—hiring actors, constructing and painting sets, designing costumes, handling advertisement, locating suitable properties, and dealing with workers' demands for payment in advance—it was too much. "Sick and absolutely worn out," he suffered a "complete collapse" and was hospitalized with typhus.

Three weeks later, deeply depressed and destitute, Borg left the hospital. The doctor had been kind. He was told not to worry about the bills, he could pay when he was able to, but his prodigious efforts had been for nothing. He had lost the Hotchkiss (Casino) Theater and the money he had sunk into it, and

Carl Oscar Borg, photograph by W. Edwin Gledhill.

he was too weak to work. In Stockholm, Paris, London, or New York he might have been worse off than when he arrived, but Los Angeles was a friendly city then—"of what may a man be proud if he cannot be proud of his friends"—[1]and in the few months that Borg had been in the city he had made friends. One of them reached out to help him.

William H. Cole invited Borg to go with him to Arrowhead Hot Springs to recuperate. In the mountains, in the sympathetic company of his friend, Borg slowly regained his strength. One of the darkest periods of his life was transformed to a time of hope, confirmation and new determination. His essential goal had been and was to be an artist; he had made a promising start in the year that he had been in Los Angeles. A picture had been accepted for exhibition, and he had two good friends in the Los Angeles art world—one a dealer, the other an influential critic, both of whom believed in his talents and his ability to make his way as an artist. Borg took his near brush with death as a sign that he should not be tempted or distracted by business. The time had come to concentrate his energies on his art.

He looked like an artist. When Borg returned from the mountains in the winter of 1905, he filled the stereotypical nineteenth century romantic image of the young artist carrying the burden of his gift. He was strikingly handsome with precise, even, chiselled features and long, wavy, light brown hair parted to the side. He was pale and thin. He looked delicate, but masculine and wiry

like a highstrung thoroughbred straining to start. He sported a long waxed moustache and a goatee and wore wide, flowing ribbon ties and a dark suit. His eyes, intense and distant, seemed to gaze deeply inward; his high cheekbones stood out sharply in the studied profile photographs accompanying Antony Anderson's long *Times* articles celebrating the young artist's "fine and unusual talent, indomitable spirit, and genius."

In 1906, Borg's circle of friendships in Los Angeles widened. Through artist Richard Kruger, Borg met Idah Meacham Strobridge, the first of three older California pioneer women to extend her friendship to Borg. A bookbinder, author of articles and books celebrating the Southwest, the desert, and the Indian, she also owned a little gallery, "The Little Corner of Local Art" on Avenue 41, and often came downtown to take tea with Los Angeles artists in their studios to learn of anything or anyone new and interesting in Los Angeles. In Kruger's studio she spied a painting by Borg that she particularly liked and asked to meet him. She met Carl Oscar Borg, found him, as almost everyone did, "an extremely likeable fellow," and took him under her capacious wing. She encouraged him, hung his pictures in her gallery, and introduced him to other artists, to potential customers, and to everyone she knew in the Los Angeles community who might prove congenial or helpful. "She was very good to me. Her encouragement at that time made me try to work and do something."

Idah Strobridge was in her fifties. A widow whose three sons had died in infancy, she was ready to act as a surrogate mother to the sincere, gifted, lively young man. It was not at all unusual at that time, in California, for a younger man or woman to be "adopted" by an older person, to call someone who was no blood relation at all "mama" or "little mother" or "papa." Ties of friendship often necessarily replaced kinship ties. A spiritual bond between people was enough to pull a newcomer into a "family."

Through Mrs. Strobridge, Borg was brought into the extended Garvanza family. He gained support and definition throughout his thirty-odd years as a western artist from the individuals associated with that group. In the late nineteenth and early twentieth century, the term *Garvanza* referred to that eastern area of Los Angeles known today only as Highland Park. The "Lion," Charles Lummis, minister's son, bold graduate of Harvard and the frontier, settled the area in the 1890s. Then, for a time, Garvanza became more than a real estate venture. It was Los Angeles's cultural center, the head and heart of the Magic Region.

Fired with enthusiasm, seeing a new hope for man in the "blessed old land," Lummis took over the editorship of the *Land of Sunshine* in 1896, changing

its name in 1902 to the *Out West* magazine; he took on the task of preserving missions and Indians, of establishing an archeological society, of bringing life in the West to the attention of the rest of America, and of heralding a new civilization. He gathered about him talented, independent, strong-willed men and women, believers, like himself, in the West. Some of them kept in touch through correspondence, only occasionally touching base in Garvanza; others including Idah Strobridge, settled for shorter or longer periods around Lummis in the bungalows, "those little thin walled dwellings all of desert tinted native woods as indigenous to the soil as if they had sprung from it." Garvanza was, as Mary Austin claimed, "as artists know colour and poets know it . . . the most colorful corner of the world."[2]

Western artists, critics and curators, Antony Anderson, Norman St. Clair, Maynard Dixon, William Lees Judson, William Keith, Fernand Lungren, Everett C. Maxwell, Hanson Puthuff, Granville Redmond, Elmer Wachtel, William and Julia Bracken Wendt; poets, essayists, and novelists, Mary Austin, George Wharton James, Joaquin Miller, and Idah Meacham Strobridge; anthropologists, ethnologists, and naturalists, Hector Alliot, Adolphe Bandelier, and John Muir; civic leaders and educators, Carolyn Foster, Phoebe Apperson Hearst, Frank and Mary Gibson, Carolyn Severance, and many others felt the power of the Magic Region and were members of the extended Garvanza family. They believed with Lummis that by grafting the European-spawned culture, increasingly materialistic and decadent, onto the indigenous culture of the American Indian, a great new American civilization could develop in the West. Spiritual descendants of Tolstoy, Thoreau, Emerson, and Whitman, they believed in the brotherhood of man. They were suspicious of the culture of things; they respected continuity, the symbiotic relationship of man and nature, past and present; they felt within themselves and through nature the working of the Great Spirit. Mankind, as Emerson said, "has ever divided into two sects, Materialists and Idealists."[3] The men and women who came together in Garvanza at the beginning of the century belonged to the latter group. They were, they thought, "at the dawn of a new era of spirituality."[4]

Carl Oscar Borg was the last of many artists, poets, and thinkers to be brought into the Lummis orbit, to share in the strength of the Garvanza spirit and hope. Dixon was Borg's contemporary; most of the Garvanza circle were a generation or two older; some had already died. By the mid-thirties, they were all dead or in mourning for a spent dream.

The Lummis house and museum survive in Garvanza. Isolated bases of excellence and memory, they remind us of an epoch. The reverence and hope

that once pervaded the "aerial softness" are gone from the minds of the men who live there now. Today, concrete carpets, thousands of heterogenous dwellings, and automobiles strangle the area. When Mrs. Strobridge brought Borg to Avenue 41, life was full of mystery and idealism and imagination. As Mary Austin wrote, they delighted in the "dells all laced with fern" and the "little streams dashing down the runways . . . with here and there a miniature fall singing like a bird . . . between moss encrusted banks," and felt "the palpitations of the Mountain Spirit."[5] It was an ideal nurturing ground for a young artist with great dreams.

Borg was drawn in, recognized and molded by the community. Life turned congenial. The sunshine and the land, the freedom and the easy conviviality, the warm appreciation of his artistic talent and his personality, all promised a brighter future than the past he had known. Borg met most of Los Angeles's

working artists and many of its civic leaders in 1906. He developed close bonds of friendship with several: William and Julia Bracken Wendt, Mary Gibson,[6] and her only surviving son, Hugh Gibson, a graduate of the Ecole Libre des Sciences Politiques, Paris. The twenty-seven-year-old artist and the twenty-three-year-old diplomat became "great friends," and remained so although they were later "usually at opposite ends of the globe."

From Lummis, filled with enthusiasm and an urgent need to proselytize, Borg learned about and first became "interested in the Indian people," an interest which dominated his life and work. In the Indian and his land, Borg eventually found the truest expression of his own personality and philosophy. Lummis, expounding far into the night on Indian habit, custom, and virtue, planted a seed in the young Swede that bore amazing fruit.

In Borg's native Sweden, people had been reserved, conscious of social position and the stigma of poverty. Borg easily accepted his new friends' motto: "to love what is true, to hate sham, to fear nothing without, and to think a little."[7] According to Eva Lummis, Borg was "so unaffected, so humanly with you on your level whatever that level was," that "no one could have disliked him." His "personality attracted interest. He had the air of a Viking, an artist. His interests were broad."[8] His warm welcome by the Lummis circle ensured his welcome throughout California; the network of friendships, based on an appreciation of the essential worthiness of the newcomer, reached throughout the state.

Aspects of Borg's personality that had remained hidden burst forth in the congenial atmosphere. The "gracious and somewhat mystical"[9] Carl Oscar Borg became known for his humor, his playfulness. "He was very fond of jokes and kept everyone stirred up and amused by jest and word play."[10] He was very poor; often they thought "he must have eaten very little," but no stigma attached to poverty in Garvanza. Some in the circle were wealthy, most were not. Money didn't matter in that "wonderful community" of men and women "who have brains and the use of them";[11] spirit did.

Borg sat with the others under the great sycamore that spread like an Indian prayer in four directions in the courtyard of the Lummis home and joined in the conversations, the story telling, the "home made sings." The music was "officially Spanish," but as Lummis indicated in his invitations, "if there is any song your mother used to sing, maybe we can get a little congregational chorus on it."[12] Borg had no voice, but he loved the sound of the violin and picked up Lummis's enthusiasm for simple Spanish folk tunes. He shared the chicken dinners and the apricot brandy, and he worked tirelessly.

SOUTHERN CALIFORNIA ARTIST

1906-1909

In 1906, Borg painted in watercolor and oil and experimented with monotypes. He "had a long and hard road before him," but his Garvanza friends "introduced [him] to so many new friends and customers who came to [him] for pictures," that his following was soon wide enough to encourage him to attempt an exhibition of his own. An exhibition was arranged at George Steckel's Galleries on Broadway, April 19-30. Preparations were completed on the fourteenth, and Borg took a few days' holiday to visit a friend and see the collections in museums in San Francisco—there were no museums in Los Angeles then. He expected to return to Los Angeles on the eighteenth, but nature intervened.

The earthquake that devastated San Francisco struck shortly before dawn on April 18, 1906, as Borg lay sleeping on a cot in an old wooden boarding house on Mission Street. He managed to make it to the door and into the street where, still in pajamas, his clothes and shoes in his hands, he joined a "screaming half-naked throng of panic stricken human beings." Tangled electric wires set off fires everywhere.

Streets had been split open and trolley-car tracks bent in circles looked like intricate skeins of threads. Hordes of people hurried about not knowing where or why. . . . Distressed voices called out, cried and wailed, and even laughed, a mad, despairing laugh. I heard someone say:"Oakland is in flames and Seattle, Portland and Los Angeles—all the coast cities are ruined. Chicago has sunk in Lake Michigan. New York, Boston and Baltimore are inundated or have sunk into the sea." Most thought the world was coming to an end.

Jostled along with the crowds, directed by soldiers from place to place, he observed a woman pushing a baby carriage containing a sewing machine, another who had rescued an empty bird cage, a man who wore several hats and nothing else. He eventually found himself in Golden Gate Park with thousands of others. Chaos reigned for three days as the fires raged and the dynamite used to contain them exploded. Martial law was declared and looters were shot without mercy, but cooperation and generosity were evident too. The post office accepted letters written "on scraps of wrapping paper, anything, in any condition and without envelope or postage," and the railroad companies offered free transportation out of the city. "No one was allowed to come in."

On April 22, Borg returned to Los Angeles. He had missed the opening, but:

Antony Anderson and a few other friends had arranged everything. Some canvases had been sold and for a first exhibition it had gone off

very well. In many ways, it was the best, or rather, the most pleasant exhibition I have held.

Borg immediately set to work preparing for two other exhibitions to be held in November and December at Mrs. Strobridge's Little Corner of Local Art on Avenue 41. The exhibition in November included oils, watercolors, and monotypes. In December, he concentrated on monotypes, a process in which he gained some celebrity for perfecting a polychrome monotype, "an advance entirely his own and deserving the greatest encouragement."

Two of his monotypes, *Evening* and *Behind the Scenes*, were exhibited in the Second All California Spring Exhibition at the Blanchard Gallery on South Broadway. The curator of that gallery, Everett C. Maxwell, who served as art critic for Lummis's *Out West* magazine, became a friend, the second of the three Los Angeles critics to believe in and support Borg, the artist and the man. Alma May Cook, art critic for the *Los Angeles Express*, became the third influential critic in Los Angeles to extend friendship and support. As early as November 17, 1906, she predicted that he would be "doing great things."

In 1906, although friends could take pleasure in and comment on his industry and development, an honest critic had to admit that "he is not yet a pleasing colorist";[1] Alma May Cook noted his preference for greys, and Antony Anderson went so far as to tell readers in the *Times* that "every now and then he has struck brown mud of a quality bituminously unpleasant."[2]

In 1906, if his colors did not always please the critics, the shift in subject matter did. In the beginning of the year, Borg's works were often imaginative, based on legends of stormy seas and Viking ships, "restless interpretations of nature, the elements at war." Borg had vivid personal memories of violent seas and his early pictures were often a blend of his own experience and his imagination, phantom ships in real storms, but by November, a "distinct departure" was discernible. His colors lightened and he no longer preferred "the dramatic side of life which seems an inborn feeling common to all painters in the Northland"; he relied less "on his own imagination and [painted] more from direct knowledge."[3] Violence gave way to tenderness. The ship of Borg's life moved now in the peaceful waters of a friendly shore. Borg was beginning to "see" California. The land and his new friends exerted a powerful influence and he responded. He saw and painted *Nature's Tender Harmonies, White Clouds, A Turn in the Trail, After the Rain, Sunset Glow, Night's Mysterious Approach, Days of Golden Dreams, Sunday Afternoon, The Way to Skyland*, leaving the storms behind him.

He even looked different. The profile photographs of February and April 1906 show a dark-suited, deeply serious artist, his head bowed, carrying the full weight of the artist's necessarily severe, perhaps tragic destiny on his shoulders. In the full face photograph taken for the November-December exhibitions at Mrs. Strobridge's Little Corner, a cheerful, smiling young man in shirt sleeves looks out at us; a cowboy hat sits jauntily back on his head. He looks like a young Lummis.

Borg quickly perfected his skills in monochrome monotypes and they sold rapidly. Accepting the justice of the criticism of his oils, he turned toward developing his skills in that medium. In 1907, he did not exhibit. He learned how to paint as he looked over the territory. He had met William Wendt, the recognized master of Southern California landscape in the first decade of the century, in one of the Spanish classes that Eva Lummis conducted in Garvanza for a group of friends who sometimes paid for their lessons with money and sometimes with pictures. Wendt invited Borg to go with him on his sketching, painting trips to Mount Wilson, Arrowhead Hot Springs, San Pedro, the Simi Valley, Santa Barbara, and the Santa Barbara Islands.

Wendt, an immigrant from Northern Germany, fifteen years Borg's senior, was a close and reverent student of nature who had "steadily laboured to simplify his findings, giving us only the beauty that is eternally significant." He was a kind man with a "giving spirit." Alma May Cook called him "the soul maker of a city."[4] He and his wife, the gifted sculptress, Julia Bracken Wendt, became Borg's closest friends among the Los Angeles artists. Years later, when asked who his teacher was, Borg could answer truthfully and proudly, "No one," but he still credited William Wendt with teaching him "more about painting than anyone else."[5]

Borg spent weeks in Wendt's company and weeks alone learning about the new land and developing his skills. (He also took advantage of skills already mastered and earned money by decorating the Venice auditorium and the lobby of La Petite Theatre in Santa Monica.) By January 1908, he was ready to exhibit again, and Mary Gibson, the second California pioneer woman to take Borg under her wing, arranged for an exhibition at the Friday Morning Club where she was an active and influential member. Mrs. Gibson, who, according to John Collier, was "father and mother to a whole generation of Californians,"[6] had been a member of the same Spanish class that brought Borg and Wendt together.

The eighteen new oils and the group of monotypes, watercolors, pen and inks, and pencil sketches exhibited at the Friday Morning Club were "well received." Borg had "several good sales" among Club members and Mrs. Gib-

son's and Mrs. Strobridge's friends. Alma May Cook singled out *On a Lonely Shore* as one of "the most successful oils." She commented on "the almost tragic note in the quiet calmness . . . that mysticism which is in all Mr. Borg's work. It breathes of other people who have gone before or out into the wide, wide world."[7]

Borg had plunged in determined to improve his technique in oil, and, as usual, he accomplished what he set out to do. One critic noted a "new tenderness of coloring," and Antony Anderson heralded the exhibition as representing "another milestone in his interesting career. Mr. Borg has won a more refined and delicate appreciation of color harmonies."

Borg returned to Los Angeles for the exhibition, but the city could not hold him long. "Mr. Borg feels the restraint of studio walls after the free life, and is planning yet another pilgrimage perhaps to the desert country."[8] Borg did not go to the desert in the spring of 1908. He and William Wendt wandered off again to the Simi Valley where Borg lingered for six weeks. He returned "scorched and blackened by the sun and wind" with stories of rattlesnakes reluctant to move off the painter's box and forty canvases "all painted out of doors from start to finish."

Mrs. Gibson arranged for a second exhibition at the Friday Morning Club in April 1908. Antony Anderson lamented that a larger public could not view these pictures, which were studies of "great truth and much beauty." *Valley of the Simi, Rugged Hills, A Grey Day, Forenoon, Passing Shadows,* and *Across the Valley* were some of the canvases in which "the prevailing mood [was] a quiet one . . . a feeling of friendly isolation," in which there seemed to be a "mystic light."

In less than three years, Borg had become solidly entrenched in the group of Southern California landscape artists, a group including Fernand Lungren, Guy Rose, William Wendt, J. Bond Francisco, Granville Redmond, Norman St. Clair, Jean Mannheim, those who painted "within that realm of the inner mind known . . . as feeling";[9] those whom Everett C. Maxwell and Antony Anderson, John Borglum, and others felt would be in a unique position to make a major contribution to the history of American art. There was an expectation of great things, a certainty that "out of this land of silent places will come a native art as strong, as vital and as colorful as the land that inspired and fostered it."[10] The isolation of Southern California from the larger fads and fashions of the art world augured well for a distinctive contribution. Artists, patrons, and critics alike were proud that in Southern California "we are quite in another world."[11] Borg shared in the pride and the expectation. His tough self-reliance,

his enthusiasm for and knowledge of life out of doors and the poetic idealism of his personality and his pictures made him peculiarly a Southern California painter. As an artist of the Magic Region, he remained separated from the main currents of art as they were being formulated in the great art centers of Europe, particularly in Paris, by those whose vision had become circumscribed by life in industrial cities and an over-intellectualized view of man.

By the time he was twenty-nine, Borg had emerged from obscurity. The Swedish-American was a "native son" busily engaged in creating the "native art." He wandered over the land seeking subjects, painting, reading, exploring, collecting Indian artifacts. His intelligence was as marked a gift as his talent. His need for solitude never changed; it was part of his nature, the brooding, reflective, mystical alternate aspect of a personality compelled to learn about and experience firsthand all that his world and time had to offer. He needed and liked to be alone; he considered himself an essentially isolated, solitary individual, different from other people, and he had an amazing gift for friendship.

A hunter for fame and knowledge, Borg sought enlightenment from every source: people, books, artifacts. By 1908, he had gained a reputation in Los Angeles not only as an artist, but as a collector. "Friends and patrons know him as a curio hunter," Alma May Cook informed her readers in the *Express*. His friends in Garvanza were archeologists and collectors too. Lummis set the example in his home and museum, and soon, Borg's own home, his barn-studio at 315 South Bunker Hill was "loaded with paraphernalia from all parts of the world:" fabrics, medieval armor and weaponry, potshards and bones, and rare books.

If Borg wasn't out on a painting trip, or in his studio, or in Garvanza, he could most likely be found at Dawson's Book Shop on Broadway among the rare books and curios. He had discovered Dawson's soon after his arrival in Los Angeles. It became a second home, a place where Borg could receive messages and meet friends as well as buy and trade books and artifacts. Ernest Dawson, an early admirer and supporter, bought one of Borg's first oils, a landscape depicting a path leading up to Mount Wilson.

In June Borg left his books and collections and wandered up the coast to paint out of doors again. His friend Hugh Gibson had gone to Washington, D. C., bearing testimonials to President Theodore Roosevelt from Charles Lummis to help him in his bid for admission to governmental service. Gibson's diplomatic career was smoothly launched in the summer of 1908; Borg was having a harder time of it. He wrote Gibson that he had been working very hard; business was "rotten"; he "always got along somehow," but he "simply had to go some-

San Miguel Island, 1908, oil. Collection Katherine Haley.

where.'' He had intended to go up the coast to Monterey, but had changed his mind and gone instead to the Santa Barbara Islands where he planned to remain for five or six weeks.

> It is about the wildest place you can possibly think of but good to paint. The only way to get there is to go with a crew of seal hunters. I have been over on the biggest of the islands and it is *GREAT STUFF FOR PICTURES.* It is more desolate than the desert, with rocks and a few straggly pines and a gale blowing about sixty miles an hour but *GREAT COLORS*—brilliant as opal. I expect to have some striking things in the late fall.

Gibson thought that Borg was ''decidedly lonely''; mail reached him only when the seal hunters came to the mainland for provisions.

Borg was probably lonely on the islands, but he considered them, nonetheless ''among the most interesting places in California.'' He was absorbed not only in painting, but in tracking down the signs and symbols of other civilizations. The temperate climate, abundant fish, wild fruits, herbs, acorns, and pine nuts had once sustained a population of several thousand ''very large, handsome and gentle Indians.'' They were driven off by rapacious seal hunters, sheep and cattle ranchers; only their bones and artifacts remained.

On San Miguel, the most deserted and desolate of the Islands, on a ''stretch of land covered with bones,'' Borg found artifacts that he prized, two prehistoric

skulls of enormous size. A Stanford University research team "offered a considerable sum for them," but Borg, poor though he was, refused to sell. The find was personally too important. Hamletlike he studied the skulls, reflecting upon man's fate and the cycles of civilization. Those heavy heads were among the very few possessions Borg did not sell when he finally returned to Sweden in the midthirties.

He could not, of course, live on reflection alone. When his funds ran out in the summer of 1908, he joined the seal fishermen, working with a crew of Mexicans, Negroes, Chinese, and Japanese who "looked like pirates." They were good to him, sometimes taking his watch so that he could go on sketching, but the work was strenuous and the wages very low. Hugh Gibson thought Borg's a hard life. "It is a wonder he does not get altogether discouraged," he wrote his mother on July 17, 1908. "If he does," he added, "he manages to keep it pretty well to himself. He is a brick."

Others thought so too. The captain in charge of the seal hunting expeditions, Captain Colés Vasquez, and Captain George McGuire who owned the "motorized *Gussie M*" (the vessel from which they hunted) became Borg's friends. Captain McQuire, who also owned a motion picture theater on State Street that he decorated with marine paintings, bought one of Borg's pictures. Another, *The Capture of Seals at Painted Cave*, took a blue ribbon at the International Exposition in Seattle in 1909. Borg aimed for accuracy and almost photographic detail in his paintings of the caves, islands, and fishermen. In 1908, one of the artist's functions was still to report the curious world, to provide documentary evidence illustrating a people, place, and time.

Other friends helped break the isolation that summer. W. Edwin Gledhill, a young Canadian of Scottish ancestry, brought his bride, Carolyn, to the islands several times to camp, to photograph, to gather cactus fruits for preserves, and to visit with Borg. They became close friends in spite of the fact that, at the time, Borg had what Gledhill considered the "very disgusting" habit of chewing tobacco. Occasionally, Margaret and Kathryn "Kitty" Burke, two spirited, independent Irish sisters, came along, and once, they were joined by Margery Forbes, "a little Seattle girl whom Borg took quite an interest in."[12]

Gledhill thought that "she possibly would have made him a wonderful wife," but she moved as easily out of Borg's life as she had moved in. Margaret and Kitty Burke, however, like the Gledhills, remained in Santa Barbara and became supportive, lifelong friends. They had common interests. The sisters became knowledgeable antiquarians and ran an antique shop; the Gledhills became internationally renowned portrait photographers.

Borg stayed away from Los Angeles longer than the five or six weeks he had anticipated. He returned in the fall and ran into Mary Gibson at the Southern Pacific railroad station. She had been looking for him. Theodore Roosevelt had appointed her son to the American delegation in Honduras and she was planning to visit him. In his letters Hugh Gibson repeatedly cautioned his widowed mother not to think of travelling alone. She was going with another woman, Mrs. Woods, but wanted Borg to come along too, for her sake and his. She knew that he had been having a hard time; she knew too that he had promised her son that he would follow him wherever the foreign service sent him as soon as he got "the signal."

In a letter written to his mother, September 13, 1908, Hugh Gibson gave the signal. An artist was particularly welcome, as a matter of fact, because he could help make the country well known and officials were ready to do "anything in their power to make Borg have all sorts of opportunities." Gibson waxed enthusiastic about the painter's prospects in the country:

> There are more Gringos here now than at any time during the last ten years and they are still coming. Young Book . . . is with a very agreeable pair of fellows, a Dr. Brown of Los Angeles and a young chap named Youngblood. They are going prospecting in the Olancho region and are to be there for about six months. I told them about Borg and they say to send him along to them and they will see that he sees some good country for pictures. They can probably pass him along from one crowd of Gringos to another the entire length of the country and it would be a blessing to all of them as they are all dead tired of their own crowds after a few months and hungry for somebody new. And the country is wonderful—the rain clouds and sunshine and storms and green hills and streams with every sort of foliage from pines and cedars to bananas and orchids give him enough variety to paint a thousand pictures.

Borg had heard a good deal about the other Americas. Almost everyone in Garvanza, the serious students of California at the turn of the century, had visited the republics and studied the mix of Indian and Spanish civilization, which they considered relevant to an understanding of the American Southwest.

He was eager to make the trip, to explore new territories, to see Hugh again, but, as usual, even though Mrs. Gibson would pay his travel expenses and he could live at Gibson's place in Tegucigalpa, he didn't have even the little extra money needed for art supplies and incidentals. He did, however, as usual and as promised, have new pictures to sell from his excursion to Santa Barbara.

Mary Gibson, 1929, photograph by Carl Oscar Borg.

Because Borg had no time to arrange an exhibition, Mary Gibson, who had a reputation for determination and efficiency as well as kindness, told Borg to give the pictures to her. She would see that they were sold. Borg could not have had a better agent.

Mary Gibson found buyers for Borg's pictures not only because she was persuasive, but because the community of friends—every man and woman had not yet begun to be proud of a personal vision—could be counted on to see what she saw in the paintings of this worthy young man. Several members of the Friday Morning Club assisted Mrs. Gibson in getting Borg off to Central America. Three of his paintings dated 1908 hang in the living room of the building that now houses the Pasadena Historical Society, once the home of Mrs. Gibson's friend, Mrs. Fenyes.

In October 1908, Borg sailed for Central America. Five years earlier, he had been the officers' mess boy on a ship steaming out of San Francisco harbor; he dined now at the captain's table in the company of one of the kindest, most intelligent, and most influential of Southern California's pioneer women. The "big land of the West" had indeed proved to be a "place of refuge and good fortune."

Borg had learned Spanish from Eva Lummis—English first from necessity, then from pleasure and interest. Mary Gibson had been a teacher before her marriage; among other accomplishments, she set up English-language programs

for immigrant wives. She too, by example at least, was instrumental in Borg's developing language facility. Like others associated with Garvanza, Mrs. Gibson had a positive view of man; she believed in sharing, educating, building, and preserving. Her association with Borg only affirmed his own sense of ability and purpose. He had already emerged as an artist and collector in Los Angeles, a gifted man with an attractive personality. The trip to Central Amerca marked the emergence of Borg the pundit, a man whose artistic development was followed with interest and whose views on a wide range of subjects were quoted for the next quarter century.

Borg became known in the community as a "born scholar" as well as "artist, soldier of fortune."[13] Visiting in Central America, he fulfilled the three roles. He wrote his first prose analysis in English, a description remarkable in its clarity, detail, and suggestiveness.

We arrived at Antigua one hour after sunset. Everything was still and mysterious; the old walls pale and ghostly in the moonlight. No sound was heard except the clatter of the mules on the cobblestones. . . . My "quarto" was in the second story, an immense room lighted by one candle. I had never seen such an empty and big room. The walls were bare but for a black crucifix over the bed and portions of destroyed frescoes, with the common I.H.S., painted above the door, indicating that the house at one time belonged to the church. At the slightest movement my own shadow thrown on the wall would move and follow me, like some giant, and when I sat down in the only chair, it stopped and seemed to watch me. Altogether the impression was decidedly uncanny. After the candle was extinguished it was less disturbing, and it was not long before the day's wearisome journey told on me and, in spite of the insects, I slept.

Next morning when I went out into the streets the scene of the night before was entirely changed. The glaring sunlight . . . made everything resplendent with color. . . . The Indians here are more primitive than in the capital. The tribes wear different colors and costumes. . . . Here one sees the women in bright colored shawls and heavily embroidered "camisas," their hair in two braids in which are wound colored cords. Here are sellers of pottery with pyramids of red, brown, black and yellow earthen ware of all sizes. . . . Small children, most of them nude, or dressed simply in a piece of cloth, or wearing a string of colored beads with a crucifix, or some kind of amulet, were playing on the ground

Street Scene in La Antigua, 1909, oil, 49.5 x 76.2 cm. Collection Mr. and Mrs. Jules Delwiche.

among pigs and chickens, some of the youngsters trying to catch the slow buzzards, that are in constant evidence and act as scavengers . . . yellow matting shades their wares, harmonious in color with the old ruins surrounding the scene, and above it all a sky blue and cloudless and hard as metal.

In the fourteen-page essay, Borg moved from personal observation to a detailed geographical analysis of the area and then to the succession of historical events, including devastating earthquakes, that had played over the land. The habit of history was deeply ingrained. Borg always looked beyond what his eyes took in to the past that had created the present. In Antigua he had seen hardly "anything but ruins, overgrown and crumbling walls . . . old ruined churches and convents." In no other place had he "ever seen such low and massive walls, such stumpy and gigantic pillars, such depressed domes and flat arches." He saw a lesson in the fact that not "even these could withstand the last earthquake." He concluded, as was his habit, by uniting time and space. With a vision of the myth underlying a reality, he called Antigua "the Niobe of the cities of el mundo nuevo."

Ruinas de la Recoleccion, 1909, oil, 50.8 x 76.2 cm. Collection Phoebe Hearst Cooke.

Borg took photographs and sketched in Honduras, San Salvador, Nicaragua, and Guatemala. He painted *Las Lavenneras, Palacio de Donna Beatrix, Ruinas de Santa Isabel, Ruinas de la Recoleccion, Ruinas del Palacio Arzobispal, Antigua, Ruinas de Santa Clara.* He "felt like an explorer"; he witnessed "revolutions, street riots, mobs and murder"; he fought with some Indians and nearly broke a leg; he was accused of being a spy for taking photographs and thrown in jail, not an unusual event then when, as Gibson indicated, "Americans [were] being popped in jail." The diplomats were kept busy "getting them out of hock." He fell ill of a tropical fever and was "in a hospital—so called—for six weeks."

In April 1909, when Borg's ship steamed away from Guatemala where a smallpox epidemic raged, he was relieved to think his adventures over. They were not. In a dense fog with a fierce gale blowing landward, the *Indiana* hit a rock and foundered off the coast of Mexico. For hours the passengers did not know their fate. With the exception of the captain who remained behind and committed suicide, they were all safely transferred aboard the *Albany,* one of the American warships anchored off Magdalena Bay.

Alma May Cook summarized the events of Borg's six-month tour of the

Americas: "Carl Oscar Borg has more lucky escapes and secures a larger number of sketches between 'experiences' than any other California artist."[14]

When he arrived in San Francisco on April 9, 1909, Borg let his Los Angeles friends know. "I am back in God's own country and think I had better stay here some time now before I start out on another adventure . . . that will do for some little time."[15]

Borg's tales of his adventures, the pictures and reports that he brought back from the trip were widely circulated. Although his work was not yet generally known in San Francisco, his arrival as a "famous" California artist returning from Central America was picked up by the newspapers. On April 25, 1909, the *Chronicle* ran a large photograph of Borg and a story, "Amid the Ruins of Guatemala and Honduras."

> There is one painter who has discovered what is to be gotten out of the region . . . who has dared to brave the hardships necessary to the pursuit of a big purpose. . . . He is young, bold, and confident . . . there should be no worthier man to open the eyes of the world to the buried treasure of Central America than this same Carl Oscar Borg of California.

In Southern California, Everett C. Maxwell, who as the curator of the Blanchard Gallery was arranging the second annual exhibition of the Los Angeles Painters' Club, quoted, on July 9, 1909, Borg's impressions of the social-political situation. An article revealed that the area was "an artist's paradise, but . . . the political situation is deplorable." Guatemala was a "hornet's nest."

> . . . no action is taken to redress the wrongs heaped upon their countrymen [in Quatemala] by the nations of Europe on account of the Monroe Doctrine policy. They decry the wrong of allowing such misrule to continue, but for fear of offending the United States government they stand mute while their countrymen are imprisoned without trial, flogged in the streets, poisoned or murdered in the cafés. They are abusing the Monroe Doctrine. Foreigners in the ill-fated country say, "The United States with their Monroe Doctrine won't allow our countries to protect us." I have seen this thing first hand. From all sides the situation is dark and deadly. Conditions were bad enough before the priests were driven out, but they are worse since. The priesthood seemed to be the hoop that held the staves together—now all is confusion, no law, no order, no political or religious head. I agree with Mr. Roosevelt when he stated

in his first message to Congress seven years ago, that the Monroe Doctrine in order to remain respected in the world, must entail international responsibilities as well as international privileges.

Borg sounded secure and certain, a man comfortable in his opinions; he spoke with the authority that comes with success, and he had had extraordinary successes within a short time. He was, however, still a very poor man, almost literally a starving artist. The pictures from Central America exhibited at the Blanchard Gallery in the Second Annual Los Angeles Painters' Exhibition, provided the "feature of the exhibition which has perhaps attracted the most attention;"[16] one of them, *La Puerta de Santa Clara*, was awarded first prize and was purchased by W. H. Cole to add to his "valuable collection," yet Borg was, in spite of the enthusiasm of the critics and the sale of a few pictures, a poor man. Friends were aware, as Turbesé Lummis put it, that he too "often felt the crushing hand of lack."[17]

Soon, however, that "crushing hand" was lifted.

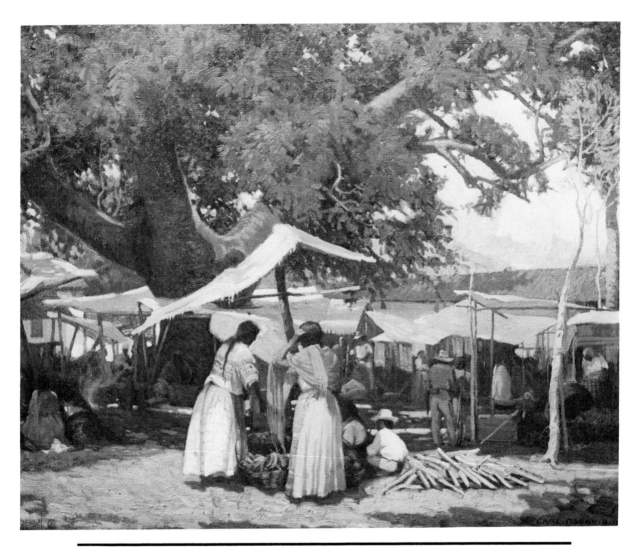

Central American Market, Esquintla, 1909, oil.

PHOEBE HEARST

In the summer of 1909, Eva Lummis, unable to put up any longer with her brilliant, egocentric, philandering husband decided to divorce him. She left Los Angeles, accepting Phoebe Hearst's invitation to remain with her until her plans were certain.

The widowed Mrs. Hearst was in "full sympathy with dear Mrs. Lummis"[1] whom she thought "especially deserving of peace and comforts after the many trials and great unhappiness of her life with Lummis." Mrs. Hearst knew a good deal about family problems, wayward men, and brilliant, domineering husbands. A superb manager of the great fortune her husband, George Hearst, had amassed through his mining interests in the West and in Mexico, she was a perceptive and tough woman, and a highly intelligent, warm, and sensitive one too. She shared with her friends, Eva Lummis and Mary Gibson, an active, generous nature, an interest in art, history, archeology, and anthropology, and a passion for doing. Like them, she too had once been a teacher. Although critical of Lummis as a husband, she had been a good friend to both Lummises for years, a supporter of Lummis's projects among the Indians, his Southwest Society, Landmarks Club, *Out West* magazine, and museum.

Eva Lummis carried with her a number of pictures that Borg had given her in exchange for Spanish lessons. She gave one to her hostess. The paintings and Mrs. Lummis's enthusiastic testimonials to the artist's talents, charm, and worthiness prompted Mrs. Hearst to write to Borg.

August 20, 1909

Mr. Carl Oscar Borg

Dear Sir;

When Mrs. Lummis came to visit me she gave me a most charming sketch made by you. It has given me a desire to see more of your work and to meet you.

I am writing to ask if you will come to my mountain home near Shasta and stay until Sept. 12th. There are many lovely places where I think you will enjoy sketching. After the 12th of September I should be glad to have you make a visit of two weeks at my Hacienda not far from San Francisco. You will find there a few scenes to please you. I am requesting my business manager to send you a check for fifty dollars to cover the expenses of your trip here. As you are, I hope, to be my guest, it is my privilege to send the amount to meet all expenses. Enclosed find

directions for the route from S.F. to McCloud. Please send a telegram to let me know if you can come and when we may expect you.

Yours sincerely,

P. A. Hearst

Borg accepted the invitation. He looked forward to seeing Eva Lummis and her daughter Turbesé, to painting in the North, to freedom from financial worries, and to meeting the millionairess whose interest in and championship of other artists was almost legendary.

Hostess and artist soon discovered common interests: books, antiques, archeology, art, theosophy. Mrs. Hearst, who lived now in the shelter of wealth, listened as Borg, succinctly, vividly, with an eye for detail, related his adventures. A mother, whose only son, the newspaper tycoon, William Randolph, was "selfish, indifferent and undemonstrative,"[2] she warmed to the young artist with whom, in spite of differences of age, sex, and wealth, she had a good deal in common.

A hard worker herself, Mrs. Hearst admired Borg's drive and accomplishment. She had been disappointed in one family friend and protegé, the portrait artist Orrin Peck, who had almost entirely deserted his paints for food and drink. In Borg she saw a new and worthy protegé. She liked his humor and his eagerness, his enthusiasm and intelligence, his droll, heavily accented English, the sensitivity she perceived beneath the strength and activity. She learned that Borg's mother had died the year before, that his father, brothers, and sisters remained in Sweden. She too, years before, had left family far behind to come to California. He was self-educated, had come unprivileged into this world; so had she.

Dinners were casual and often out of doors at the Lummis home in Garvanza. At the Hearst home the occasion was formal. Eva Lummis cautioned Borg about the different style, and he wore his dark suit the first evening; on another occasion he put on a suit of chain armor that "fit him to the dot."[3] The party, thinking he was "a ghost out of ages past," experienced a moment of real fear before breaking out in laughter. Ghosts and spirits were on everyone's mind in the great isolated house in the vast, untamed land.

One of Mrs. Hearst's secretaries died suddenly a few days before Borg's arrival. Borg was not told of her death, or that he had been given her room until he reported that a ghost had come during the night. Turbesé Lummis, then sixteen years old, was not in the least surprised by Borg's occult knowledge. "There was a flavor of magic about him," she recalled. She "knew that Borg knew things

Carl Oscar Borg, 1909, photograph by W. Edwin Gledhill.

that others would not have believed and that no doubt he could make spells and probably had a wishing ring.'' It did not surprise her either

> when he told me as a secret that we would share, that he did his paint-ing by drawing on an outer power—some source not of himself. It seemed mystically clear to me then, but now I am not sure if he meant that it was the power of some artist dead and gone or some more impersonal force.[4]

Mrs. Hearst introduced Borg to many people. Several became his close friends: Albert Falvy, a Hungarian-born antique dealer and estimator for the government; Professor Gustavus Eisen; Dr. and Mrs. Axel Oscar Lindström, a strikingly handsome couple who directed a Swedish Medical Gymnastic Insti-tute and gave treatments to both Borg and Mrs. Hearst. She took him with her to San Francisco and bought him a tuxedo and a gold watch. Wealth, attention, and gifts did not change him. Each day he wandered off alone to paint. Then he sat among the ''noted'' guests (they were usually eighteen at table), the ser-vants hovering behind, as easily as he sat among bums or seal fishermen. An image of Borg remained fixed in Turbesé Lummis's mind.

> When I think of Carl Oscar Borg, I think of him as always laughing, a quiet laugh, just to himself, and under his small Viking mustache, as

California Landscape, 1909, oil, 50.8 x 76.2 cm. Collection Phoebe Hearst Cooke.

though he knew something that would make others laugh too, if they knew it. He would make a long opening of his mouth and laugh silently and long clear to his eyes, rather looking down at you as though to see if you were sharing the fun. Perhaps Vikings did not have mustaches like his, but it seemed greatly to belong to the brotherhood of those world-faring men. It had the sharp cut and the dash of the prow of some Norse ship making new paths across uncharted waters.[5]

Borg seemed "to have come from, and to be going toward, far places." Mrs. Hearst must have thought so too, and wished to help him on his way. In the late summer and early autumn of 1909, by his presence, by his words and pictures, he gained her affection and support. She bought two thousand dollars worth of sketches and paintings, one of which, *Street Scene, Tegucigalpa,* she donated to the University of California, Berkeley. She promised to arrange an exhibition in San Francisco and then to send him abroad for the Continental exposure considered essential to the development of every American artist.

When Borg left the Hacienda "his presence was sorely missed," but his friends "shared in the thrills of his fairy story, excited that Borg had sold pictures to Mrs. Hearst, that Borg was going abroad, that he had things he had never had before."[6]

As a parting gift, Mrs. Hearst gave Borg a scarab. From Santa Barbara, on

October 21, 1909, he wrote a letter thanking her for her kindness and for the scarab. He would try "to be worthy of her friendship and interest."

> In the twilight as I have laid down my palette and finished my day's work—then is my dreaming time. . . . That little symbol will conjure up to my mind's eye the mighty people of the past and I see Egypt in all its glory, processions of its Priests and Priestesses, its kings and warriors, its magicians and wondermakers, builders and artisans, the beaten gold and the carved stone. A wonderful picture ever changing, ever joyous. But underlying the gaiety is a subtle melancholy that is really no melancholy but is the dignity of knowledge, a knowledge of world secrets and of world sorrows. And it brings to mind Kipling's poem, "The Palace" where the King carves the stone. "After me cometh a builder, tell him, I too have known."

The compelling vision of Borg's life and work is revealed in those few words of Kipling's. But Borg and Mrs. Hearst had talked not only of dreams and visions. They had discussed practical matters. If Borg were to succeed, his name would have to become familiar to the larger, more sophisticated San Francisco public. He should exhibit in San Francisco before departing for Europe. His return would then be a matter of interest in the state's largest city as well as in the developing center to the South. As Mrs. Hearst's protegé, he was certain of publicity. The Bohemian Club and Vickery's had been mentioned as possible choices for an exhibition.

The three critics in Los Angeles were as excited and pleased for Borg's prospects as Mrs. Lummis had been. They anticipated the exhibit in the North and wrote the reviews before the opening. Alma May Cook was the first to spread the good word. On December 30, 1909, she wrote in the *Los Angeles Express* that "Carl Oscar Borg has been fortunate in the Northern metropolis He is busily preparing for his Spring exhibition in San Francisco. . . . His exhibition promises to be one of the artistic treats of the year." On March 26, 1910, in an article written for the *Graphic*, Everett C. Maxwell informed readers that Borg had "thirty-five splendid new canvases," including *Summer Day, Street in La Antigua, Solemn Night, A Coast Canyon*, and *Lonely Hills* that revealed his "mingled tendencies of explorer and poet." Maxwell knew "of no other of our young Western painters whose advancement has been so marked or who evinces greater promise for a brilliant future." Finally, Antony Anderson, in the April 3 *Los Angeles Sunday Times*, contributed his share of good wishes and enthusiasm. He celebrated Borg's "genius for noble and impressive composi-

tion, the epic quality of his art. . . . San Francisco does not yet know Borg's work. It will know these strong canvases in a few days, however, and its surprise and pleasure will be great."

Borg was ready for the exhibition, but frustrated in his attempts to locate a public gallery. He had heard from Vickery, and wrote Mrs. Hearst of his disappointment.

> He won't set any definite date. He is also trying to tell me again that he knows what his customers want—and how their homes are (I don't see what that has to do with my exhibition) and if he or anybody else thinks I am going to paint pictures for Mrs. Grundy's parlour, they are very much mistaken. I know that there are men that so prostitute their art. But rather than that I would give up painting and never touch a brush again.

Borg had done his work; he was tired and vulnerable and in need of help when on March 10 he wrote a much less defiant letter to his "faithful friend."

> In a few days I am going to give up my studio here. It is too expensive and I have been inside every day since before Christmas and the Doctor told me I would have to get out in the air more and I think I have enough pictures for an exhibition . . . so if you still think that there is any possibility of an exhibition in San Francisco the best thing would be to ship them up there someplace until the proper time for exhibiting them as that would lessen the expenses. . . . If you think an exhibition can be arranged, then I will come to San Francisco, and, if not, I will have to store my pictures here and will go somewhere so that I can work outside for some time. I feel that I need the change.

His letter crossed one of hers in the mail, and in a letter dated March 14, his relief was evident.

> It was kind of strange about my last letter to you. When I dropped it in the mail box I felt sure that you had written to me and that our letters would cross each other. And on Friday evening when I got home from the studio there was your letter. So I was not mistaken. I don't know how to thank you for your kind interest. It means more to me than I can tell. . . . So I will accept your kind invitation and come up as soon as the pictures are packed.

The gallery was still undecided, but Borg and his paintings would go to

Wyntoon, 1910, oil. Collection Phoebe Hearst Cooke.

Pleasanton. It was, afterall, almost spring; time to move again.

An exhibition was finally arranged at Helgesen's Gallery on Fillmore Street from April 23 to May 14, 1910. The critic for the *Chronicle,* April 24, 1910, reported that the exhibit attracted "much attention." He thought Borg's scenes "decidedly attractive"; there was "much of charm," but the patronizing, sophisticated northern critic also reported something no southern critic found in the canvases, "an overintensity at times which gives his work an aspect of immaturity." Rather than admiring the "epic quality" of many of the canvases, he thought Borg worked "mostly on big canvases" because "he seems not to be free on small dimensions."

Mrs. Hearst's support was apparently more important than the moderate review. When the closing date arrived, a notice appeared in the *San Francisco Examiner* indicating that because "thousands of persons have visited the studio and expressed their enthusiasm," the artist would continue the exhibition a short time. "Several of the finest canvases will remain in San Francisco to adorn the walls of several elegant homes." Thousands may have visited the galleries,

49

but only Mrs. Hearst, her friends the Clarks and the Lindströms, and gallery owners Rabjhon, Morcom, and Helgesen had actually bought paintings. Fourteen of them had been sold with prices ranging from $75 for *Street in Tegucigalpa* to $750 for *Central American Market, Esquintla*. Borg earned $3,100, enough to set up a studio in the Majestic in San Francisco. For six months, until September 14, 1910, when he left California for Europe, Borg divided his time between his studio and one of Mrs. Hearst's homes. In the summer, he and Mary Gibson were both house guests at her mountain retreat near Shasta.

Another Swedish American, Dr. Gustavus Eisen, was chosen to be Borg's guide in Europe and to purchase antiques and artifacts for Mrs. Hearst at whose expense he also travelled. A graduate of the University of Upsala, Eisen had arrived in California in 1873. A formidable figure physically and intellectually, and a mystic, Eisen was President of the San Francisco Microscopic Society, Curator of the California Academy of Science; he was a prolific writer; a distinguished professor of biology, zoology, horticulture, archeology and geography; a photographer, and explorer.[7]

The erudite Swede, a bachelor thirty years Borg's senior, was a brilliant choice of companion. Eisen became Borg's private tutor in archeology, ancient history, and world religion; a firm and enduring friendship developed between them.

The Hacienda, Pleasanton, 1909, watercolor, 12.7 x 21.6 cm. Collection
Phoebe Hearst Cooke.

GAINING A REPUTATION

Gustavus Eisen and Carl Oscar Borg arrived in Gibraltar on September 29, 1910. They continued on to Granada, and, after a night at the noisy Hotel Victoria, settled in at the Villa Carmona, Puerto Del Sol 19, a pension no longer in existence, but still remembered by tour guides as having housed romantic painters. The pension was run by Dona Carmen, "Tia Gorda," an enormous, moustached woman, always dressed in widow's black, always trailed on her daily market rounds by her dutiful maid carrying a large basket. Tia Gorda, Borg observed in the diary he intermittently kept, was "very smart and businesslike," and made good use of the then well-known fact that John Singer Sargent used to board his students in her pension. With disarming sincerity she recited "when Sargent lived here" for gullible American and English tourists, producing an old fan or mantilla supposedly used by Sargent in his picture *Carmencita* (at the Louvre). She regularly sold and replaced the props.

Soon after their arrival, Borg and Eisen were joined by a journalist and his bride from Los Angeles. Both in their sixties, they were honeymooners. One night at dinner they were all

> talking about California, not thinking that anyone was listening. . . . Suddenly the lady at the other end of the table said, "So you are from California, that terrible country. I am from Boston, and I have never seen anything so boring as San Francisco and California. It was something dreadful."
>
> There was silence for a moment and then the journalist began to tell a story. "I had a remarkable dream last night. I dreamed that I was dead and found myself in front of the door of the kingdom of heaven. I met St. Peter with his bunch of keys and he asked who I was and what I wanted. I answered that I was Mr. Andrew, a journalist from Los Angeles and I asked to come in. St. Peter said that I was not dead, but since I was a journalist he understood that I wanted to come in and take a look at the splendor. He whistled for an angel and directed him to show me around everywhere. We began our tour through streets trimmed with gold and jewels and into wonderful buildings. But there was one place which the angel did not show me in spite of the fact that we had passed it several times. I asked him why he did not allow me to go in there. The angel said that it was the one place they were ashamed of in heaven and that they did not want it to be known. I insisted and said that I was a journalist and that I was used to going in everywhere, and besides St.

Peter had promised to let me see everything. The angel was evidently susceptible to rational arguments for he took me in.

"We went into a very large building. Inside was semidarkness, so at first I could not see anything except some pedestals standing around the floor, but gradually I could see that people were chained to the pedestals. They pulled on their chains and tried to break loose. I asked what all this was. The angel, obviously embarrassed, said finally: 'We in heaven are really ashamed of this place, but the fact is that these people are from California and they do not want to stay here; they all want to go back to California.'"

Everybody laughed, thinking the story was finished, but . . . Mr. Andrew continued without casting a glance at the lady at the end of the table, who seemed to be interested.

"Finally we came to the entrance of heaven and I thanked St. Peter for his kindness. I had evidently enlisted his sympathy for he said that he thought that now, since I had seen heaven, he was sure that I would also want to see hell. At first it seemed a little gruesome to me, but remembering my profession I answered, without hesitation, that I would be grateful if I were allowed to see this most interesting place. St. Peter whistled again for an angel and told him to take me to hell. When we arrived we rapped on the door and it was opened by Lucifer himself, who asked who we were. I told him who I was and why I had come and he asked me to come in. Even here I got a guide, a little devil who took me everywhere. There were big lakes and small lakes of burning sulfur, grilles where men were roasted and pinched with tongs. . . . We went into one building after another and all were very interesting, but even here, there was one building I could not enter. Finally I asked the little devil why I could not go in there. He hemmed and hawed and said that this place was never shown to anyone. I stood up for my rights and referred to the fact that the Chief himself had promised that I should see everything and that he had not made any exceptions. It worked and we went in. However, I could hardly see anything at all, because it was almost dark. On the floor was a cage from which hot air was pouring. When I looked up, I observed a group of figures hanging from the ceiling. I asked what it meant and the little devil answered that it was really very painful to describe but all these people who were hanging up there were from Boston and they were so green they had to be hung to dry before they could be burned."

The westerners laughed at the well-told tale; the easterners were not so pleased. They left the table as soon as the punch line was delivered and the pension soon after. Borg and Eisen settled happily into an agreeable routine, which Eisen described in copious travel notes to Mrs. Hearst.

They got up with the sun, watched dark-eyed, attractive Andalusian maidens milk their goats in the streets and doorways, breakfasted outdoors on coffee and the thick, hard, white *pan de castillo*. If they were not off on a longer excursion to the Alhambra or a distant castillo, they walked one of the four paths leading in different directions from the pension in search of subjects, their cameras slung over their shoulders, Borg with his sketchbook. They studied the sights and scenes until noon: old Moorish houses, markets, antique "factories," gardens. "The painter," Eisen reported, "is always in raptures whenever he sees a Cypress or a tall Poplar tree." They studied "interesting types"—men, women, and children guiding mules loaded with provisions; water vendors, wood sellers, street sweepers. Sometimes Gypsies descended upon them, the women pretty in brightly colored skirts, but filthy and full of sores, mocking and menacing, demanding to be photographed. They did not photograph them, preferring instead an ancient fruit vendor, a woman "older than Methuselah and more weather beaten than the summit of Muleyhacen."

At noon, sketches made, photographs taken, they returned to the pension Carmona to enjoy a heavily garlicked meal. In the afternoons, they separated, the scholar to the University and his "old, musty volumes," the painter to his pen or paints.

Borg preferred working out of doors, sometimes difficult to do because of the many beggars who crowded around. He was acutely sensitive to having escaped that degrading poverty, while others, even those with some gifts, perhaps, had had no luck. Several times in his life, most often in America, he saw himself in the beggar whose outstretched hand he usually tried to fill and to whose story he often stopped to listen. In Granada, however, he could not stop to listen or to pay. Eisen had warned that if he made the mistake of giving a single beggar a coin then "woe to you. All the beggars in Granada will know it the next day. Your generosity will fly like wildfire from street to street, . . . you need only show yourself outside to be followed and pestered to death." The numerous, well-to-do Spaniards seemed oblivious to the apparent distress of so many.

At five o'clock, the workday finished, the artist and scholar met at the Café Alameda on Puerta del Sol where they drank coffee, sipped brandy, watched the perennial bilking of the tourists, the daily sale of "the oldest crucifix in the

world,'' and exchanged notes on the day's experiences. William Davenhill, son of the English Consul, and a German painter by the name of Achtstatter often joined them there along with other Americans, congenial residents of the Pension Carmona, Mr. and Mrs. Troy Kinney, illustrators from New York, and Miss Kellerman, a Phi Beta Kappa graduate of Ohio State University's class of 1909. Miss Kellerman observed that Eisen and Borg, in spite of the great differences in their ages, were good travelling companions; that "Professor Eisen did not like women"; and that "Don Carlos was a tall, slender, handsome man, pleasant to be with, interesting to talk to."[1]

After coffee, they took a leisurely stroll to the pension, the Alhambra walls and towers deep orange in the brilliant sunset and "glowing as if they emitted fire." Then came dinner and a final walk by moonlight. In November, when it began to be uncomfortably cold in the pension, which was heated by a single brazier filled with half-burnt-out charcoal, Eisen and Borg made travel plans. Because Eisen disliked Madrid and Borg wished to go there to study the paintings in the galleries and museum, they temporarily separated. Miss Kellerman, who handled the Spanish language like a native and knew Madrid well, was Borg's congenial companion in the city while Eisen explored his own interests in southern Spain.

Borg and Miss Kellerman lived at a pension run by the sister of the owner of the Pension Carmona. They visited theosophers and flea markets. Borg, who knew better than to try to paint a beggar in the streets, tried to bring one into the house to pose for him, but the Señora who ran the pension, "did not think much of that." He studied the paintings in the Prado and was surprised to discover his childhood idol, Raphael, somewhat eclipsed by Velasquez. He had seen Raphael's pictures only in photographs and in his own mind; actuality fell short of his dreaming. He absorbed the difference and went on with his dreaming.

Borg and Mrs. Hearst corresponded often. Mrs. Hearst thanked "her most faithful correspondent" for his gift of a little book. She told him she had ordered all of Swedenborg's religious books, that quite an "unusual English woman, deeply interested in theosophy" would be her guest, that she was sorry Borg could not meet her, that "your friends here are thinking of you." She worried about his health, aware of his susceptibility to colds; she worried that he would work too hard, that he might try to exhibit too soon. She urged him to go directly to Egypt where at least the days would be warm and to wait until spring before making the trip to Rome. She sent letters of introduction to Dr. Reisner, the Harvard archeologist working in Egypt. Sometimes she wrote of herself:

Mother and Daughter, Tangiers, 1911, watercolor, 49.5 x 39.4 cm. Collection John Villadsen.

Today was glorious. I felt tempted to go off to the hills . . . enjoy the fine views and do a little thinking without interruptions. As it seemed impossible to do as I wished, I submitted to discipline and went quietly down the walks accepting the comfort of a visit with the flowers. The roses, violets and chrysanthemums spoke words of affection and we understood. After a time I forgot the petty cares and heartaches of life.

The modest bookplate that Borg designed for Mrs. Hearst, where a single simple flower serves as emblem, testifies to the sympathetic understanding between them.

At the beginning of the new year, Borg and Eisen travelled together to Tangier, which they found "very interesting," and on January 18, 1911, left Gibraltar for Egypt aboard the *U.S. India.* Miss Kellerman would have gone with them, but her mother wired her to "come home."

They remained in Cairo for a month. They stayed at the Hotel Bristol in the "modern section" with squares, parks and flowers; the broad, acacia-lined streets were clean, the electric trams and street cars well managed, the hotels and stores as good as those found anywhere in the world. They "hurried past all this 'modernism' as fast as [they] could." Avoiding the hoards of chattering tourists with their Baedeckers and Kodaks, "known the world over as 'cookies,' " they explored the old city and surroundings.

They took long streetcar rides along the Nile; wandered through mazes of narrow, crooked streets; visited bazaars, mosques, tombs, ancient Coptic churches. They took note of the crosses tatooed on the arms of young Chris-

Fellahin Women of Upper Egypt, 1911, oil, 91.4 x 119.4 cm. Collection Lowie Museum of Anthropology, University of California, Berkeley.

tian boys, the flies on the eyes of the babies. They watched barehanded Bedouin women mold camel dung into loaves like bread to be baked and used as fuel, Sudanese soothsayers read fortunes from double triangles they traced on the sand. They took photographs and Borg sketched. They hunted through an "ocean of ashes," the remains of the ancient city of Cairo burned in 1060 by the Sultan who wished to thwart the advancing crusaders. They found old writings, old prints, pieces of pottery made of glass or enamel, and Roman lamps. They visited the Mokattam Hills, saw the black-cloaked Fellahin women walking home at dusk, baskets or waterjars on their heads, a procession of exquisite dignity and simplicity that Eisen described in words and Borg in many pictures. They visited the Pyramids and the Sphinx, at first disappointed and filled with sadness and contempt at man's vandalism and neglect; later, awed by their power and mystery. The experience of Cairo "entirely overwhelmed" them.

In February, when funds arrived from Mrs. Hearst, they explored upper Egypt—Luxor, the Valley of the Kings, Edfu, Assuan, Philae. They were, Eisen wrote, "like children with new toys, all enthusiastic and eager"; they made the acquaintance of Mohammed Abdelrasoul who had discovered the Tomb of the Kings and wanted them to help him excavate another under his own house. Eisen took "a number of photographs which might be of use for some future lecture," and Borg took "many more, also, many in colour by the Lumière process." He sketched a waterwheel, a mangy animal, a sheik, the desert, rendered the intensity of light, the play of shadow, the gentleness of an Egyptian night, the stillness of a sleeping village. He sought to capture both the historical and

spiritual truth in what he saw. *Egyptian Village* became a major oil, a quiet painting haunted by a world of dreams; *The Waterwheel* became another oil, a close study of an ancient technological invention. In careful, appreciative detail, Borg painted the hand-hewn wheel, the massive wooden gears, the stone supports, the equal parts played by nature, man, beast, and invention to bring water to the desert.

On February 25, 1911, they were sitting on the veranda of the Hotel Rossmore in Luxor. A stranger addressed Borg in Swedish, *"Skall det vara en spådom?* (Do you want your fortune told?) Borg turned to find a Hindu fortuneteller, one of those men who had had the honor of choosing between wealth and languages and had chosen languages. For five shillings the man told Borg's fortune, his past and his future. He would marry twice, and one day, when he was a much older man, his native country would present him with a medal.

On April 1, they returned to Cairo for a final visit, and a few days later they sailed from Alexandria aboard the steamer *Perseo* bound for Naples. They had had "a most wonderful time, the time of [their] lives."

They remained in Naples a few days and then made their way to Rome where Mrs. Hearst's bankers, Sebasti and Reali were expecting them. To their address on the Piazzoni di Spagna they had shipped their collections and through them they received letters and funds.

Eisen wrote up his notes of their Egyptian travels—one essay, "With Camera in Cairo," was published in *Camera News* in Los Angeles in 1912—and pursued his new interest in Etruscan beads, an interest that he cautioned his patroness not to take as an indication of senility or second childhood. Beads were serious business in which the scholar could read the rise and fall of civilizations.

While the professor wrote and studied, Borg settled into a period of intensive studio work. He painted Eisen's portrait soon after their arrival in Rome and gave Eisen the painting. He rarely refused commissions for portraits from wealthy patrons, and executed a number while in Rome; but when it was a question of choice, not money, Borg invariably chose to paint old scholars, servants, beggars and artists. Using sketches and photographs from the months of wandering, he worked on other canvases to be submitted to several exhibitions in the spring of 1912.

On June 17, Eisen reported on Borg's physical condition, always of interest to Mrs. Hearst. "Mr. Borg is getting actually fat since he began to eat clabber milch every day. He is well and paints steadily from morning to night and must have a dozen canvases under way and some of them are very good indeed." And on January 25, he reported that

Mr. Borg is simply a wonder. He has finished some 15 large land-scapes and is now sending them to various exhibitions in the capitals of Europe. They are all good, and some very fine, and I am satisfied that if he keeps up as he does now, he will in a short time become one of our greatest landscape painters. It seems to me that Egypt inspired him in particular and developed his sense of color.

Although Borg spent most of his time working in his studio at 33 Via Margutta, he could not neglect Rome. He bought a fur-lined coat and visited the museums, monuments, galleries, and churches. He studied the Renaissance masterpieces and expressed his reaction in a word—"wonderful." He wrote of his enthusiasm for the work of a number of contemporary artists: Arnold Böcklin, Alfred East, and Beppi Giraldi.

On March 2, 1912, he wrote to Phoebe Hearst.

Liebe Mütterchen—I have been working as I never did before. . . . I need a rest and feel as weak as a piece of boiled macaroni. I have sent two pictures to St. Petersburg to the Imperial Academy's spring exhibition and today I received notice that they have been accepted. . . . I have sent six canvases to Amsterdam to the "Internationale Kunst Ausstellung," two to Venice to the "X Esposizone Internazionale di Belle Arti." They will all open in April or the end of March.

The year's intensive work completed, Borg needed to rest his eyes from reading as well as painting. Eye strain was a persistent problem. He intended, he wrote Mrs. Hearst, to be out of doors as much as possible. He planned to visit the exhibition in Venice, return to Rome, and then move on to Paris. His things were already packed and headed for Paris by slow freight. Intuitive, mystical, and gracious though he was, Borg was also methodical, disciplined, and deliberate as he set about building his knowledge and his credits in Europe.

Borg arrived in Venice on April 17. He thought the exhibition "very good, the best I have seen." He arrived in Paris on April 28, in time for the opening of the Salon des Artistes Français. The Salon was a disappointment. It "lacked the good taste of Venezia." He found too many "poor pictures [painted by] old fossils."

Borg was on his own; Eisen, who "did not care for Paris" and was usually sick there, remained in Rome. Borg tried to find a studio, but the places he saw had "neither room nor light and [were] more fit for horses than painters." He gave up the search and spent the summer months largely out of doors, travel-

Roma, 1911, watercolor, 38.1 x 27.9 cm. Collection Howard Woodruff family.

ling and sketching in other parts of France and Switzerland. In the fall he returned to Paris and located a room at 29 Rue des St. Pères where he lived for the next two years. He was a curiosity in the building, because, finding wall paper "so cheap, a dollar fifty for everything," he had cleaned and papered his room before moving in. He was probably the only struggling artist in the history of the Latin Quarter to care enough about making "everything clean" to do the job himself.

Borg did not mind being a curiosity, but he reacted sharply to some of the curious things he saw happening in art. Could Borg have interpreted the signs, he might have anticipated during this exposure to the fermentation and changes occurring in western art, the coming shipwreck of his own world view. But in 1912-1914, although he was often outraged by what seemed to pass for art in Paris, no shadow of fear troubled his confidence in and enthusiasm for his personal vision.

In the spring of 1912, Borg wrote of "poor pictures" by "old fossils" at the conservative Salon des Artistes Français. In the fall he reacted to the revolutionaries. Since its inception in 1903, the Salon d'Automne had hung pictures

by nontraditional painters. The Cubists had begun exhibiting there in 1908, and by 1912 were a self-confident group of artists dedicated to the idea that art should be emptied of feeling, subscribing to Braque's formulation that "the intellect alone is a shaping, constructive force."[2] Not only Cubism, but half a dozen other movements vied for attention in Paris that year: Fauvism, Surrealism, Machinism, Purism, Dynamism, Orphism. Nothing had prepared Borg for what he saw. He reacted in much the same way that many other Americans would react when the "moderns" made their debut in New York at the Armory Show the following year. He thought the pictures "the most madful things [he had] ever seen"; he felt that he "should not have sent there." He "tried to withdraw [his] picture, but [it was] impossible."

Borg did not understand the impetus behind the detached and mathematical art, the violent art, the private art; he did not see that the artists involved in this seemingly distorted way of seeing things might be prophetic. His life and vision were grounded in nature, the past, and reverence. Truth was eternal, mysterious, and continuous for Borg, and to toy with it was sacrilege.

Another western American artist who came to Paris to study art in 1908 was less secure in a personal vision and "wallowed in every cockeyed *ism* that came along." Thomas Hart Benton admitted that it took him "ten years to get that modernist dirt out of [his] system."[3] He eventually came to the same conclusion Borg instinctively and immediately came to: the Parisian artists and intellectuals "were an intellectually diseased lot, victims of sickly rationalizations, psychic inversons and God-awful self-cultivations."

In his notebook Borg pasted a cartoon from the Parisian press mocking the Cubists. A desolate father looks at a monster infant in the nurse's arms. The infant's soft body, wrapped in a long baptismal dress, contrasts sharply with the head where human eyes stare out of a cube. The father laments to his friend: "And I told my wife not to go to the Exposition Cubiste!" The cartoonist captured a truth. A way of seeing becomes after all a way of being.

After two years in Europe, Borg felt that his experience had "undeceived" him about art. "Before I had an idea that there were lots of masters in Europe, but, as a matter of fact, I find those supposed to be the greatest ones are merely good advertisers."

A man Borg considered genuinely a "master," the Spanish artist Ignacio Zuloaga came to visit him in his studio. A passionate and realistic painter, traditional and expressive, Zuloaga had found his subject in Spain among the Spanish people. He was recognized as a major painter when Borg met him, but he had been neglected in Paris for years. Like Borg, Zuloaga was a mystic, interested

Guardians of the Temple, 1912, drypoint etching, 24.8 x 17.5 cm. Collection Santa Barbara Museum of Art, California.

in the past. The two men had a good deal in common, and drawing on his own experiences in Paris, Zuloaga, nine years Borg's senior, urged the younger man whose "pictures he praised very highly" to "leave Paris, to go to London or New York." Borg's work was "too good for the merchants." In Paris, Zuloaga warned, "he would be unappreciated." Borg recorded the praise, but rejected the advice.

He remained in Paris, determined to gain his reputation in that city. He purchased a second-hand press for forty-two francs and on September 26, 1912, he "tried [his] hand at etching for the first time. The result was not good." The second attempt was "much better," and, not long after, Borg completed his first successful plate, *The Temple of Luxor.* From his first efforts, Borg preferred the challenging dry-point method. Moving from large to small scale, from color to black and white, he later often executed a dry point of a favorite scene first rendered in oil.

As 1912 came to an end, Borg's achievements in Europe were considerable. He had taught himself a new medium and his paintings of Egyptian and European ruins and landscapes, of Moroccan women, Egyptian fellahs, French and Spanish peasants and fishermen had been accepted at every European exhibition to which he had sent them. He had exhibited in Rome, Venice, Paris, London, Ghent, Amsterdam, Vichy, and St. Petersburg; in Rome, his landscapes had been singled out as "excellent pieces of work, with a largeness of composition that is lacking in so many landscapes of the present day." The same qualities that had provoked criticism and skepticism in San Francisco—the canvas of vast space and dimension—were celebrated in Rome.

In spite of his successes, Borg had no sense of pride or achievement. Without the monthly allowance Mrs. Hearst provided, he could not survive. The isolation and difficulty of his life weighed heavily upon him as he sat alone in his room in the Rue des St. Pères on Christmas, 1912, "the loneliest Christmas I have ever had." He had sent deeply personal presents to the Wendts who would understand their significance, an Albert Dürer wood engraving illustrating the *Labors of Hercules* to William, and a sixteenth century engraving, *The Trials of Job*, to Julia, but he had had no word either from friends in America or relatives in Sweden. France was not California, and in the winter, when the skies were grey and the streets wet, and the cold settled into the room where he worked, Borg missed the warmth of California and friendships. Mrs. Hearst, however, was supplying the necessary funds to keep him in Europe for another two years. He was not due home until the spring of 1915. After all, "the artistic atmosphere, the association with artists and seeing the fine collections mean so much to an artist." However lonely Borg might feel in Paris, he would not leave until he had done what he set out to do, establish himself as an American artist with the still necessary European reputation.

In the beginning of the new year, on January 5, 1913, Borg was given the opportunity to gain that reputation when the owner of the Jules Gautier Gallery on 19 Rue de Sevres offered Borg a one-man exhibition of his work. Borg was ready. He was "playing his last aria!" If the exhibition were not a success, "well, I hate to think of it."

The exhibition was a resounding success, news of which reached across the ocean and echoed in Sweden. French critics were given the opportunity to see the range of Carl Oscar Borg's achievement and they found it considerable. The one hundred examples from the collected works of Carl Oscar Borg, shipped to Paris through Mrs. Hearst's largess, and with the help of the Gibsons, provoked an enormous and sympathetic interest. Through this exhibition and the

critical acclaim it evoked, the Californian's European reputation was assured.

In the year that French "modern" painters swept into New York causing delight and consternation, French critics in Paris, in *La Revue des Beaux Arts, La Libre Parole, Le Temps, La Revue Moderne, Masques et Visages, Gil Blas, Le Journal des Arts*, and *L'Art et Les Artistes*, responded with unbridled enthusiasm to the Swedish-American's sensitive portrayal of man and nature. "The important collection of works" provided "a very remarkable impression of ensemble" that revealed Borg's "intimate, penetrating and always sincere emotion," his "simplicity of means," his "delicate and energetic, light and thoughtful" artistic nature which "analyzed and composed with equal subtlety." His work was "powerfully expressive," his paintings "glowing studies" where one felt the "intense poetry." Borg was called a "master of his means of expression," who kept the observer "under the spell of mystery which pervades all his works." The essential characteristics of Borg's serious art had not changed and would not; critics on both sides of the Atlantic responded to the same qualities: simplicity, poetry, mystery.

No dissenting voice was heard. Thadée de Gorecki's seven-page article, "Carl Oscar Borg," which appeared in the April-September issue of *L'Art et les Artistes*, was merely a fuller presentation of an appreciation that seemed universal. The critic included a photograph of Borg and nine photographs of paintings: *Femmes en Promenade* (Guatemala), *Marché dans l'Amerique Centrale, Paysage de Californie, Les Deux Pêcheurs, Habitants de Tolède, Musiciens Ambulants, Ruines de la Villa Adriana, Tivoli, Village Eqyptien, La Côte de Californie*. He described Borg's character, background and work.

> Today, he is one of the strangest and most original figures of modern art.[4] . . . This sensitive, spontaneous, profound and imaginative . . . artist . . . doubles as a scholar and poet. . . . His inexhaustible imagination is of a pantheistic comprehension. . . . According to Carl Oscar Borg, the best way to be original is first of all without any other thought to follow beauty, beauty which even to her elect only reveals herself slowly and little by little, and then to try to conceive and to realize works far from the beaten paths. He who thinks and feels by himself is assured of giving to the universal symphony the note which will save him from oblivion.

Gorecki was pleased and moved by the large vision in the frankly emotional pictures. "Ah, how good it is to see a young painter who unites everything . . . who looks at trees, the earth, houses, the sky, without worrying

about anything else than to try to translate his emotion." He drew attention to the distinctive qualities of California and to the role California had played in the artist's development.

> Carl Oscar Borg passionately loves . . . California, his second home, this privileged corner of the world which seems to keep the remembrance of other times . . . where the climate is gentle and the earth fruitful. . . . Moreover, California possesses the immense advantage of not lacking in space and of not having her fields surrounded by barriers as we have in Europe. It was in California confronting nature that the artist's hand and spirit were educated, and this stay in a country where nothing recalls our prejudices and our quarrels, where everything speaks of independence, was for him like the retreat that pious persons make fleeing the dissipation of the century in order to find themselves face to face with God again. . . . He represents not only what he sees, but what he feels.

While the French critics of 1913 wrote nostalgically of an artist who came from that "privileged" corner of the world called California, the California critics carried news of Borg's "remarkable successes" to Los Angeles. "Carl Oscar Borg's European successes are becoming material for frequent mention"; the critics "back home" were proud that they had "recognized [Borg] from the first as a professional painter of great ability." "L.A. may well say, 'I told you so,' to the Parisian journals à propos of the marked success of Carl Oscar Borg," who "has won artistic fame in five European capitals."

Alma May Cook reported that Borg was

> loyal to California, Over in gay Paree there is a young artist, a "jeune peintre" as they say, who is winning his way and attracting much attention—and it's good news to his Los Angeles friends that a Parisian critic in a recent article says that "Carl Oscar Borg aime passionement la terre Californie sa seconde patrie," for it shows that Mr. Borg still passionately admires the beauties of California. Los Angeles in not only proud of Mr. Borg and of his allegiance to California after his European successes, but it had the pleasure—also the good sense—to appreciate his work before he won his European reputation. . . . Mr. Borg will return with a European reputation to the city where he began his art career.

Mrs. Hearst learned of her protegé's successes from the papers and friends.

Dr. Eisen wrote from Rome on February 12, 1913, that "Mr. Borg has received very fine notices in the Paris papers. . . . One writer expresses astonishment that he is equally master in oil, watercolor and black point." She wrote Borg that she was pleased that he had sent "pictures to numerous exhibitions," and "proud of [his] success in having an exhibition of [his] own."

She continued to worry about his health and with good cause. Eisen had reported that Borg had written of having a bad cold and cough, alarming symptoms in those days. "I feel sure that you economize in your living expenses to the detriment of your health. There is one thing I *insist* upon—that you take better care of your health." Like most advice, Mrs. Hearst's went unheeded. Borg's depression, however, lifted with the critical acclaim and with the sale in January of 1,000 francs worth of pictures, not a bad sum when rent cost him 115 francs for three months.

On May 10, 1913, Mrs. Hearst wrote that she wished Borg could "spend the summer at the Hacienda and have a good rest, then return to Europe and stay until the spring of 1915," but Borg did not return to California that summer. He travelled to Ghent where two of his paintings were on exhibition, to Amsterdam, and briefly, in spite of Mrs. Hearst's fears that he would "not have much pleasure if he went there," to Sweden to visit his father and the Nilmans.

In 1913, in addition to the major exhibition at the Gautier Galleries and the one at Ghent, Borg exhibited *El Cerro*, a poetic Central American evening scene (praised by Antony Anderson as having "the sympathy and solemnity of a Millet") at the Royal Academy of Art, London. The painting, along with two California scenes, *A Coast Canyon* and *Island of Santa Cruz*, was reproduced in *The Studio*, London, 1913. Gustavus Eisen wrote an article in Rome featuring Borg as "one of the most interesting painters of California" and sent it to Borg who placed it in *The Studio*. Though despising publicity, Borg knew its necessity and value.

In Paris, preferring the company of "fossils" to "madcaps," Borg exhibited again with the conservatives at the Salon des Artistes Français. *Un Village Egyptien* and *Les Collines de Mokattam* drew rave notices. "An intense poetry emanates, a delicate sentiment is expressed which makes these two of the most exquisite exotic landscapes in the exhibit."[5] Hugues Balagny, writing in *Le Chroniquer de Paris*, bestowed honorary French citizenship on Borg; he was "des nôtres." When *Un Village Egyptien* was exhibited at the California Art Club in Los Angeles and San Francisco, American critics reported that the "scene near Luxor by moonlight . . . with [its] air of ruin and mystery is remarkable."[6]

The year had begun in isolation and loneliness; when it concluded, Borg's

personal ambition and the ambition of his supporters had been realized. He had become a "renowned artist" with a "European reputation." He had been celebrated. Photographs of the artist and his paintings had appeared in newspapers and magazines in Paris, London, Gothenburg, Boston, Los Angeles, and San Francisco. He was a "lucky Swede." Had the major exhibition of his work been scheduled a year later, he would not have received the same attention. Art could not occupy France and Europe at war.

In the beginning of the new year, Borg did not foresee the war nor pause to rest on his laurels. Working as hard as ever, he continued to submit paintings to exhibitions, to the International Exhibit at Aix-les-Bains, to Belgium, to Les Orientalists in Paris, to the Société des Amis des Arts de Seine-et-Oise where he won a silver medal, and for the third year, to the Salon des Artistes Français where Borg's paintings again attracted favorable attention. In an otherwise highly critical article which appeared in the *Chroniquer de Paris*, June 5, 1914, Hugues Balagny singled out Carl Oscar Borg as "one of our most subtle and most exquisite painters [who] affirms his great understanding with two Spanish types treated with verve and vigor."

On June 26, 1914, Borg's solitude and the rigor of his self-imposed routine was interrupted when Hugh Gibson, who had just been assigned to the legation in Brussels, dropped in to see him. Gibson was in the company of family friends and fellow southern Californians, Mrs. John Percival Jones, the Senator's wife, and Mrs. John Daggett Hooker, wife of the President of Western Union Oil. When they asked him to join them for a day's motor touring in the country, he "came on the jump and seemed to revel in having somebody to play with." They looked at his pictures before setting off. He had "a lot of good stuff," Gibson wrote to his mother June 28, 1914. The Egyptian watercolors were, in his judgment, "wonderfully good, and quite different from anything else he has ever done," but the continuous and lonely effort apparently told on Borg. They thought he was "having a pretty bad time." The women, who "were quite taken with Borg," insisted that he join them again the following day for a "square meal" and a gallery tour. Gibson reported that "Carlos enjoyed himself tremendously."

When they parted, Gibson promised he would send his mother the photographs Borg had given him of pictures painted and exhibited in Europe, and Borg promised his friend that as soon as he got "a couple of exhibitions off his mind, he would get to work illustrating" the short stories Gibson had written dealing with his experiences in Central America.

By July, however, the world had been disrupted, and all plans changed.

"There is going to be a general European conflict," Borg recorded in his diary, July 28, 1914; "all paper money refused. If one wants to buy anything, one must pay with gold, or even silver." Borg did not expect to see again the three pictures he had sent to Belgium just before the war or the four pictures sent to the International Exhibition at Aix-les-bains.

In the states, Borg's Los Angeles friends were anxious for word. One of his watercolors, *Quo Vadis, Domine*, the facade of a Roman church, was reported hanging in the Roymar gallery where it attracted a good deal of attention, but no one knew where the artist was. The *Express* ran a photograph of the painting and the missing artist and told of the war's disruption. "The location of anyone or anything in Europe now seems to be only problematical."

Borg tried to leave when the war broke out, but was unable to. He had not dreamt that he should "ever witness such terrible times". On August 30, Borg saw Paris "full of refugees from Belgium. Everybody in the street seems to carry a suitcase or a parcel of some kind." He saw "misery and suffering writ large in every face," German airplanes dropping bombs, people shooting at them "from housetops and streets but without any effect, women and men crying in impotent rage," finding it "incomprehensible that no French airplane is seen anywhere." Everybody who could was leaving Paris.

For almost three months Borg witnessed "blood pouring over land and sea, flowing in streams, the demon of hate sowing his seeds in the hearts of men." He persisted in his efforts to leave and, in October, he was finally successful. The Swedish consulate—Borg was still a Swedish citizen—arranged for some of his paintings to be shipped to San Francisco. Some were left with a friend in Paris, and Hugh Gibson was later given the task of trying to retrieve them; some were irretrievably lost in occupied zones. On October 10, Borg sailed from Le Havre aboard the *Tourraine* bound for New York.

THE PANAMA-PACIFIC EXHIBITION

1915-1916

Borg remained in New York for two months, long enough to become as familiar with the galleries and museums as he had once been with the docks where he had tried to drum up business for sweetheart portraits. He lived at the Salmagundi Club at 47 Fifth Avenue, the artist's club and residence with which he was to be associated for more than thirty years.

The librarian of the club, Charles F. Naegele, suggested that Borg join with other club members in painting treasure boxes. Borg had been praised for his expansive landscapes; now he painted a scene on a $9 \times 7 \times 5$-inch box which appeared in the members' exhibition of treasure boxes held at the Plaza ballroom in February 1915. "For the first time in the art history of this country a collection of treasure boxes [was] decorated by artists of the highest standing."[1]

Before returning to California, Borg took the time to arrange for an exhibition in a New York gallery. He had the credentials. "His pictures have received the unqualified endorsement abroad of such eminent critics as Max Nordau, Arsense Alexandre, and Thadée de Gorecki, and being shown in this country for the first time, will delight lovers of a sadly neglected method of art expression." In December 1914, the new gallery of Arthur H. Hahlo and Company exhibited thirty-eight of Borg's watercolors—pictures Borg had carried aboard the *Tourraine*—from Egypt, Morocco, Italy, Spain, and France, scenes of cemeteries, tombs, markets, ruins, old streets, lakes, and temples, Tangierian women, Tangierian "types," and Moorish storytellers. Borg attended the opening and then left for California.

From December 1914 until June 1916, Borg remained in the San Francisco area dividing his time between his studio on Post Street and the Hacienda at Pleasanton to which he periodically retreated to paint, to rest, and to enjoy the society that, even in the increasingly difficult times, gathered about his "little mother." It was always "entirely convenient" for him to come to the Hacienda where his "Mütterchen" was "glad to have him at any time and for as long as he would wish to stay."

He renewed his acquaintance with antique dealer Albert Falvy to whom Mrs. Hearst had introduced him in 1909. Falvy's shop on Sutter near Mason became the second "home" that Dawson's was in Los Angeles, a place where Borg could pick up messages, learn about and handle artifacts, meet and talk with other knowledgeable and enthusiastic collectors.

Borg joined the small band of artists working through Helgeson's gallery, a group which included Granville Redmond, Clarence Hinkle, Gattardo Piazzoni, and Armin Hansen. He became a member of the San Francisco Society

of Etchers, established in 1911, the year before Borg began experimenting in that medium in Paris. The other artists knew him as "a very highly strung . . . gentleman, slender and aesthetic." He "dressed well"; he was "not Bohemian."[2] His friendship with Mrs. Hearst enabled him to pursue his career as a serious artist, but his existence, secured by a maintenance allowance, by the money his few students brought in and by the occasional sale of paintings— three to the Hearst Free Library in Anaconda, Montana—and enriched by presents of books, silver tea sets, and clothes, was still marginal. He was tempted to sell his collection of Egyptian artifacts in 1914 when he was offered $1,500 for it, but Mrs. Hearst advised against the sale; it would be worth more. He had a reputation as a lively, interesting conversationalist, but he rarely joined in the free-ranging discussions about art. He had spoken openly and revealingly about beauty and art in his interview with Thadée de Gorecki in Paris; usually he did not speak his deepest feelings or perceptions. Privately he gave voice in his diary and his poems to what he publicly expressed in his pictures.

For ten years, Borg had unhesitatingly and persistently pursued his goal of "being a great painter"; he was respected now as an eminent artist whose name was known throughout the state. He received the California Art Club's first prize in the winter of 1915 for his oil, *Summer Afternoon*. In the spring of the year, he was one of the prominent artists exhibiting at the Panama-Pacific International Exhibition where he was represented by four etchings and an oil, *Le Château Gaillard*, a painting praised by Parisian critics. The painting—the ruined castle of Richard the Lion Hearted set in Les Andelys on a height overlooking the Seine—reflects Borg's abiding interest in history and nature. Its selection for the Panama-Pacific Exhibition suggests Borg's awareness that the Exposition was designed to emphasize San Francisco's cosmopolitan rather than regional character.

Ironically, Borg showed his qualifications as an international artist in the year that Western art became a subject of national interest. The Panama-Pacific International Exposition in San Francisco focused national interest on California and Western art. The first comprehensive study of Western art, *Art in California*, was published to commemorate the event. California critics and teachers of art and art history contributed essays, Borg's friends from Los Angeles, Maxwell, Cook, and Anderson, among them. Their consensus was that California had "a place dramatically apart from her sister states because of her beauty, romance and youth," and that "the future of art in America [was] most vitally concerned with California."[3] Everett C. Maxwell contrasted the "intellectual" art of Northern California with the "sensitive, feeling"[4] art of Southern Califor-

The Awakening of Spring, oil, 40.6 x 50.8 cm. Collection Howard Woodruff family.

nia. It was Maxwell who named that southwestern territory extending in California from Santa Barbara to San Diego, and including the states of Arizona and New Mexico, the Magic Region.

In 1915, the year of the International Exposition in San Francisco, the eastern art critic, Christian Brinton, echoed the western critics when he confirmed that "the West has a great future in art." The artist's function, Brinton thought, was to "keep alive that primal wonder . . . concerning the universe." With the "freshness and vitality" of life in the West, the "future of art belongs to the West."[5]

In the same year, Mary Austin, who had lived in Garvanza at the turn of the century, and who continued to circle in the Lummis orbit, wrote similarly of the distinctive quality of Western art in *Century Magazine.*

> . . . the creative spirit in the West is affected by the sense of sustained vitality in nature. . . . At every turn there is the consciousness of something doing, of something vitally connected with the large process of nature and our own means of subsistence. . . . Whatever is written or painted in the West should evince breadth and power. . . . The final achievement ought to be a newer and more consoling expression of man's relation to the invisible, to the trend and purpose of things. In other words, one would expect the art of the West to be strongly religious in its implications.[6]

Carl Oscar Borg was one of those Western artists whose serious art was "strongly religious in its implications." In 1916 he went to live with the Hopi and the Navajo, finding the subject that allowed him more fully to express his own as well as the Western essential interest in "man's relation to the invisible."

THE INDIANS

1916-1917

Three years before her death, Borg's "little mother" again acted as Borg's earthly guardian angel. She arranged for him to go into Indian territory to photograph and paint the Indians "as they are" for the University of California Department of Ethnology and the United States Bureau of Ethnology. "The West needs a painter who understands the Indian's soul. Your eyes are clear enough to see, and your hand strong enough to draw these twilight gods."[1]

In 1906, when Borg was still a newcomer in the West, his first American "mother," Idah Meacham Strobridge, gave him a book she had written and published herself in 1904, *Miner's Mirage Land*. In it she described her response to the desert:

> In the desert you have climbed more than halfway up the ladder that reaches Godward. . . . It is not a far thing from reverence. . . . you lie awake at night under the low hanging stars, [and] you know you are part of the pulse beat of the universe.[2]

When, in 1916, Borg's third American "mother" made it possible for him to know the land, his response echoed Mrs. Strobridge's. The desert became "my desert." "My God, how I love it," he cried. "Here one is much nearer the creator of it all." He had travelled in many lands, but for him, "the Navajo and the Hopi land" became "the most interesting in the whole world." He rode his horse "through the painted desert and slept on the ground wrapped in a couple of blankets and looked up at the velvet sky. The air was so clear that it looked as though one should be able to reach the stars just by reaching up one's hands."

The high-strung and driven artist felt at peace in the desert among the Indians. He arrived in Arizona in the spring of 1916 shortly after the auction at the Curtis Gallery in May of "famous Borg art"—ninety-three European and Western canvases—and he returned to the Indian reservations almost every spring for the next fifteen years. He rendered in gouache, watercolor, oil, woodblock, and drypoint, the "real" American, his spirit and his land, as they were witnessed and understood by an artist who was also a historian, a mystic, and a poet walking the edge of a time. The Indians called him Hasten-na-va-ha-sa, he who comes in the spring.

How many times Borg migrated in the spring. He had left his home for Stockholm, Stockholm for Europe, Europe for America, New York for California, the city for the desert in the spring; his reverse migration from America to Europe occurred in the spring, and his final voyage, for which he was utterly prepared, also came in the spring.

Sa-la-ko, 1923, drypoint etching, 15.2 x 15.2 cm.

In 1916, there were no roads into the Hopi villages, which were even more isolated then than they are now. Borg went by train as far as he could; a mail carrier then took him in his Ford to a trading post outside of Flagstaff where, "in the middle of the night," he joined "an Indian caravan consisting of about half a dozen wagons and twenty-five mounted men." They rode in the dark. Borg could not see his fellow travellers until the sun rose and then he saw that "their faces were painted and they were all armed." They rode all day, stop-

ping only briefly to eat a little dry meal; that night, tired though he was, he could not sleep. He was not afraid, but his "fantasy had new material to work on."

Initially insecure and uncertain among the Indians, Borg soon came to understand the full significance of paint and adornment and to sleep more easily and profoundly on the desert floor than in any room. He became close friends of the Hopi chief of the Snake Clan at Shipaluvai, Su-pe-la, his wife, Sa-la-ko, and their son Harry. He spent several weeks each spring in the little tin shack that he rented from them on the mesa. He painted their portraits in oil, etched them in dry point, and carved them in woodblock. He painted their ceremonials too, and after a time, when they were certain of his sympathy and sincerity, he was admitted into the kiva and initiated into the clan.[3]

Membership in the Snake Clan gave Borg the power to give Indian names. When Hugh Gibson's son was born in Brussels in 1929 while Gibson was serving as ambassador, his parents named him Michael, and his "Uncle Oscar" named him Swa-mi-wi-ki (Roasting Corn). "This in Indian language means that you shall have food in plenty and never go hungry," Borg explained.

Almost nine years after his arrival in Shipaluvai, on a blazing hot July fourth—water was scarce and Borg drank canned tomatoes to assuage his thirst—Harry came looking for Borg. Borg interrupted his work and sat silently with Harry Supela until the Indian was ready to speak. Harry told him that his father had died, that his mother, Sa-la-ko, who had converted to Christianity, wished to have a Christian as well as a Hopi burial. Would Borg perform the service?

Together they went to the desert floor not far from Shipaluvai where they built a coffin of "rough boards and covered it with velveteen." The family placed food, corn, and water in crocks in the coffin; jewelry and a saddle went in too. Harry, a rain-cloud mask over his face and prayer feathers in his hair, performed the Hopi rites, and then Borg began the Christian rites as best he could, recalling burials at sea. He was interrupted by Sa-la-ko who, having always seen a priest holding a book while engaged in a Christian ritual, would not let Borg continue without one. Borg went the long way back to his shack and returned to complete the ceremony holding a painting catalog. He did not have a Bible in the desert. The casket was sealed, placed in the

> grave and covered with earth. Later the chief's burro was stoned to death and its body placed on the dead master's grave. . . . The Indians [believed] that the donkey's spirit would join that of the Chief so that he might have a beast of burden to ride while travelling in purgatory in the Grand Canyon, called by the Indians the Skeleton House. . . .

Anga Kachina Dancer, **1917, watercolor, 71.1 x 55.9 cm. Collection Lowie Museum of Anthropology, University of California, Berkeley.**

After being in purgatory the spirit went to the top of the San Francisco mountains in Arizona, a heaven where foods, sunshine and rains were plentiful. A manes[4] cane was driven into the center of the grave, its handle projecting above the ground. A shallow trench several feet long was then dug due West from the cane and in this trough was placed a twisted cotton cord. a feather was tied to the end of the cord, its tip pointing West. The cane was to assist the chief's spirit to rise from the grave, the cord and feather indicated which way it should go—West to the Grand Canyon.

Although Borg kept his word and never wrote or spoke of the ceremony by which he had been initiated into the Snake Clan, Borg's records in words and paint form a detailed and accurate portrayal of other aspects of the daily life of the Hopi and the Navajo, their myths and activities, the fusion in Indian life of past and present, life and death, nature and man. Not only did Borg feel a spiritual kinship with the Indian philosophy, he respected and shared their reverence for the stark world they inhabited. The color and form of the desert, the atmosphere's ability to render a hard, distant form soft and fluid, and the clouds in the endless sky fascinated him. The clouds meant a great deal to the Indians, carrying as they did both souls and rain, all that was powerful and good. Moved more profoundly than he had ever been before, sensing the human dreams and prayers that for continuous ages had spilled over in that land, he painted and wrote (in English) poetry celebrating the spirit, the Indian, and the West.[5]

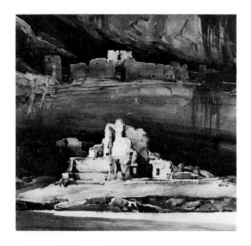

The White House (Casa Blanca), watercolor, 48.3 x50.2 cm. Collection Gothenburg
Ethnological Museum, Sweden.

THE DESERT MOON

The moon shows pale in the morning sky
God! how wonderful it was last night!
It is pale as the memories of yesteryears,
But, O, how the light that was haunts my soul!
The black mesas on the horizon-line,
The silver sheen on the fragrant sage;
White as specters stood the ruins
Under the canyon walls,
Veiled in mystery that no man knows. . . .
Here sages read the signs of elemental laws
And glimpsed a partial truth.
No more have done the wisest men,
Of nations great and famed.
But as yester-eve'n's moon was bright
And this morning's of a lesser light,
So all things that men attained
When grasped, the reason fades,
Unless with humble soul and prayers
Upon their lips, they kneel and thank
The Gods for light.

ON THE DESERT HORIZON

Far in your haze haunted distance
I am walking alone
Holy, sequestered, apart.
And the soul of the world comes to bide with me there.
The beauty of opal and amethyst distance
Are but the garments it wears.
In those moments I hear the music
Of the all, uncontradicted, sublime
Moments divine
When the soul of the world
Speaks to my own.

Although the Navajo and Hopi land did not first inspire Borg's pantheism—Thadée de Gorecki had written in 1913 that Borg's feeling for religion was of a "pantheistic expression," experiencing the Indian land and observing the pattern of life among the Indians enhanced Borg's commitment to the long, whole view and to nature. The Swede reverentially recorded the land, man, and method that he found so simple and profound.

In a letter to Phoebe Hearst written in 1910, Borg commented on an old Indian couple he observed watching the "airships" in Los Angeles from their position on the highest row of the grandstand.

> The old Indian was standing there looking intently at the great aeroplanes moving overhead. He did not shout and clap his hands like [those about him] who in spite of all their demonstrations did not understand the problem and its significance any more than he did. He at least looked dignified and the others did not. At his feet the old woman was sitting watching as intently as he. . . . They showed no sign of surprise. Late in the afternoon when I left they were still standing in the same place gazing out over the crowd towards the hills where Paulhan's aeroplane [circled] in the sunlit sky. It made a great picture and for a long time I have not seen anything that appealed to me as strongly as those old people, the last of a lost race and one of the modern inventions.

Borg was sensitive to the tension between the advance of civilization and traditional beliefs; he recorded instances of the Indians' rejection of the white man's machines.

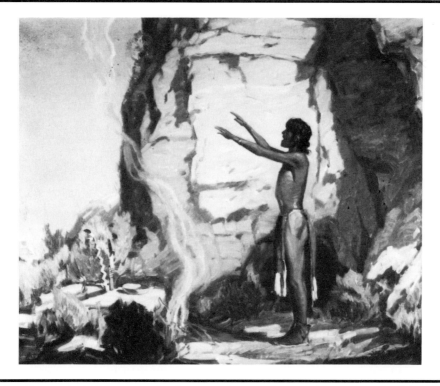

The Altar in the Wilderness, oil, 50.8 x 61.1 cm. Collection Howard Woodruff family.

When the first radio was brought into the reservation, all the chiefs sat around and listened attentively as the voices that came out of the box announced: "This is New York," "This is Chicago." "This is Denver." . . . After a while one of the chiefs who had reflected on what he was hearing asked: "What's doing in my hogan now?" When informed that the radio didn't work that way, the chief announced, "Me no want." When the first car was brought into the reservation, one of the chiefs looked at it thoughtfully. At that moment a cow with a calf went by. The chief turned to me and asked, "Does this one have little cars?" When he was told that it didn't, he answered, "Me no want."

In 1916 Borg was spiritually and physically at home in the West and approaching the height of his fame as a California artist. He had discovered his great themes—the landscapes of Southern California, Arizona, and New Mexico, and the Hopi and Navajo Indian. He responded to and painted America's Magic Region as long as there was a Magic Region and an audience who perceived it.

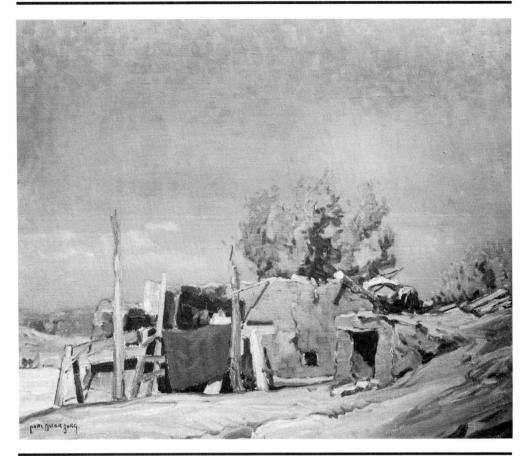

Navajo Dwelling.

He visited the Grand Canyon for the first time in the fall of 1916 as he made his way out of Indian territory. As usual, he spent days alone discovering, interpreting, "feeling," the Canyon; he photographed, sketched, painted, and meditated. Emerging from his solitude, he sought society again. He met and became friends with another Swedish-American, Charles A. Brant, the manager of the El Tovar Hotel who gave him room and board in exchange for a promised Canyon picture. In December, from Santa Barbara, California, Borg sent a completed Canyon painting to Brant, and on December 27, 1916, Brant wrote to thank him:

Now my dear friend, I know I told you that you possessed extraordinary gifts as an artist. . . . I am not coming to this conclusion from my own observation, but we have here with us today the dean of America's landscape painters, Mr. Thomas Moran, and Mr. Moran stated

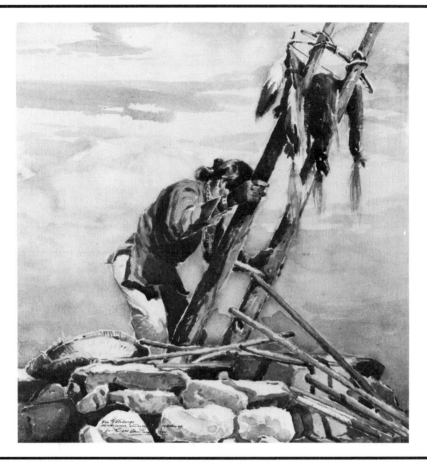

On the Top of the Kiva, Mishogononi Snake Kiva, watercolor, 40.6 x 42 cm. Collection
Gothenburg Ethnological Museum, Sweden.

to me in the hearing of a dozen others that he considered you preemi-
nently the highest grade of any artist in America today. Mr. Moran is not
a man who slops over in praise of other artists' work—in fact, quite the
reverse. Mr. Moran stated that we did not have a painting of the Canyon
in the hotel today that comes anywhere near showing the artistic skill
displayed in the picture you sent me.

Thomas Moran had stopped at the El Tovar on his yearly winter migration to
Santa Barbara. He did not know Borg. Two years later the artists met in Santa
Barbara and became friends.

Borg remained in Santa Barbara long enough to complete a number of can-
vases and to purchase a piece of property. He was determined to settle there.
He was almost forty; he had wandered "without house or home" for a long

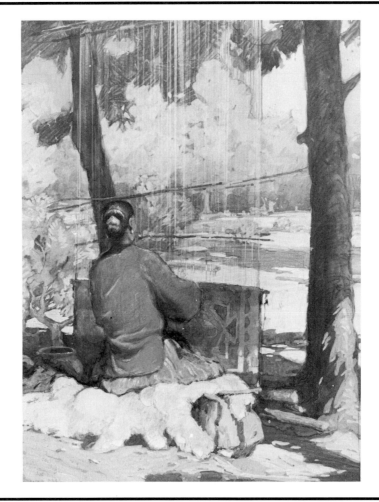

Navajo Blanket Weaver, 1916, gouache, 25.4 x 17.8 cm. Collection Henry Art Gallery, University of Washington, Seattle.

time. He had remained in San Francisco as long as he had largely because of Mrs. Hearst. Now that he was an established artist and his patroness old and frail, he wanted to return to the area of California with which he most closely identified and in which his closest friends resided.

When Borg finally returned to San Francisco, he brought an impressive number of paintings. An exhibition exclusively of Indian pictures, "Land of the Hopi and the Navajo," opened at the Palace of Fine Arts February 27, 1917. The paintings, including *The Hopi Potter, The Hopi Snake Priest, The Burden Bearer, A Hopi Planter, Procession of Kachina Priests, Shipulavai, City of the Painted Desert,* presented "the Indians at their daily tasks," and the land they inhabited.

Shipaluvai, 1916, gouache, 18 x 25.5 cm. Collection Helen and David Laird.

They were all in tempera, opaque water colors mixed with Chinese white, painted on grey paper, and small because "only small pictures can be packed about in the country he went into for his subjects. They are terse as a sonnet, but they are complete. He started and finished each picture right in the field; [they] forcibly express the loneliness, simplicity and infinitude of the native existence."[6]

Two thousand San Franciscans viewed the exhibition on March 4, 1917, and 1,500 of them heard Mrs. Rose Berry, chairman of the Fine Arts Department of the General Federation of Women's Clubs lecture on "Carl Oscar Borg, an Appreciation." Mr. Borg had taught Californians "to expect great things of him, but in this present exhibition, he . . . far surpassed expectations." Mrs. Berry's appreciation was the first of many. "Before this crowning success" Borg had done "a tremendous amount,"[7] but now, after years of wandering and reflection, with mature technique, and profound empathy with his subject, he attained a new vision and a certainty and intensity of feeling to which the public and the critics responded.

In painting the Magic Region and its natives, Borg accomplished his artist's task. He succeeded in transmitting his own emotion, his sense of awe, and the loneliness and dignity to which he responded. His best canvases evoke in the spectator a powerful sense of wonder at the sadness and the dignity of man in nature, whether man is absent from the canvas or whether a single or a few solitary figures are set within the frame. A tension is felt between the brave, vulnerable individual and the powerful permanence of nature.

85

MARRIAGE AND FAME

1918-1924

Borg had been essentially a "man's man," a "brother fellow" for years, travelling with and learning from men from all walks and stations of life—artists, bums, sailors, craftsmen, educators, dealers, diplomats. He had enjoyed the company of older, independent women, or married women, where friendship, not sex, dominated. He had been attracted to young women, had invited one to come along to Egypt, but had formed no lasting alliance. Not only had his gifts and ambition absorbed him, he shared a background with many sensitive, poor Scandinavian sons who had suffered in childhood along with their patient, uncomplaining, but obviously unhappy mothers. Many such sons married late or not at all.

In 1917, in his thirty-eighth year, Borg was famous, confident that he could support a wife and maintain a home, ready to settle down. He was middle-aged and sensitive to the passing of his youth. "My youth has been given me for nothing. . . . The nights I know are long." Dr. and Mrs. Lindström introduced the erudite, companionable bachelor to a young woman of seventeen who had come with her mother from Los Angeles for an extended visit to San Francisco. When Madeline Carriel joined one of Borg's art classes, he began to see a good deal of her and soon fell in love. She was petite, dark complexioned, black haired, vivacious, and very beautiful. Borg was "attracted by her beauty,"[1] and she was just as attracted to the famous, sun-bronzed, handsome artist. He was twenty years her senior, but age seemed no barrier, and with the mother's strong encouragement, they became engaged.

In January 1918, Borg returned to Santa Barbara to build a home for himself and his fiancée on the point high on La Mesa close to where the table land rises from the waters of Santa Barbara. He attended the spring exhibition of the California Art Club in Los Angeles (his *Festival in Hopi Land* took the Black Prize as best picture in the nonlandscape category) and took his usual spring-summer excursion to Indian country. Otherwise, from January through September, Borg remained in Santa Barbara absorbed not only with his painting, but with constructing his own "château," a building "copied from the old Spanish church at Zuni, New Mexico, built long before the Spanish Missions of California."[2]

Phoebe Hearst did not know Madeline Carriel, but she corresponded regularly with her protegé, enthusiastic that he was establishing a home at last, sure that "all of his collections would give him real pleasure," that "his work would be known and appreciated." In February 1918, she purchased and presented two "notable pictures by Borg to the Department of Anthropology" of the University of California, Berkeley: *The Hopi Snake Dance* and *The Niman Kachina Dancers*. She supported Borg with encouraging words and gifts of

money, silver, china, curtains, linens, furniture, and mattresses. House plans and every detail of the house were familiar and of interest to her, and Borg, completely lost in his private world, could write of nothing else.

Mrs. Hearst's letters reported family news and the reality and effects of war: the loss of servants to the draft, the necessity of selling or giving away the horses, the selling of diamonds to raise money for the Red Cross, the knitting. "Everyone here is knitting sweaters, socks, helmets, etc. When I have finished the twenty-fourth pair, I will rest from knitting." But there was no war for Borg. The student of history, blind to time and circumstance, was completely absorbed in building his personal shelter.

Borg was at times acutely aware of his own capacity for dreaming, and of the extent to which he constructed the world of his desire.

> Some eve'n hour, in silent dusk,
> I see the garden of my dreams.
> And while the image that I've
> Made to live stands inside,
> Smiling and serene, I shall go in
> And take my own and fold the whole
> Within the embrace of my soul.

Carl Oscar Borg and Madeline Carriel were married in Los Angeles at her parents' home on August 15, 1918. On September 18, when Borg wrote to Phoebe Hearst that "the house is now completed," he saw only joy in the achievement and the promise:

> It is wonderful. I do so wish that you could see it, for it is beautiful, everything has turned out so well. I must say even better than I dared to dream and I think that barring anything unforeseen the future will be very happy in every way. I know that you would love the place. . . . I am so happy in it! And my little wife is a dear and she loves it and takes such an interest in everything really beyond my hopes.

Within a few months newspaper articles began encouraging people to make "a pilgrimage to the home of Mr. and Mrs. Borg" for a "most interesting experience."

> Gazing from without one instinctively feels that the place is of exceptional interest. In response to a rap of the old Spanish knocker the

The Hopi Snake Dance, 1917, oil. Collection Lowie Museum of Anthropology, University of California, Berkeley.

host or hostess comes, and should it be the latter the one without glimpses for an instant a Signoretta through the antique grille transferred from its home in some ancient Spanish house to this California abode of the well-known painter, Carl Oscar Borg and his charming little bride. . . . The house has a three-fold interest of a charming home, a studio, and an assembly place for treasures sought and found all over the world by Mr. Borg who is a great traveller and collector of antiques. . . . In the studio and throughout the house are marvelous collections . . . rare books . . . etchings, engravings, and prints . . . scarabs . . . glass beads . . . coins and signets . . . chests and cabinets . . . armor, lacquer and Chinese embroideries, finger rings . . . old silver and china . . . photographs and textiles, about all of which Mr. Borg possesses a marvelous fund of information. . . . A little gallery opens into a balcony with a wooden rail hung with a bright colored sarape, and from which one may look at entrancing views of mountains and sea.[3]

One of the early "pilgrims" to come to the Borg home was Mary Gibson who brought a friend, John Collier. Borg showed them his pictures, recited his poems and talked of his life among the Indians. It was Collier's "first convinc-

ing contact with that Indian spirit which since has come to mean more than anything else in life."[4]

John Collier, for many years secretary of the Indian Defense League, who has fought for the Indians for the last ten years, was sworn in as Commissioner of Indian Affairs today in Washington. I met him first in Santa Barbara with Mrs.Gibson in 1919. He knows the needs of the Indians and I hope will be able to do something for the Original Americans.

A small group of the "original Americans" also made the pilgrimage to Borg's home. When Navajo friends came to Santa Barbara, Borg took them to meet his friend Albert Falvy who had built a house next door. In Falvy's ornate, antique-filled living room, the prisms in the crystal chandeliers threw out flames of rainbow lights. The Indians, amazed and confused by the dancing colors, nudged their painter friend, who seemed able to do everything, and whispered to him: "You catch it. You catch it."

Later, they all stood by the ocean and Borg sketched *Navajos at the Pacific Ocean* and wrote a poem.

> In wordless wonder we stand
> Before you, Mother of Waters;
> In silence we have waited this hour
> To kneel before you
> Giver of life, Mother of Waters
> Greetings to you from
> Your children of the Painted Sands . . .
> We go home to the desert . . .
> Where smoke from the hogans
> Speaks to the sky . . .
> And there in the sacred councils
> We will speak of your unmeasured depths
> Mother of Waters, Giver of Life.

Borg celebrated the Indians in poetry and picture. He also collected funds for the Indian Welfare League, a national organization sponsored and supported by Garvanza friends Mary Gibson, Charles Lummis, and Mary Austin, and other prominent Americans including botanist Luther Burbank and author Hamlin Garland. In August 1923, Borg was pleased to have "made over a thousand dollars for the cause right here in Santa Barbara."

Steps to Acoma, gouache, 48.3 x 40.6 cm. Collection Eugene B. Adkins.

Borg was what his Los Angeles friends had predicted he would become, "one of California's best known artists." A letter written by Charles Lummis, June 4, 1920, testifies to the esteem in which he was held:

> Would you tremble for the Fate of Art if I were to become Director of the L.A. County Museum of History, Science and Art? Eighty of the real Builders of the Material and intellectual structure of the Community are backing me for the place left vacant by Daggett's Death. I can see a *Man's Game* in it all—to give it ideals, standards, standing, character. As for the art angle, Mrs. Wendt, Prince Troubetskoy, Bond Francisco, Guy Rose, F. W. Blanchard are already hopeful to have me; and I'd like to know how *you* stand. Been hoping to see you here long ere this. Hastily, but Always your Friend.
>
> <div align="right">Chas. F. Lummis</div>

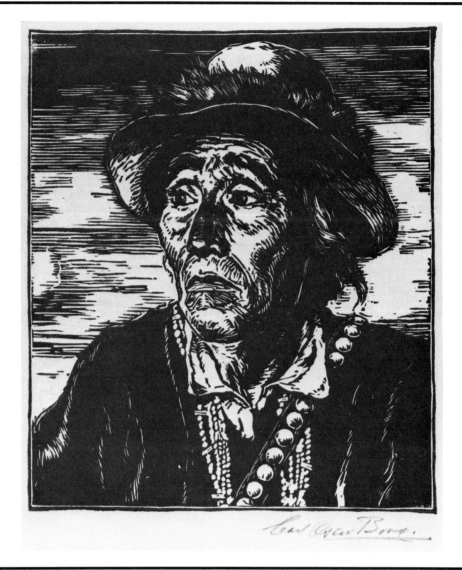

Navajo Chief, 1923, woodblock, 26.7 x 21.6 cm.

Although Borg continued to work as a landscape or *plein air* painter in California—*California Hills* won the Huntington prize for landscape in 1923—after the move to Santa Barbara, he was most frequently referred to as a painter of the Indian and the Great Southwest. Like the celebrated Taos and Santa Fe artists of the first decades of the century—Ernest Blumenschein, Walter Ufer, E. Martin Hennings, Victor Higgens, and Irving Couse—Borg's "soul [was] keenly sensitive to the sadness and sorrows of the desert Indians."[5]

"Lovers of good pictures . . . interested in desert scenery and Indian life"[6] were urged to see *The Rainmakers, Pueblos, The Altar in the Wilderness, The Awakening of Spring, Steps to Acoma, Oraibi, Canyon de Chelly, The Bad Lands (Arizona), Hopi Potter (Nampejo), The Red Rock Wall, Navajo Chief, Hopi Chief, The Lone Rider, Hopi Stronghold, A Bit of Old Zuni, The Great Silence, On the Lonely Trail, The Glory of the Mountains.*

His pictures were celebrated nationally and internationally. He won a silver medal at the Salon des Artistes Français exhibition in 1920; the Bibliothèque Nationale received his dry point etching *Navajo* from the American Federation of Arts; Gothenburg newspapers in Sweden avidly followed his career. Americans interested in art outside California knew of his achievements through articles that appeared in the *Christian Science Monitor* and the *American Magazine of Art*. On October 9, 1923, Borg was cited in the *Monitor* as "an artist of whom Southern California may be justly proud having become one of the most sympathetic and truthful exponents of the land of the Hopi and the Navajo." In December 1921, the *American Magazine of Art* indicated that "success has crowned his efforts and revealed a rare poetical nature. . . . He grasps his subjects with a power and a breadth born of genius"; in April 1923, it called attention to Borg's "Scandinavian facility with wood working tools." He had "cut some striking blocks making use of Pueblo Indian subjects."

The *Magazine* called attention to other artists living in Santa Barbara, the "artist's paradise":[7] Alexander Harmer, Lockwood De Forest, Dewitt Parshall, John Gamble, Ed Borein, and Thomas Moran. Borg enjoyed their companionship and developed close friendships with several.

Thomas Moran was a friend as was his daughter, Ruth. Borg painted Moran's portrait and gave Ruth a picture, *Medicine Man*, and an accompanying poem. He drew a picture in Moran's guest book that reveals his admiration for and spiritual affinity with the older artist: an Indian carves Moran's name on a central "mystic isle" stone; the top of the letter M is lopped off to form triangles, symbol of wisdom, recalling Borg's signature on his early portraits of Buddha, Mohammed, and Christ. In 1923, when Moran was made "the only honorary member of the Los Angeles-based Painters of the West, the dying artist was pleased,"[8] his daughter reported, "that it was the name of his friend Carl Oscar Borg that led the membership list."

Ed Borein, another Western enthusiast, collector of Indian artifacts, and good friend of Lummis's settled in Santa Barbara the year after Borg settled there. Borein was only five years older than Borg, and the two became good friends. Borein's studio in the de la Guerra and Borg's on the Mesa were gathering places

for artists. Charles M. Russell, another of Lummis's good painter friends, often came up from Pasadena where, seeking relief from painful rheumatism, he wintered from 1919 until his death in 1926. He exhibited then in the same galleries in Santa Barbara and Los Angeles that Borg and Borein did. They had all covered a lot of territory, had plenty of experiences to weave into tales, and were as good at spinning yarns as at sketching.

Borg had another circle of friends in Santa Barbara, bookdealers, photographers, antiquarians, mystics, intellectuals: Carolyn and W. Edwin Gledhill, Margaret and Kitty Burke, Edward Connaughton, Leonard Woodruff, Reginald and Miriam Vaughan, Karl Koehler, and Albert Falvy among them.

Borg was absorbed with his work, friends, and students. He took extended trips to New Mexico and Arizona, on one of which he met and painted the portrait of the renowned Swedish geographer and explorer, Sven Hedin. He taught the outdoor painting and sketching class at the Santa Barbara School of Arts. One of his students, William Otte, became a close friend and a painter of some local reputation; another, John Dominique, blind, but still painting in the late 1970s, remembered Borg with affection and admiration; he had had another famous teacher, Maynard Dixon. When asked to compare his teachers, he answered simply: "Oh, Dixon was an illustrator. Borg was an artist. He could see nature. It was so easy for him to see things."

It seemed that fortune had dealt Borg all the aces. He had a home, wife, friends, work, interests, collections, reputation. In 1919, Borg was described in the *Westerner* as "virile, versatile, likeable, and a man." The noun was inclusive, but the adjectives gave a partial picture. Certainly he was "versatile" and "likeable"; the playful side of his character, his humor, erudition, and love of words were public knowledge in the twenties. In 1923 when the Tutankhamen dresses worn by women in Los Angeles required interpretation, "that well-known authority on Egypt, Carl O. Borg," was called on to interpret the inscriptions. He obviously enjoyed the occasion, telling reporters that they were "lifted by the cloth makers from various tombstones," and might "literally be translated as: 'May my twins be well taken care of while I'm away'; I'm looking for a soft place to light': 'My home is a place of heavenly bliss':'Here's hoping for wine on the trip.' " He could be witty and poke fun at almost anything. His own home was not a place of heavenly bliss.

Borg was a complicated, moody husband, volatile, nervous, intense, sensitive, fastidious, absorbed in his art and his own interests, and often difficult to live with, at least for a lively, cheerful, willful young woman who had no compelling interests of her own. Madeline could not understand or sympathize with

her husband's absorption with books, paints, ideas, and "old men."

W. Edwin Gledhill observed that "Madeline was very young and inexperienced, unable to meet Carl's friends and help him with the required social graces. A poor cook, it is doubtful . . . that Mrs. Borg entertained any of her husband's friends for a meal."[9]

As the initial excitement and novelty of marriage and the new environment wore off, differences in age, experience, and inclination began to tell. Madeline wanted activity, gaiety, a different, younger, less bookish society. She was not "at home" on the Mesa, which even in 1924 when Lucille and Ed Borein began to build there, was still considered "the desolate mesa."[10] Open houses, teas, bridge parties, an occasional piano lesson for the children of Borg's friends, and discussions with Borg's friends did not satisfy her for long. They had no children, and the "little wife" who had first "taken such an interest in everything, really beyond [his] hopes," became increasingly distanced, almost a stranger to her husband's enthusiasms. That Borg should have seen her early "interest in everything" as almost "beyond [his] hopes" may indicate a recognition of differences which might and finally did cause a rift.

In his personal life, Borg seemed doomed to unhappiness, destined to experience life as a passionate observer from a distance. He had had "no childhood"; his youth had been given him "for nothing"; now his middle age was haunted by an increasingly difficult, unhappy marriage.

Borg was famous, but he didn't have much money. The construction of the "château" had reduced his "bankroll to the extent that it cannot be found." He had borrowed money to build, and what money he earned from his students and the sale of paintings was largely absorbed in paying debts. Gifts from his benefactress ended with her death in 1919. Borg was financially on his own, and he had "no talent for business." He was not even very good at selling his own pictures, often more interested in engaging a prospective client in conversation than in selling him a picture. Borg had observed, too, that an artist who showed himself in need of funds was in a vulnerable position.

When it became clear that relative poverty would be a daily fact of life if they continued to live in Santa Barbara, and that Madeline was not happy living there, the Borgs decided to move to Los Angeles. There the opportunities to make money were greater, and Madeline might be happier nearer her family and friends.

In 1924, Borg sold his "château" for $16,000.

HOLLYWOOD

1925-1930

Carl Oscar Borg and Madeline Carriel Borg moved to a modest, ordinary, unexciting house on North Hobart Avenue in Hollywood. Even though situated in the flatlands, they had a view of the hills. Only other bungalows dotted the area, flowers were everywhere, and the Borgs felt no sense of confinement in a concrete land. Borg built a studio in the rear garden, not as grand as the one he had left, but adequate.

Hollywood had grown rapidly in the twenty years since Borg first arrived in Southern California, from a village of seven hundred to a city of 100,000. But eagles still soared overhead; rabbits and squirrels abounded; "coyotes and owls patrol[led] the streets at night." Looking down from the Hollywood Hills to the east and southeast, one could see the highly modern city of Los Angeles—hazy blue in the distance. In 1924, people in Hollywood kept "their own places beautiful and [were] concerned with the beauty of the street." They were "lovers of flowers and birds"; they "surpassed the world in the splendor of their public schools."[1]

With somewhat less enthusiasm, but the conviction that all would yet be well, Borg and his wife settled into their new community. Madeline had been born in Los Angeles, and so, in a sense, had Borg. He had first been recognized as a serious artist there; he had been called "Los Angeles' own." Many of his old friends were still there, Antony Anderson, Everett C. Maxwell, and Alma May Cook, the critics, and Idah Strobridge, Charles Lummis, and Mary Gibson, his spirited Garvanza friends.

Lummis wrote in May 1925 that he was glad that Borg had "fixed up the new home and studio," and that he was "impressed very much" by his pictures:

> Not an unsound one nor a weak one, nor a foolish one among them. And while some of my friends are following after False Gods, in their anxiety to be called "Strong" and "Original," and are only making fools of themselves, I am glad to know that you keep to the old sanities and still acknowledge the attraction of Gravitation. There is nothing new in *ART* and there isn't going to be anything new in Art, anymore than in literature; and the poor simpletons who do Futuristic stuff, or write Free Verse, are not doing something new—for there have been fools ever since the world began. In letters or painting, all that is new is the personal creative interpretation of the same old mountains, and the same old sea. We cannot create any of them new, nor change their color, nor their composition, nor their place. You paint finely, because you see sincerely.

Borg's old painting companion, William Wendt, was no longer in Los An-

Borg in his studio, 1926, North Hobart Boulevard, Hollywood, California.

geles; he and Julia had moved to Laguna. But a large artists' colony thrived in the city, including, among other painters: Christian Von Schneidau (with whom Borg founded the American Scandinavian Art Society of the West), Jean Mannheim, Hanson Puthuff, Elmer and Marian Kavanaugh Wachtel, John Frost, Edgar Payne, and Paul Lauritz. Paul Lauritz, a Norwegian who had come down from Oregon, became a close friend. Dawson's Book Shop, always a shelter, was in Los Angeles, as were the two major galleries which showed Borg's pictures, the Stendhal (later the Ilsley) Gallery in the Ambassador, and the Biltmore Gallery in the Biltmore Hotel. Borg felt at home in the familiar environment.

Life, however, soon took an unexpected turn. Although Borg was a skilled photographer and as a young man had both designed sets and been ''one of the first, if not the first to advertise'' the new movie industry, he had not anticipated becoming involved with movies. But Jannis Anderson, his friend and his student—Borg gave art lessons in Hollywood as he had in Santa Barbara—worked for United Artists and knew that Douglas Fairbanks was looking for an art director for *The Black Pirate*. He proposed the movie assignment to Borg who at first refused to consider it. Always ready to talk with interesting people, however, Borg agreed to meet with Fairbanks whom he had met before when Fairbanks consulted him about Indian costume and custom during the production of *The Man from Painted Post* and *Arizona*.

Borg considered Fairbanks a genius and an artist to his fingertips. They were men of a kind, both "dynamos," students of art and history.[2]

In his popular book, *Making Life Worthwhile,* Fairbanks prescribed "a well-trained mind, a body to match and a love of achievement," declaring that "feeding the intellect [was] naturally the most fascinating pursuit in this life," and that a man "could be and needed to be in tune with the infinite."[3] Borg subscribed to the same beliefs. He felt a clear and instant rapport with the ebullient, friendly, popular hero. He believed in the man, and by the time the enthusiastic Fairbanks finished describing the pirate romance with its "storybook quality," he believed in the project too. It called for artistic talent, imagination, and intelligence. As Fairbanks's art director, Borg would be free to create what his own historical research dictated. Seeing promise in the endeavor, Borg took it, pleased to be associated with Fairbanks and convinced that the movie would be a work of art.

Although insiders were aware of a less idealistic side to the developing industry—bitter struggles to monopolize production and distribution—many Americans were enthusiastic about the potential of film when the industry was new, hoping that the Californian and his photoplay might even "find their immortality together as New England found its soul in the essays of Emerson."[4] By 1924, the industry had reached a "new cathedral era"; then it was "the artist's paint brush" that was thought to "catch every dream of the heart's desire . . . [and] liberate us from the sordidness of material existence."[5] Borg's quest had always been "to make golden cities of the daily drab." He was true to his character when, at the age of forty-six, like some blessed and foolish knight in a tale, he charged, brush in hand, into the new territory.

He painted hundreds of sketches of sets and characters; he became a spokesman for the artist in the film and wrote poems that revealed his absorption in and fascination with the romance of the pirate past.

> Romance—thy road leads backwards,
> And thy tales are voices of the past.
> Thy ships are wrecked
> And the sea is singing . . .
> Memory waits the rebirth
> From out of legends dust—
> Those ships of other days—
> The commanders and the captains of Romance.

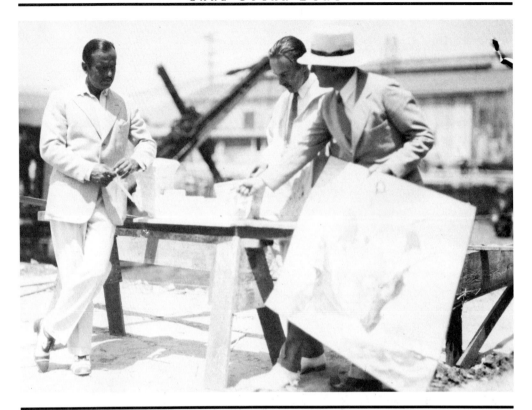

**Douglas Fairbanks, Carl Oscar Borg, and director Albert Parker
during filming of *The Black Pirate*, 1925.**

When *The Black Pirate* was completed, the "renowned Carl Oscar Borg" was credited in an article that appeared in *California Sports Magazine*, with "the biggest movie discovery since D. W. Griffith invented the close-up"— "the scenario writer of the future will be an artist instead of a mere author." Ideas had to be blocked out in pictures, because the "written word is incapable of expressing screen meaning." Borg was on another frontier. He saw films as presenting "immense opportunity" for the "dramatic painter who comes to Hollywood today and draws the movies." The reporter had seen Borg's paintings "stacked in great heaps in the barn-like studio on Fairbanks' lot." The "brilliant painter" had created "an entire historical romance on canvas before a camera crank turned."

Canvases were propped up all over the dingy studio. For hours the staff poured over the paintings. They studied composition, detail, action, costumes, everything. Then bit by bit they pieced together every

Borg with his technical staff on location during filming of *The Black Pirate*, 1925. Borg seated far right.

sequence of the film. . . . The results are evident. *The Black Pirate* will probably make a sensation. Certainly in technique and complete and magnificent balance it is a record maker.[6]

Borg helped make film history. *The Black Pirate* was America's first full-length film in color and it did "make a sensation." It was extensively and favorably reviewed in newspapers across America from February through April, 1926. A reviewer in *The Christian Science Monitor* called it "easily the finest film yet made in this difficult and almost untried medium." A reviewer in *The Liberty* wrote that "the whole picture is done in colored photography and done so beautifully that one feels colored photography is now something to be reckoned with seriously. *The New York Times* reviewer remarked that the "beauty of the different episodes [was] remindful of the old masters, which [was] not so astonishing when one considers that Mr. Fairbanks had on his staff, Carl Oscar Borg, the Swedish artist."[7] The critic for the *Evening Telegram* went into more de-

tail. Filming on location on Catalina Island had proved impossible because the color was "all wrong"; consequently,

> All the sets of Borg . . . had to be duplicated in the studio. Borg painted what he would. . . . Not only the setting had to be studio-made, but also the pirate ships . . . copied also from the canvases of Borg. They were placed in the enormous tank that usurped most of the studio space. From the sides airplane propellors blew up waves three feet high, ruffling the waters to a gently swaying motion. . . . This indoor filmed picture of outdoor life . . . made cinema history. In London as well as in New York, *The Black Pirate* has been hailed as a master movie . . . with a radiance all its own, which makes nature seem grander than ever.

Literally, not one frame in the film escapes Borg's influence. The details of the pirate ships, the intricate wood carving, the positioning of rope, webbing, net and sail, the ornate sun dial, the Egyptian ring with its ankh symbol that the Black Pirate uses to reveal his true identity, the desert scenes, the placement of palms and water pools, the solitary adobe, the western corral, the single white stallion, the mystic rock that looms up on the screen as it does in so many of Borg's paintings—every episode reveals the artist's vision and style.

With the extraordinary success of his first movie, Borg was absorbed into the cinematic world of magic. His talents in demand, he worked for United Artists and Sam Goldwyn. "I got into the movies and no matter how hard I try, I cannot get out." He "almost killed" himself with work; his eyes, which always troubled him after periods of intensive work and which had been weakened by the sun and wind in the desert, were badly strained and he wore glasses, but in his early involvement with films, he not only earned a "princely" salary, he "took joy in making a movie."

In rapid succession he designed sets for *The Gaucho, The Winning of Barbara Worth, Night of Love, The Flower of Spain, The Magic Flame, The Viking,* and *The Iron Mask. The Winning of Barbara Worth* (a film featuring Ronald Coleman and Vilma Banky and directed by Henry King) did not receive the notoriety of *The Black Pirate* when it was released, but this realistic film about the reclamation of Imperial Valley, California, and the harnessing of the Colorado River into a mammoth irrigation project, is now considered a classic. It was shot largely on location in Nevada's Black Rock Desert, and, unlike most Westerns of the era, was historically accurate.

Borg's set design for *The Gaucho*.

Art Director Carl Oscar Borg drew up plans for the three towns that had to be built in the desert. . . . The documentary reconstruction of *The Winning of Barbara Worth* is of such a high standard that it places the film on a level with other Western epics *The Covered Wagon* and *The Iron Horse*. But whereas those films were set in the nineteenth century, this is an epic of twentieth century pioneering. The difficult transition between the Old West and the New is captured with fascinating fidelity.[8]

On November 12, 1927, *The Gaucho*, which "from the standpoint of art and picturesque interest, will stand comparison with any film ever produced,"[9] premiered at Grauman's Chinese Theater. It was preceded by a staged prologue whose elaborate settings were designed by Borg in collaboration with Sid Grauman.

In February 1928, Borg's watercolor sketches for *The Gaucho* were exhibited in San Francisco, and in June of the same year, "painter and art director Borg"

Frame from finished set for *The Gaucho*.

exhibited his studies for *The Black Pirate, The Magic Flame, The Night of Love, The Winning of Barbara Worth*, and *The Gaucho* at Exposition Park in Los Angeles. The studies were not "serious art," but "commercial art," still, "in these days can any definite line be drawn between commercial art and any other kind of art?"[10] queried one reviewer. "The motion pictures should partake of and be part of the great art of this century, . . . a worthy end for artists and art patrons to strive for."

On December 18, 1928, in an article by Borg published in *The Christian Science Monitor*, Borg traced a history of "the backgrounds against which the film stars shine." His interest in and pride in his work as an art director is clear.

> As a rule, more artistic than the architect he superseded, the art director composes the set with figures and furnishings. This drawing, or composition sketch, is then given to the drafting department, where it is projected back to provide a floor plan also. Then the drawings are sent to the mill, where the actual building of the set starts. The finished product

Borg's design for *The Winning of Barbara Worth*.

literally is the materialization of the artist's thought. . . . To draw or compose some of these motion picture backgrounds requires exhaustive research into the accumulated knowledge of the ages. . . . Many artists, perhaps most of them, are not fitted for art direction, for, like doctors and lawyers, many of them are specialists, and limit themselves to the painting of figures, or landscapes, or marines. Most of them too, have little or no knowledge of building trades activities which would enable them to estimate, or at least appreciate, the cost of sets.

Borg had the knowledge, talents, and skills to be an art director in the twenties. Lummis sought his help on a related project. In 1927, he sent Borg a letter and a photograph of an old Indian, Santiago Naranjo. He had waited thirty years for the photograph, Lummis said, and he wanted to use it as a cover for Indian Week at the Hollywood Bowl. Unfortunately, Santiago Naranjo was wearing an unsuitable, manufactured coat and shirt.

They should be painted out to show bear skin, or a rabbit-twist robe. The earring would be all right if given a touch so that it would look like shell instead of so plainly metal. I think the Banda would do, for its texture is not very clear; it might be one of the Aboriginal weaves. Of course the object is to get the First American, and cutting out everything that indicates our modern sophistication. I also want to show the Real

105

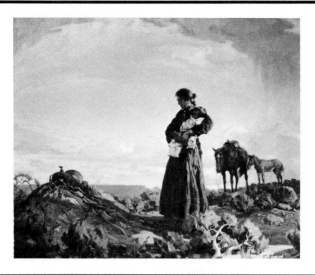

Navajo Grave, 1929, oil, 108 x 132.5 cm. Collection The Amerind Foundation, Dragoon, Arizona.

Indian—instead of the war-bonneted cigar store tomahawking type that is worked to death in the movies and literature and everywhere else. Here is a face as fine as your old Su-pe-la and with more vigor in it.

I don't know of anyone else who can bring old Santiago back to the primitive as you can, and shall be greatly indebted if you will do this for me.[11]

Gallery owners solicited Borg's work too. They were aware that he was "hard hit for exhibition material," and willing to wait, ready to exhibit when he was. His work was, as Erwin Zimmer, director of the Biltmore Galleries indicated, "of extreme importance to any gallery of Western painting."

Although Borg held few one-man exhibitions of his serious art when he worked for the movies, he continued to exhibit in group exhibitions. He continued to go into the desert in the spring to live among the Indians, to sketch, to paint an occasional oil or gouache or watercolor, to etch a few plates, to find solace and his deepest companionship alone in the silent spaces of his meditations. Repeatedly Borg pulled out of the frenzied pace of movie demands into the deep core of himself where he found his meaning and his art.

In 1925, when the Los Angeles museum celebrated the opening of new galleries, museum director Dr. William Alanson Bryan, was photographed for the *Times* standing beside Carl Oscar Borg's oil painting, *Festival in Hopi Land*[12] considered by "some critics to be one of the finest Indian paintings in America."

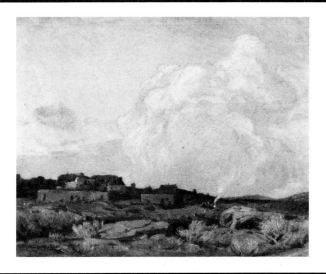

Oraibi, 1929, oil, 40.8 x 50.1 cm. Collection The Amerind Foundation, Dragoon, Arizona.

Borg's painting, *The Bad Lands, Arizona*, won the Painters of the West silver medal in that year. In 1926, the Pasadena Art Institute exhibited a collection of Borg's opaque water colors. They were "indicative of an art of singularly distinctive quality." *The Hopi Shrine* was one of the "masterpieces . . . deeply suggestive of religion, human sympathy and sentiment." In 1927, Borg was one of ten painters, including Charles Russell, Frank Tenney Johnson, and Ed Borein, to appear in Charles O. Middleton's portfolio edition of Western painters and etchers. Borg's *Land of Mystic Shadows* was reproduced. An etching, *Land of the Navajos*, was included in the American Collection shown in Florence. In 1928, the year that Borg became a citizen, he took two medals: a gold in the Painters of the West exhibition for an oil, *Santa Barbara Hills*; and a silver for a watercolor at the California Art Club exhibition. In the same year, he exhibited an etching, "a striking head of a Navajo Indian" in the Ninth International Print Makers Exhibition. In 1930, at the Ebell Salon's First Annual Exhibition of Southern California Oil Paintings, Borg took the Fischer prize for the best painting. *Oraibi* was "one of the most impressive pictures of the show . . . many figures and horses moving in a pueblo under a superb sky of clouds."

Borg's reputation was secure in art circles in California and throughout the nation. Photographs of his paintings, *California Summer* and *The Loom of the Desert*, were published in the *Christian Science Monitor* on July 9, 1926, and March 6, 1928, respectively. In March 1927, *The American Magazine of Art* celebrated "The Art of Carl Oscar Borg" with a four-page biography and pho-

California Summer, 1925, oil, 76.2 x 101.6 cm. Collection Mr. and Mrs. Jules Delwiche.

tographs of five of his Western pictures: *A Knight of the West, The Fallen Monarch-Grand Canyon, The Gamblers, Hopi Village,* and *Monument Valley, Arizona.* Jessie Selkinghaus, who wrote the biography, noted that the

> artist, whose work has taken such an important place in the art of western America has chosen as his most satisfactory medium the opaque water color as best expressing the peculiar quality of topography and atmosphere [in the Hopi and Navajo Lands]. Oil seems to him too heavy for the vibrating transparency of the great distances and transparent color too fragile and delicate for the majesty of it all.

Fate continued to be kind. Borg was famous, earning a good deal of money; he knew how to deal in the "markets and marts" of Hollywood and how to retreat to see the "real" wealth in nature; he believed in the worthiness of films and his own art. As the decade ended, however, it became clear that an epoch in the West was ending as well.

In 1930, Borg worked with Fairbanks as one of the art directors for *The Iron Mask.* The picture marked Fairbanks's farewell to films and Borg's as well. Prophetically, it was the only film to end with the death of the hero. "It was Fairbanks's way of saying farewell as well as an expression of his religious philosophy . . . 'there's a greater adventure beyond.' "[13] The era of silent film ended. Technological changes revolutionized the industry and the country. "The work in the movies is pretty well shot to pieces," Borg wrote Hugh Gibson. "The talkies have changed the whole industry."

As a thirty-two-year-old artist living in Paris, Borg covered the notebook in which he traced his life with clippings mocking Cubist art. As a fifty-year old artist in Hollywood, he covered another notebook with clippings mocking the "art" of the movies. They are humorous, but the implications were serious:

THE SPOKEN MOVIE IS HERE!!!
Get in now!! Make Big Money!!
Actors That Can't SPEAK in the Future
Will be Opening Oysters.
We teach—English, diction, transition
of speech, detonation, elocution, shouting,
whistling, spelling, yodeling. How to laugh
and how to scream in a raid. Nursing, engineering
palmistry, gargling, coal mining, bottle opening,
tire repairing, dancing and anything pertaining
to the legitimate Stage. Complete courses the year round
by mail. YOU TAKE NO CHANCE!!
 WE GUARANTEE SUCCESS!!
 DON'T DELAY!!

Reginald W. Valvestem of Hokuspokus, Wis.,
writes: After your third lesson, I sold the farm
for $40 and got a part with Betty Compson at $7.50
per day.

BACKWARD PUPILS BROUGHT FORWARD
Enroll NOW! Diplomas printed on premises.
Students joining now will receive ABSOLUTELY FREE
a brand new nickleplated jews harp.
SPECIAL RATES TO MIDGETS!
The Squeekie School of Execution

Borg did not foresee the enormous changes that would sweep the industry making his gifts and standards obsolete any more than he had foreseen the vastly new times that "madcap" modern art in Paris prophesied. Borg left the movies for some of the same reasons he eventually left California and America. Not only had technological improvements in photographic equipment radically altered the role of the art director, rendering the "motion painter" obsolete, the more sophisticated cameras and soundproof studios required "masses of capital." Along with the capital came a new breed of men, strangers to the Western dream and spirit, outsiders whose aim for the "new art of this century" was no longer primarily artistic but financial. The world of crass materialism became not a fear for man, but a dominant reality.

CHANGING TIMES

For twenty-five years Carl Oscar Borg had been at home in America's Magic Region, his life in the West marked by an extraordinary number of triumphs. He felt a kinship with the land and the individuals who introduced him to it; his rich gifts of intelligence and talent had unfolded; his will and his efforts had been celebrated. He was "Carl Oscar Borg of California" in the first decades of the century because his serious quest to forge through his art the links between man and man, man and spirit, past, present, and future represented the serious ideals of a community.

For twenty years Borg had made his way as an artist in the West through the generous support and encouragement of individuals. But as the West began to resemble the rest of America and its heroic age—the age of the individual—moved into history, industry—the railroad, the movie, and the automobile—supported the artist.

In the twenties, the Santa Fe railroad hung Southwestern paintings by Carl Oscar Borg, Theodore Van Soelen, Hansen Puthuff, Gerald Cassidy, E. Irving Couse, Ernest Blumenshein, Victor Higgens and other prominent artists in their offices on South Hill Street. Photographs of the Santa Fe collection, including Borg's *Niman Kachinas,* which had been commissioned by the railroad in 1920, were used to attract the interest and attention of tourists who were encouraged to take Pullmans and Harveycar Motor Cruises into the "Great Southwest." The Eastern artist, John Sloan, found subject for satire in the Santa Fe's promotion of the Southwest.[1] Western artists did not. Incapable of satirizing an authentic experience, they welcomed the commissions of the railroad; they were well paid and free to paint as they wished.

In 1927, fifteen million model Ts rolled off the assembly line to sell for as little as $290; mass automobility had become a reality. Publicists in Los Angeles used the work of well-known Southwestern artists to educate the public and to induce families to take to their automobiles to see the region's wonders for themselves.

In May 1926, five block prints by Carl Oscar Borg, all Indian portraits, under the title *Lo, the Poor Indian* appeared in the Automobile Club's publication, *Touring Topics.* In October 1928, Borg's painting *Grand Canyon* appeared on the cover of *Touring Topics.* It was the first of "twelve of the outstanding scenic attractions of the Golden State and its environs," which the club had commissioned "twelve of the foremost landscape painters of California" to paint. Carl Oscar Borg, William Wendt, and Maynard Dixon headed the list. In November 1929, *The Province of Tusayan*, a portfolio of drawings by Carl Oscar Borg with a foreword by the artist appeared in *Touring Topics.* Thirteen of Borg's

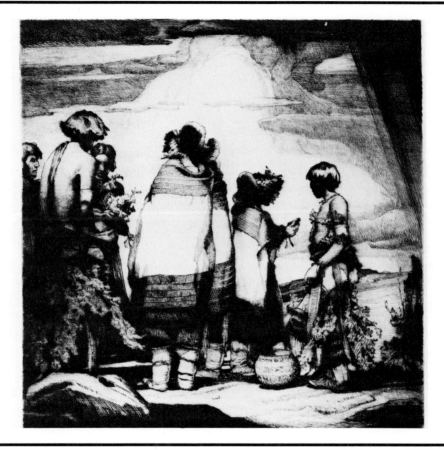

The Niman Kachinas, 1920, drypoint etching, 25.4 x 25.4 cm.

drawings from Arizona and New Mexico were reproduced in the seven pages of the issue devoted to the Indians and their country. Borg did not initially perceive the irony in his putting himself and the Indians in the service of the automobile, a machine he never learned to use and which became a chief agent in the breakdown of the old order he valued.

Borg ended his involvement with the film industry in 1930, but it was not until May 1931, when he finished a series of frankly commercial paintings celebrating the major epochs of Southwestern history, that the artist finally severed his connection with American business. Published in book form by the Automobile Club in 1936 under the title *Cross, Sword, and Gold Pan,* they were originally used as separate covers for monthly issues of *Touring Topics* in 1931. Borg had needed the commission. He wrote Hugh Gibson, January 25, 1931, that he would have been in "hard luck" without it, but, in his diary he recorded

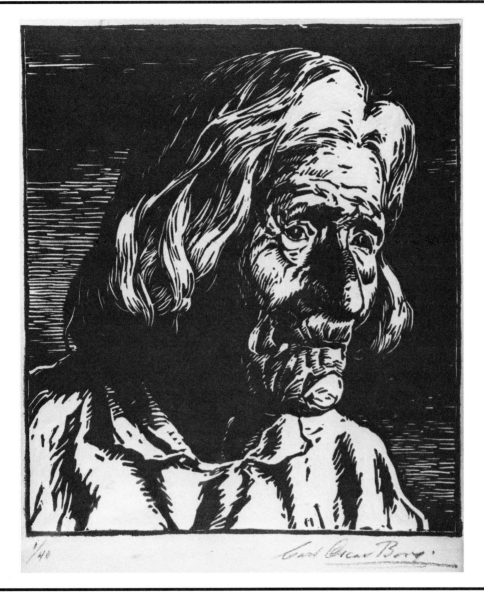

Hopi Patriarch (Su-pe-la), 1923, woodblock, 22.2 x 25.4 cm.

its completion with relief. "Thank goodness it is over with. It has been a tedious and thankless job and I am free once more."

Borg "went back to his Indians." Among them, he still felt at home, but in the common, new world which had evolved, where money mattered more than man, Borg felt more a stranger than he ever had in his wanderings in for-

113

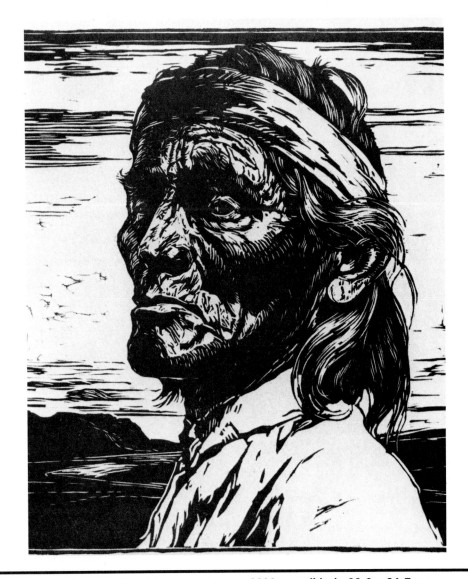

Hopi Medicine Man, Horace Se-is-se-ta, **1923, woodblock, 22.9 x 26.7 cm.**

eign lands. Many of his first friends in California, the pioneers who had welcomed him, Lummis, Strobridge, Gibson, Anderson, Hearst, were dead. "One by one the old friends pass away, and I suppose some of them willingly. This is not the world that they knew, an entirely new era."

For a few more years, in articles and books, rare survivors, Everett C. Maxwell, Alma May Cook, Leila Mechlin, individuals associated with and suppor-

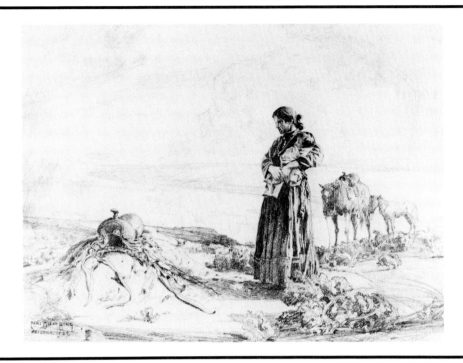

Navajo Grave, 1929, pencil drawing. Collection Katherine Haley.

tive of Borg from the time of his first appearance in Los Angeles, attempted to remind an increasingly apathetic public of the achievements of their representational artist.

Supportive words and a few new honors could not, however, dike the swell of change. Shifting populations moved over the depression-ridden land in the thirties, thousands into the Southland. Men and machines to both create and fill their needs followed, bringing an unsettling of vision, a displacement or disruption of standard.

Borg antagonistically greeted the advent of modern art in Paris in 1912. His own art did not seem threatened then, but in the thirties, it clearly was. When he looked "at some of the so-called modern work from every standpoint," he was "absolutely overwhelmed by the bad taste that prevails."

Borg saw in the growing popularity of "modern" art a conspiracy. The same greedy merchant group that had moved into films had moved into art; the old standards were falling under the manipulative hands of art merchants "in league with critics, dealers, and producers of the new art. Everything is handled differently now," Borg told his friend, Magda Måneskjöld, a reporter for *SVEA*. "Everything is mass production." Art had been cheapened; it had become respon-

sive to "whims of fashion"; like all whims, it would not endure; "this cheapened art like most radical ideas built on loose ground one day will fall and disappear by itself," he prophesized.

It was, however, representational art which almost disappeared.

Others criticized the modern sweep. Walter Clark, engineer and businessman, turned his attention from machines and mass production in the early twenties and devoted himself to the "real thing—drawing and painting."[2] Crusading as hard for art as he had for business, believing that there were hundreds of thousands of people in the United States who would enjoy owning pictures, he enlisted the support of wealthy friends in forming the Grand Central Galleries in New York. One hundred American artists, including John Singer Sargent and Carl Oscar Borg, were asked to be members and contribute paintings to that "important institution." The drawing and painting that Clark believed in, for which the Galleries were created, had nothing to do with modern art. Clark was as much its enemy as Borg was. When he came to see Borg in 1932, Clark said there was

> nothing doing in New York. I asked him how long the "modern art craze" was going to last. He said, not long. But anyway, he had only one thought in mind in wanting to live to be a hundred years old, and that was to see the whole movement dead and buried.

On October 21, 1933, Raymond Henry summarized the not uncommonly held view in the *Hollywood Citizen News*.

> Shell shocked art through sales propaganda still is being dangled before the eyes of the esthetic moron with the bulging moneybags who unsuspectingly buys the dregs of the distorted mind. Through the influence brought to bear by salesmen's propaganda and the lack of appreciation or standards of art of a personal nature, some of the influential and otherwise sound minded members of society are inveigled not merely into acquiescing, but actually into forcing this morbid art upon the general public. Bankers fall prey to the financial mountebank of art; university presidents force it into the craniums of the student body and confer the honorary degree of doctor on art shysters, while museum highbrows place this art (?) in publicly owned museums. A dark, gloomy, demoralizing cloud, rumbling with destruction and devastation, hangs menacing above the present day art, like an ogre threatening every honest effort with annihilation.

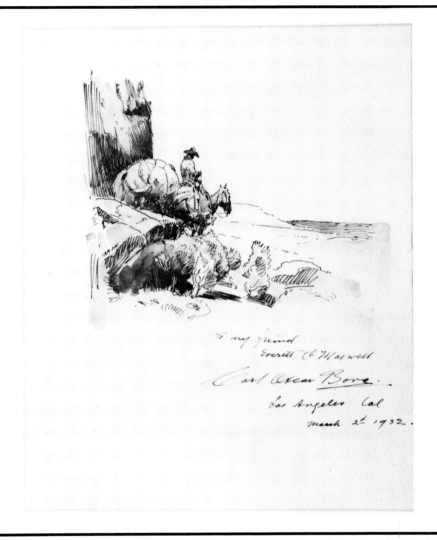

"To my friend Everett C. Maxwell," March 2, 1932, watercolor, 20.4 x 25.4 cm. Collection Mr. and Mrs. Barney Goldberg.

Trying to drum up business for the "demoralized" Western artists, Leila Mechlin arranged a travelling exhibition of Los Angeles painters. Sponsored by the American Federation of Arts, it travelled to the major museums in the country. An Eastern collector, Harry C. Bentley, sent his personal collection of thirty-four paintings by sixteen Western artists, including Borg, on a tour of public galleries throughout the United States. He hoped to encourage Americans to buy the pictures of living artists, originals not reproductions, "diamonds not paste." They could be had at "very modest prices." Not to "patronize our own

living artists . . . would constitute a sad commentary on our democratic and progressive idealism."[3]

Sympathetic collectors, dealers, and critics made efforts to keep the once-proud and secure American Western artists from going under, and the artists themselves banded together for support. In 1932, Borg joined Gerald Cassidy, Irving Couse, and other middle-aged and elderly Western artists[4] at a meeting in Pasadena to set up the tentative beginnings of a Foundation of Western Art. Borg was skeptical; he considered "the whole thing . . . problematical," but he recognized the "need for an organization of this kind to give Western artists somewhat of a shoe." Borg's friend, Everett C. Maxwell, was chosen director. In April 1933, temporary galleries were opened on South Carondolet Street in Los Angeles.

In 1934, Borg and a nucleus of thirteen other Los Angeles artists formed a second and more ambitious organization to stem the tide of modernism. With Borg's good friend Paul Lauritz as chairman, they organized not simply "another painters' club," but the Academy of Western Art. The Academy would exhibit and honor "traditional pictures of a kind people can understand."[5] The Academy would do for Western artists what the National Academy did for Eastern artists. They would "not toy with radical work," but attempt to "uphold the standards for Western paintings." America's foremost Western artists, including Ed Borein, Maynard Dixon, Armin Hansen, and Edgar Payne, Oscar Berninghaus, Irving Couse, Nicolai Fechin, and E. Martin Hennings were exhibiting members.

But it was clear that the "old masters" were fighting a losing battle. Even the term "old master" shifted in connotation. Used as praise by older generations, it had become a pejorative label to the younger. With pride and bitterness Borg reported a visit by Tom Warner to his studio on July 16, 1932.

> I asked him about his brother's son who had been in art school for the last year, and who had come to see me some time ago. Warner said he had seen the boy and asked him what I had said about his work. "Oh," he said, "he gave me some advice, but as you know, he is an 'Old Master' and people don't paint that way any more." Hurrah for me, I am an "Old Master." That is good enough for me.

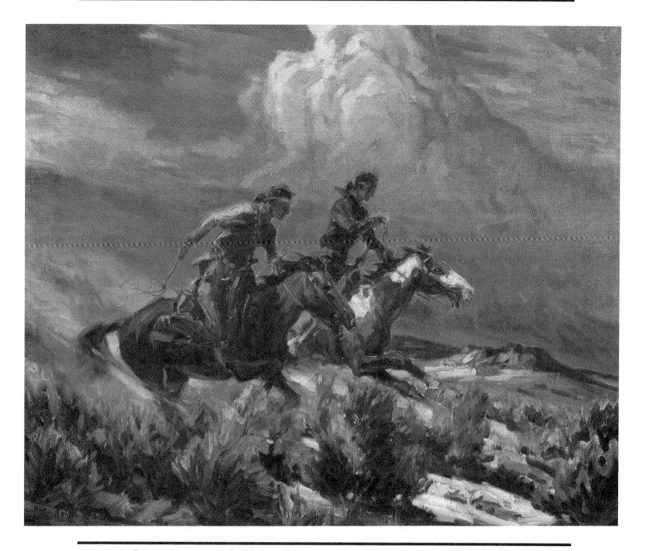

Racing Navajos, oil, 53.3 x 60.0 cm. Collection Howard Woodruff family.

THE DARK YEARS

1930-1934

If Borg's personal life had given him satisfaction, he might have weathered his disillusionment with the times and the altered West. His marriage had not been happy for some years, and his work for the movies, involving long absences on location and long hours in the studio, had not lessened tensions or brought him closer to his wife. But Borg did not regard happiness as man's normal condition. He accepted pain as well as joy and was willing to be bound to someone who evidently gave him both. In a poem written in 1928, Borg reflected on his relationship with his wife; clearly, he thought it would hold.

> Fate or caprice, has led our feet
> Unto this road of ours;
> Therefore let us walk together
> Unafraid of days to come.
> Let us brave the trail
> And bide our time and day.
> Let love and courage grow
> For every step we take.
> Let's live and taste of
> Triumph and maybe despair,
> For often love and sorrow
> Walk hand in hand as we.
> So let us fight and love! and laugh!
> Until the last sun has set.
> And then walk in the shadows
> Serene, erect, and unafraid.

In the winter of 1929, however, as the decade that had begun in Santa Barbara with such high hopes ended, Borg wrote again:

> Last night I saw through a magic glass
> The rings of mighty Saturn glow,
> And all the distant worlds
> In their reeling dance
> I heard the beat of my lonely heart.
> Bending my head in my hands,
> I heard the people laugh.
> And I saw the lonely road
> That lies before me.

Physically and emotionally exhausted, drinking heavily—according to W. Edwin Gledhill—under the stress of an increasingly discordant domestic situation and too ambitious a work load, Borg finally unleashed his frustration in a bitter quarrel with Madeline. The quarrel, which sundered their relationship, was provoked by the collapse of the Hollywood Guarantee Building and Loan Association in which Madeline had advised him to invest his savings.

Madeline did not wish to walk hand in hand with her husband anymore. She had fallen in love with a younger man, a good friend of Borg's who had accompanied him to the Indian reservations in June 1926. He too was an art director for the movies; his name, appropriately, was Paul Youngblood. Borg had first met him along the gringo trail in Honduras in 1909.

From 1930 until 1934, Borg lingered in California, estranged from his wife and the times. His wife and Youngblood lived in the bungalow. When he was in Los Angeles, Borg both lived and worked in his studio. He was as free in the thirties as he had been during his first years in Los Angeles, but now freedom held no promise. He disappeared for months at a time on painting trips to Arizona, New Mexico, Mexico, Palm Springs, and to Santa Barbara where he visited old friends Falvy, Koehler, Otte, the Boreins, the Gledhills, the Connaughtons, the Vaughans, and the Burke sisters.

Margaret and Kitty Burke had become very successful and very elegant although "the one was as fat as the other was thin." Borg was a frequent visitor in their beautiful Spanish home with its open fireplace, and in their antique shop in the old de la Guerra complex (now called El Paseo). Decorously dressed and wearing little hats, they served high tea every afternoon.

Ingeborg Landen, a newcomer to Santa Barbara, an attractive, young Swede who had wandered about the world a good deal herself and lived in both Rome and Paris, often joined Borg at tea with the Burkes or dinner with the Boreins where Borg regularly took a turn cooking Swedish meals. She owned a little import shop in El Paseo, and Borg gave her pieces of exotic fabrics from his extensive collections to make into purses to sell to tourists. Some thought that she and Carl might marry. Borg was grateful for her easy comradery, but disapproved of the careless way she let the money he lent her "slip through her fingers like butter."

In Los Angeles, Borg had a new circle of friends. Lummis had died in 1928, and there were no gatherings at El Alisal after that. The cultural center of the city had shifted, widened, fragmented into many groups where formerly there had been one. Borg associated with a small Bohemian group of well-travelled, talented people, many of them Swedes: actors, writers, weavers, painters, who

had wandered into the city in the twenties lured largely by the film industry. They came together at the Sunset Boulevard home of Paul and Lili Engdahl.

Paul Engdahl was an independently wealthy Swede. An artist inspired by Gauguin, he had lived in Tahiti before coming to Los Angeles with Lili, a Romanian weaver who wore flowers behind her ears and between her toes. "Tante" Dahlin, a seventy-year-old Swedish weaver who lived with them—"actually anyone could live with the Engdahls"—kept the coffee pot on and a well-stocked supply of "lovely Swedish baked goods." It was to the Engdahls, where life was casual and everyone sat on the floor or on orange crates, that Borg went when he needed society in Los Angeles.

He met a group of regulars there including Zane Grey, the popular author of Western romances; Jannis Bud Anderson, once the Czar's masseur, and a world champion skier and expert swordsman who coached Fairbanks and other stars in jumping and dueling techniques; John Bovington, a ballet dancer with strong political convictions; Eva Gabor and her husband at the time, a very handsome Swedish chiropractor; Paul Koerner of Universal Studios; Ray Rosen; and Saimi and Harry Lorenzen.

The Lorenzens, although very much younger than Borg and slightly in awe of him, became his closest friends in the group. They organized the first corps of foreign correspondents in the city and edited and published *The Pacific Coast Viking* (Borg designed the heading for the weekly newspaper) from 1936 until 1966. In their long and close association, they never saw Borg take a drink.

Borg was remembered as being "correct in everything he did; he was not pompous, but a little bit dignified; he gave it to other people." They knew he was a famous artist; they respected his "deep love of nature and wonderful fey-like poetic nature." As a young man Borg was noted for being the life of every party. At the Engdahls he sat in the corner and didn't "enter too much into the conversation."

He was drawn to "Tante" Dahlin whom he "just adored, as a son his mother." She was a simple, unpretentious woman, a gifted weaver who had been a maid in her native Sweden. Borg trusted her with the extent of his despair. Otherwise, his formality and dignity provided a shield and only his diary heard his lament in the dark age of his life.

His spirit was almost broken then, but his gift and his pride enabled him to etch some of his finest plates, execute colored monotypes that finally satisfied him, and paint some of his finest canvases. An oil painted in this period, called *Summer Storm* or *Summer, Arizona*, won Borg admission to the American National Academy. The painting is lyrical, a fluid, subtle study where no

hint of pain troubles the celebration of what the Indians call "Heart of the Sky, the Greater God."

In the first month of the new decade, Borg's father chose the rather peculiar vehicle of a personal letter in a public forum to reach out to his son. The letter appeared on February 6 in *SVEA*, the Swedish-American newspaper published in Worcester, Massachusetts.

<div style="text-align: right;">January 3, 1930</div>

To the artist Carl Oscar Borg, Hollywood, California

The bond between parents and children, between Sweden and Swedish Americans can never be too strong. There is a deep truth in the saying, blood is thicker than water. Carl Oscar Borg! There is more than one back home here in Dal who rejoices that you have been fortunate enough to make it as an artist. Each life's journey has its tears, and yours has certainly not been the easiest. When you wandered forth some thirty years ago, it was clearly an unfavorable economic time for Dal. . . . The years in the meantime have brought prosperity and with it great changes in everything. . . . I thank you for your friendship some time ago in sending me this newspaper. It shows that you haven't forgotten your roots. One might think that I should have thanked you in a private letter, but it pleases me, so to say,to openly say it. If these words should serve to strengthen . . . the loving bond between the many home in Sweden and the children, it is not written in vain. Dals-Grinstad. Your old father Gustaf Borg.

In the fragment of autobiography Carl Oscar Borg left, Gustaf Borg is remembered as an often absent, sometimes drunk, rather gruff, insensitive man who inspired a child's fear rather than love, a father almost spitefully antagonistic to his son's desire to paint. Now almost eighty, Gustaf Borg indirectly apologized and called upon his son for recognition and understanding. When the letter was published, Borg had no immediate plans to return to Sweden; within eighteen months to return became his most urgent need.

<div style="text-align: center;">

Always longing for the shores

That I trod as a child

Dreaming about the sun

Of those far-off days.

</div>

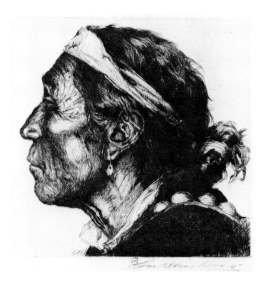

Navajo, 1928, drypoint etching, 15.2 x 15.2 cm. Photograph courtesy of the Bibliotheque Nationale, Paris, France. Gift of the American Foundation of Arts, 1928.

And now, O! God . . .
Let me see once more
The steel blue mountains
That reach the sky.

And hear the waters rush
Against the rocky shore
Where the graves of my
Long dead people are.

Borg did not return to Sweden until the spring of 1934, but he began preparing for his eventual departure in 1931, framing canvases, matting old prints, sifting through collections accumulated over almost thirty years. He cataloged his six-hundred-volume collection of Americana and sold many of his other rare books. He built bonfires in his back yard. "Old canvases and junk that would take years to describe went into the flames." He destroyed "old drawings and pictures. Burned sixty watercolors today and about one hundred drawings." He got rid of "so many useless things."

He was deeply depressed and repeatedly wrote of his sense of fatigue and futility:

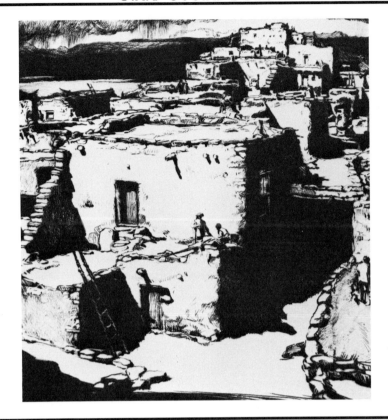

Hopi Village, Walpi, 1932, drypoint etching, 19.1 x 19.1 cm.

I feel so tired and work doesn't give me the same "kick" it used to. . . . Did not sleep well. Something oppressing was over me, I don't know what. Sort of feeling of the futility of everything. . . . am so nervous my hand shakes when I'm working. I am getting so I depend on medicine for my nerves all the time. . . . Have not felt well. . . . something the matter. . . . felt dizzy and weak. . . . I am losing weight all the time. Have no appetite and still it is not my body that is the sickest, it is my soul or my mind. I am not at ease anywhere and must repress myself in all ways.

His attempts at repression were not always successful. When his friends the Lorenzens announced that they were expecting a child, he snapped, "Why would anyone want to do a stupid thing like that!" He had to "keep working not to lose [his] mind," but completed only three etchings, *Old Oraibi*, *Navajo Camp*, and *Desert Shadows*. He struggled to move forward: "I shall be really glad when

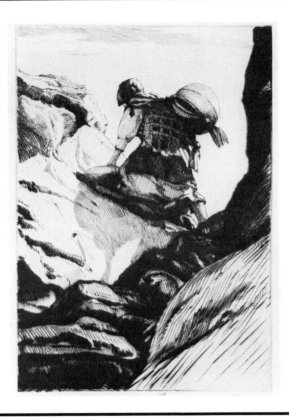

On the Walpi Trail, drypoint etching, 14.1 x 10.2 cm. Collection Santa Barbara Museum of Art, California.

I have sold all the things, books and all. It is a snare and a delusion and only bothers me now."

In 1932, he still suffered the burden of a chaotic ego: "Within this house of flesh I walk and walk./The 'I' has no rest./My eyes are burning hot from looking past these walls that hem me in." But he was able to paint again. He completed a new "Grand Canyon picture from one of [his] gouache sketches"; he sent two canvases to the National Academy exhibition; he painted *The Navajo Trading Post*, an oil exhibited and sold at the Laguna Beach Art Gallery in the spring; he contributed a painting, woodblocks, and etchings to the opening exhibition of Western artists at the Ilsley Gallery in Los Angeles. He was one of the three California painters—Armin Hansen and Mountford were the others—to exhibit in the Ilsley Gallery in the summer of that year. In the fall, Borg had the distinction of having his etching *Navajo* (one of a set selling for $2,000) stolen from the gallery.

He began, after reading an article on the monotypes of Castiglione, experimenting again in that medium to which he had been attracted at the beginning of his career. He found the process "very interesting"; thought it "curious to see how good they can be if they come out O.K. and how utterly bad if anything goes wrong." He wrote a brief history of the challenging medium, citing its mastery by Castiglione, Giovanni Benedetto, Blake, and Sargent, describing the process.

It consists in painting a picture with plate printer's ink on a metal plate. The plate is then put in a press, a sheet of moistened paper is laid upon it and the roller is applied. The painting is directly transferred to the paper. There are no acids, no bitings, no first, second or third states—it is an original. It is in no sense a reproductive process, and cannot be duplicated.

Borg's pictures met an enthusiastic reception in 1932; he submitted to exhibitions and his work sold. Arthur Millier (Antony Anderson's successor), an etcher himself as well as critic, praised him in the *Times*, April 28, 1932, as a "remarkable wielder of dry point, using it to etch the teeming mesa villages and dramatic forms of desert mountains with exceptional color, truth and force." One of Borg's prints, *Hopi Houses, Walpi*, was chosen to make a circuit tour of the country as part of the First International Exhibition of Etchings and Engravings.

In 1932, however, along with acceptances and honors, Borg received his first rejection notices. Prints submitted to the Fifty Prints of the Year exhibition were returned; the Chicago Art Institute rejected three watercolors. Borg took the rejections as confirmation that everything was "modernistic these days." "Hopi are not modern, but I'll be darned if I'll paint like everybody." Borg sounded like a fighter still, but he was discouraged. "The way things go I hardly know if it is any use sending pictures to exhibitions but will try."

An artist in a cartoon strip Borg pasted in his scrapbook lamented that after toiling and starving for thirty years the world turned his carefully wrought pictures down for the work of a beginner who painted with a broom and called geometry portraiture. The cartoon character threw himself over a cliff, but Borg did not give up. His ancestors "were poor, all of them, and had much to fight against, but I do not think it ever occurred to them to lose their courage. I believe that it is not always the victory that is the most important—it is how one fights." The "only real pleasure [for him was] to try and accomplish something

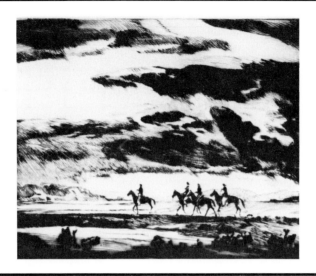

Navajo Riders, 1932, drypoint etching, 8.9 x 17.8 cm.

and he persevered, wondering even as he did "What is the use?" It had been easy to paint; now, hounded by loss and loneliness, it was difficult.

> The tears of my soul, not of my eyes
> Are falling one by one
> Like a rain that falls
> On a desert land.
> For I am a desert land,
> Barren and burnt and dry.
> The bright green of youth
> Has died away and my tears
> Are like heaven's dew when it falls
> On the hardened clay.

Although deeply discouraged and full of pain, he accomplished a good deal in 1933. He painted new canvases, gouaches, watercolors; he produced six drypoints including another *Walpi* and *Desert Horseman*; he continued to experiment with monotypes and "finally got the knack of making them in color." He exhibited "a good, spacious landscape" at the Los Angeles Museum's California Art Club exhibition. In Santa Barbara two significantly distinctive exhibitions were housed concurrently in the library. In one room were paintings by Westerners, William Ritschel, Belmore Brown, and Carl Oscar Borg. In another

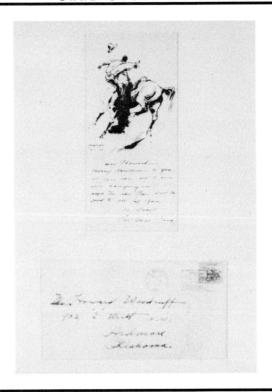

Ink drawing of Howard Woodruff Christmas card, 1933. Collection Howard Woodruff family.

room was a travelling exhibit, A Survey of Modern Painting, from the New York Museum of Modern Art.

As 1933 drew to an end, Borg faced "a very unhappy Christmas; somehow I always feel like the skeleton at every party. Everybody has somebody that really means something to him, but I am alone. Had certainly hoped to be in Sweden this Christmas." He sent a Christmas card to Howard Woodruff, whose father owned antique shops and bought Borg's pictures. "As you can see, I am still hanging on," he wrote, illustrating his point with a sketch of a cowboy barely clinging to a wildly bucking bronco.

Early in the new year he wrote Maria Nilman, "Everybody seems to feel I should go to Sweden if possible, that it would do me good," an understatement in view of the burden he carried. "Things seem very black. Not a glint of light anywhere." Because he was "tired and discouraged," Borg was, by his own standards, "not able to do much work." He executed etchings in preparation for an exhibition of drypoints later in the year at the Smithsonian Institution that rank among his finest. *Land of the Navajo, Under Western Skies,* and

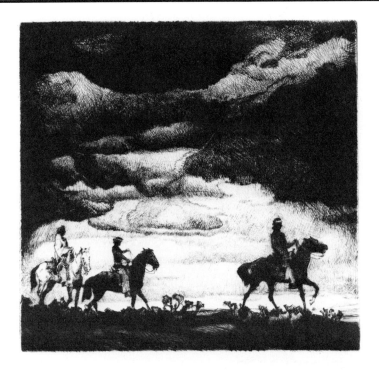

Arabs of the Painted Desert, 1934, drypoint etching, 20.3 x 21.6 cm.

Arabs of the Painted Desert came out of this dark time. The intensity of the sorrow and the nobility in the Indians he etched reflected his own experience, the strength of his own pride and will.

On March 9, 1931, while waiting his turn in a barber shop in Los Angeles, Borg spotted an article in *The Los Angeles Examiner.*

> Hopi Indians today declared that the light glowed "horizontal yellow" over the kivas or temples of the snake priests, following the death of Harry Supela, fifty-five-year-old leader of the ancient clan that enacts the treasured rain prayer of the rattlesnakes in Hopiland each fall.

Harry and his family, of all the Indian families Borg had known, were closest to him. They had initiated that "sympathetic worshipper" on whom "nature smiled in the desert as she did for the native red man" into their clan. Borg had etched their faces, caught the dignity before the dust. He wrote simply of Harry's death, but it marked another ending.

131

Harry Su-pe-la, 1923, drypoint etching, 16.5 x 14.1 cm.

My old friend Harry Su-pe-la has died. I liked him very much. He was the head of the snake clan at the first mesa and had posed for me many times. Last time I saw him in 1929 he did not look well. I was afraid of consumption as he complained about his chest. Well, good luck in the "Land of the Lost Ones." You were better than most white men I have known.

Borg also recorded change among the Navajo. He often celebrated Navajos on horseback in his pictures, and in 1925, he had celebrated them in a poem. "Under the blazing skies ride the Navajos . . . free as the eagle on high . . . they shout defiance as they ride alone." By the mid-thirties, the Native Americans were no longer alone; they had joined the American everyman in the automobile.

THE THREE CHIEFS.

Three Indian Chiefs
Sitting on a kiva roof
One is wearing a suit
Discarded by some tourist
Or "got by missionary lady."
Three chiefs under the
Leaden desert sky
Talking, talking.
"Pash lolomi"—"Ka lolomi."

The Three Chiefs, 1935, drypoint etching, 21.6 x 27.3 cm.

One had his hair cut
A la Riverside: the others
Wear their hair in the ancient tribal way,
Talking, talking,
"Pash lolomi"—"Ka lolomi."

The eagles, captive and starved,
Soon will die:
Then their feathers will be plucked
And made into a war-bonnet
To be worn by a Mexican "extra"
Playing Indian in the movies.

No more councils as of old,
No more fasting, prayers, symbols,
The twining serpents invoking
Lightning and the blessed rain.
Now is talk, talk, talk,
"Pash lolomi"—"Ka lolomi."

The price of tobacco and coffee,
And how much in pawn
At the trader's store.
Again, talk, talk, talk,
"Pash lolomi"—"Ka lolomi."
About Fords and tires
And the cost of gasoline.

THE ERA AND THE ARTIST

In 1903 when Borg arrived in the West, Charles Lummis stood beside Teddy Roosevelt at the rim of the Grand Canyon and heard him sound a warning.

Here is your country. Cherish these natural wonders, cherish the natural resources, cherish the History and Romance as a sacred heritage, for your children and your children's children. Do not let selfish men or greedy interests skin your country of its beauty, its riches or its romance.[1]

In 1923, Lummis delivered his own "sermon" to a group of Santa Barbara businessmen. He repeated Roosevelt's words and urged those who heard him to guard against the "vandal age of ignorance and carelessness and greed" that he saw spreading over the land. He addressed his sermon to "all who love Santa Barbara and for all who love the West and Beauty and History and Romance . . . for all who really have Souls. Not the gospel of Sissies and Sentimentalism but the two-fisted gospel of men who have made the world nobler by their works."

Few places, Lummis said, had "not traded away [their] birthright for a mess of Potash and Perlmutter"; he hoped those who wanted an "American flivver town, or Ford town, all interchangeable parts of ill-taste, unimaginativeness, monotony and saddening sameness" would "go and seek such towns," and leave California alone. He was "no Visionary, but a hard-headed, hard-fisted graduate of the frontier" who had "become convinced of certain infallible laws . . . the ideal lasts longer than anything . . . and Romance is the Greatest Riches of any people."

Borg shared Lummis's conviction, a belief in the ideal was embedded in the Garvanza spirit; its roots lay deeper. In 1923, westerners, in Santa Barbara at least, could still be cautioned against a too materialistic view of man; by 1934, the year Borg returned to Sweden, it was too late. By then, westerners had, as Borg's friend Everett C. Maxwell wrote,

reached a plane of the materialistic where quantity is the mark of efficiency. Mass production is the order of the day. . . . The individuality and charm that once stamped our city [Los Angeles] gives place to a standardized formula . . . not very different from any other of our modern cities.[2]

The deterioration of the look of the land, the uniformity and shoddy craftsmanship of the new buildings and the new paintings reflected lower aesthetic stan-

Desert Storm, woodblock, 24.8 x 28.6 cm. Collection
Santa Barbara Museum of Art, California.

dards and a lower evaluation of man himself. Man had been "skinned." By the
mid-thirties, California, "garden spot" of the world, could inspire no new hope
for man.

That beacon of the West, the *Out West* magazine, dedicated to the celebra-
tion of the distinctive intellectual, artistic, and social achievement of the West-
ern world, folded in 1935. No Western world existed to celebrate anymore,
no distinctive art, no distinctive spirit. "Blind realism blaspheming the dignity
of man" displaced the idealism that briefly had a hold in the land. The hoped-
for absorption of the Native American's sense of the mystic connection of man,
land, and time had not taken place. The Magic Region lost its charm; the Gar-
vanza message moved into history.

On April 3, 1934, a few days before his return to Sweden, Borg was cited

EX LIBRIS

CARL OSCAR BORG

in the *Los Angeles Times* as a "leading exponent among woodblockers," one of Southern California's four bookplate artists who were "second to none." Attention was called to his mastery of the medium, not to the philosophy he expressed through that medium. Borg's bookplates were, however, the pictorial presentations of his philosophical perceptions. The plate he designed for his own use, an Indian carving a pictograph on a stone, recalls the Kipling poem he quoted in a letter to Mrs. Hearst in 1909: "After me cometh a builder, tell him I too have known," and a couplet by Alexander Pope that Borg inserted in his notebook of poems: "Void was the chief's, the sage's pride; they had no poet and they died." Borg was by nature and art one for whom word and picture, metaphor and image were the means by which man became man; in the transmission of metaphor and image being and comprehension were linked, passed on and recognized from human to human, generation to generation. The transmission sometimes touched a spiritual core. The one who transmitted the essential human message was the poet-artist, the guardian of civilizations. Without memory of his past, a recognition of the power of the unifying ideal, man did not exist.

When Americans began destroying the word and image in the narrow quest for immediate profit, history became irrelevant, and the romantic Carl Oscar Borg turned his back on a changed America and returned home, a famous artist, and a weary, middle-aged man.

Sir Kuno, with sword and lance,
Is riding in Saga's wonderland.
There he sees beneath a pine tree's shade,
Saga's daughter coming out. . . .
She said: "Sir Knight, where leads your road?"
"I'm searching the Rose of Happiness
I'm searching day and night
I'll search to the end of life
Or else my heart can get no rest."

"A great task lies before you . . . but
I will tell you where that Rose does grow.
At the end of your road so long
It is growing near a spring.
But before you break its stem,
Drink from the water cold."

Sir Kuno found the spring,
Red in the sunlight's glow
The rose grew by its edge
He drank the water—and it was blood.
Tired from the quest, he drank and grasped
The Rose . . . then his heart broke.

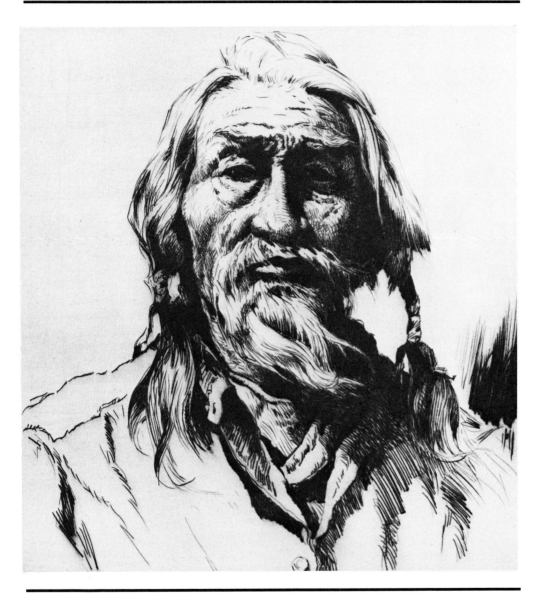

Old Piute, Mancus Jim, 1925, drypoint etching, 20.5 x 18.5 cm.

WITHOUT HOUSE OR HOME

1934-1936

To all appearances, Borg was an eminently successful man; the Swedes could not know the depth of his disillusionment or his pain. He returned like the saga-hero Frithiof, who had taken to the ocean, accomplished great deeds, and "when he gained great glory . . . hied him back again to the North."[1] He was hailed in the Swedish press as "den stora Indianmålaren" (the great Indian painter); reporters wrote that "his life reads like a story, but it is true." The returned "Dalslander, famous in the U.S.A."[2] was photographed and interviewed. "What was America like? Had Sweden changed" in the thirty years he had been away? "Yes, Sweden had changed, for the better," he told the reporter for *Ny Tid*, September 4, 1934. "Everything was beautiful, clean and proper. Prospects were good now all over Sweden for all people." In America things had changed too, but not for the better. "A new class of people has grown up. They can just buy cars and drink; before they could interest themselves in other things. They also have greater pretentions."

Borg told reporters that he "would like to paint the Laplanders. They must be a people who in many ways resemble the Indian nomads." He told them that the Navajos were not dying out, but their customs were. "My paintings have been as a document for the future"; he was interested in "allt gammalt" (everything old.)

His father had become old. The severe parent had been transformed by age to a gentle, bent, long-bearded, beneficent troll-like man who looked fondly at his famous son who sketched and photographed him again and again in that reunion summer. Gustaf Borg became, along with Lummis, Eisen, Moran, Sven Hedin, and the Indian patriarchs, one of his son's celebrated "old men." "One picture shows how papa Borg sits in front of the window and without glasses reads the *Svenska Amerikanaren* which for many years has been one of the old man's dearest pastimes."

Borg sketched his father, his home, the fields, the woods; he travelled in Norway and Sweden, visiting historical sites, sketching what he saw "as a remembrance." He returned to the museums he had visited as a youth, studied the Swedish artists, admired Carl Larsson, Albert Engström, and Anders Zorn. Borg thought Zorn's little picture of a nude, *Drömmar*, one of the most exquisite things he had ever seen. He began searching the secondhand shops for interesting old Swedish books. He was delighted to find one that he remembered watching his mother read. He stood "on the land of his childhood" and wrote a poem in Swedish.

His moods followed those of the land and the summer day. Summer and

Carl Oscar Borg, 1934, photograph by W. Edwin Gledhill.

his homeland had a calming effect; the gentle wind blowing over the yellow wheat fields, the forest's green in the distance by the blue mountain's edge, people lying on the grass talking softly were part of the day. When "the night comes, and it will come soon, the wanderer's heart becomes as dark as night, and lonely and sad," but when "the moon and the stars appear, then the suffering soul will live again in the hope and thought of the sunshine and the summercloud's dance."

Light entered the poet-painter's dark world that summer in Sweden. He gained some distance from his pain. Fatigue, frustration, and despair dropped from him like so many dead and useless leaves. He wrote "dear friends" in Santa Barbara on August 12, 1934

> I am now ready to leave Stockholm after two wonderful weeks here. Shall go up and see my father for a week or two. Then back to Gothenburg, shall sail from there on about Sept 11. . . . Reports from U.S.A. are not encouraging, but hope it is better than they say.

Borg was still in Sweden in August enjoying his family, friends, and fame when a Retrospective Showing of the Painters of Southern California was held in Los Angeles. Borg had left his selections for the exhibition with Paul Lauritz and was represented. Reports from the exhibition were not encouraging for the older artists. Arthur Millier wrote

Navajo Papoose, 1935, drypoint etching, 25.4 x 20.3 cm.

For early painters landscape was it; and nature seen through a temperament the accepted definition of art. The fame of these landscape painters went out over the land and many are still hard at work, according to their ideals. . . . Later painters have more drama, deeper color, clearer statement and often a touch of the violence and sharpness which is so different to the softer, sweeter manners of the post war times when the world was a nice place full of ladies and gentlemen.[3]

For Millier, "every good story intensifies its drama as it moves to the crisis," and "this Southern California painting is no exception." In Los Angeles, the crisis in Western art was now clear and generally recognized, but Borg was so far away the crisis was not real for him.

Navajo Medicine Man, 1925, drypoint etching, 25.4 x 20.3 cm.

In the fall he left Sweden, telling reporters that he would return. He was going to America for the opening of his exhibition at the Smithsonian Institution. The exhibition was a critical success; the reviewer in the *Washington Post* praised Borg's "keen appreciation of volumes of shadings, shadows and delicate line [which gave] real power and an unusual idea of rhythm" to his drypoints. Leila Mechlin in the *Washington Sunday Star*, November 11, 1934, wrote that Borg was

> a typical Californian, painting and etching Western subjects, consorting chiefly with Western artists, winning prizes in Western exhibitions and selling his works to Western art museums and other institutions. This is not by any means to say that he is provincial—far from it—but long before the East and Middle West became sectionally conscious in art, Southern California had developed an art all her own . . . completely independent and self-contained. . . . Production has flourished as almost nowhere else and a healthy local patronage without self-consciousness has been built up. . . . From the first to last, this collection is fine. The portraits are exclusively of the Indians of the Southwest—Navajos and Hopis—and how well they are portrayed with all their gravity and dignity, especially the older ones. Distinctly this exhibition is out of the ordinary.

Alma May Cook wrote in *The Los Angeles Herald Express* of the "singular honor of a one-man exhibition at the Smithsonian Institution" given to "Carl Oscar Borg, one of California's best-known artists." His old friend, Gustavus Eisen, wrote the laudatory foreword to the catalog for the exhibition when, in December 1934, it moved to the Grand Central Galleries in New York:

> Borg has mastered with sympathy the understanding of the Indian soul as well as his earthlife, his mystery and dreams as well as his struggle for material existence. No one now living can prove his capture of the mysterious as does our artist. What can be more impressive than his Indian portraits which radiate the very soul of that race?

Eisen and a few other individuals still responded to Borg's pictures, but sales were slow. The trip to Sweden, however, had renewed Borg's energies if not his hope, and when he returned to Los Angeles in late December 1934, he worked with a new commitment.

In January, he joined the fourteen active members (all Southern Californians) and the twenty-three invited artists who exhibited in the first annual exhibition

Kivas of Hano, Arizona, **1933, drypoint etching, 21.6 x 26.7 cm.**

of the Academy of Western Artists held at the Los Angeles Museum. Borg's entry, *Summer Storm,* was praised by Alma Cook as "one of the best things he has shown."[4] (Borg was a member of the jury that awarded first prize to Nicolai Fechin for *Summer.*) He exhibited in Laguna Beach and began to prepare for a spring retrospective showing at the Biltmore Galleries. It was to be the first comprehensive showing of his work. Oil, watercolor, gouache, dry point, block prints, and monotypes would be included. Preparation for the exhibition was exhausting. He was finally so worn out that he could hardly stand on his feet. "As a matter of fact, I have fallen several times for no apparent reason—not stumbled, but my legs just gave out."

The retrospective gave a "new idea of this painter's strength and esthetic resources. He is more than a painter of the desert, he is a painter of light and air, of trees, animals and the figure. He certainly is not an artist who has allowed himself to be typed."[5]

Preparations for the retrospective completed, he exhibited another painting, *Castle of the Gods,* at the Los Angeles Museum and went back to his etching. He was almost always up by five o'clock and often worked all day. On May 14, he "printed full editions of five plates. My hands are blistered from wiping plates and hurt." Meticulous and incorruptible, working most often in the numerically restricted medium of dry point, he usually pulled no more than twenty prints from a plate, sometimes fewer, and destroyed the plates when the edition was completed.

Borg was also careful about his signature—he signed only those pictures he considered worthy of his name. A clerk at Dawson's Book Shop who wished

In Navajo Country, Canyon de Chelly, drypoint etching 25.4 x 31.1 cm.

Borg's signature on a sketch he had just made for a mural for the store sent Dawson's young son Glen up to do what she was too embarrassed to do herself—ask for the artist's signature on the sketch. Borg was startled by the request and answered, "I do not sign such things."

The only relief from the sense of personal annihilation that haunted Borg in the thirties was to submerge himself in his work. While Borg accomplished a good deal in the winter and spring of 1935, and was pleased with favorable critical notices and the sale of a dry point, *Cliffs of Canyon de Chelly,* to the Library of Congress, the return to Los Angeles caught him in the swamp of his tormented personal life again. In May, he asked Madeline for a divorce; a property settlement was drawn up and notarized. Then it seemed to Borg that "all the sweetness, all the pleasure that I had in seeing my own people, my father and friends was hardly enough for all the misery I have had since I came back. God knows what another year will bring."

Sensing loss everywhere, belonging nowhere, Borg wrote

> I am a child of Saga and Song,
> That grew up among stories of old
> Told in the winter nights, starlit and still
> My soul was so warm, my spirit so free.
>
> But life has robbed me and taken it all
> This most beautiful dream, it is gone;
> It can only be found in the Dreamland
> The Dreamland of Saga and Youth.

147

He decided to leave Los Angeles. Nothing bound him to the city which had become "like all big cities not fit to live in." In the summer of 1935, Borg was able to rent his own house on the Mesa, and he went back to Santa Barbara.

Borg wandered about the "château" that was and was not his. It was "very strange to go alone in the silent house that [he had] practically built with [his] own hands, to see the garden and trees that [he had] planted now big and very beautiful." "Life sure is strange," he commented in his understated prose.

The community welcomed him; he was "one of the first artists to take up residence in Santa Barbara," an artist who had "won practically every honor that can be conferred on an artist in all mediums," and when he commented on "the exaggerating moderns," he was quoted on the front page of the *Morning Press*, November 23, 1935.

> The exaggerating moderns have so confused the prospective buyer of art that he won't buy. [He] is caught in the cross current of what is being hailed as "great modern art" and what he, by all traditional standards has always believed was good art.

He knew that the controversy brought "visitors into the museum and those attendance statistics are what museum directors want to show their governing board."

Borg not only opposed modern art, but the new American Scene school which seemed to him to give no true picture of American life, representing only the squalor and poverty in America. He thought some of the artists talented, but resented the persistently bleak portrait that did not recall his experience. If the pictures "were shown on the Continent or the Orient, those people would get a bad impression of what the United States looks like."

In October Borg was standing on State Street looking in a shop window when

> an old man came up and started to beg. I was just going to go when I noticed his accent was Scandinavian. Same old story, an old man without work, could I help him, buy him a loaf of bread, he had had nothing to eat today. When anyone asks for bread I cannot refuse, so I told him to come with me to a market. There he told me he was a painter and a decorator and that he was Scandinavian, so I started to speak Swedish. He responded perfectly. He was from Stockholm, was 65 years old, and was living by the railroad track as a tramp. I bought him some bread, butter, cheese, meat and potatoes, and he was very happy. He said that

Capitain, Navajo, **1930, drypoint etching, 25.4 x 20.3 cm.**

he had asked at least 40 people that day for something to eat. The last thing he said when he left was, "Hope this will bring you luck."

Borg hoped it might, but as 1935 drew to a close, his "soul and heart [were] so weary [that] earthly things, books, possessions, manuscripts of sages dead," all seemed like "weights of stone; these trifles weigh me down." He saw death as the life that beckoned him, saying, "Come here, my child, come here and rest." But he did not rest. He prepared for another exhibition. In November-December 1935, an exhibition exclusively of Borg's colored monotypes hung at the Biltmore Galleries.

Navajo Camp, **1931, oil. Collection Peter A. Juley & Son, National Museum of American Art, Smithsonian Institution, Washington, D.C.**

In the *Times*, December 1, 1935, Arthur Millier reported the ''freshness and joy'' in the monotypes which ''few artists have so mastered.'' In the *Express*, November 30, Alma May Cook, who had first called attention to Borg's interest in and success in the medium in 1906, wrote that Borg

> has brought new meaning to the word monotype. For years this phase of art has intrigued the artist, and from year to year, he has experimented in this medium. . . . As always, this artist has a deep appreciation for solitude; the recent monotypes are by far the most subtle and the greatest achievement.

Alma Cook was now the last critic still writing for the Los Angeles papers who remembered his fledgling efforts. The exhibition of monotypes in the winter of 1935 represented Borg's final attempt at a major exhibition in Los Angeles.

The death of modern architecture has been given a precise moment; no such moment designates the demise of California representational art. There were intimations of an end before 1930; Millier reported the crisis in 1934. Borg felt his ''real'' art threatened in the thirties, but it continued to be exhibited and to meet a generally favorable reception. The year 1936, however, marks the end of Carl Oscar Borg's identification with the West. The exhibition of a ''brilliant desert landscape which was given honorable mention'' in the second annual Academy of Western Painters exhibition in January 1936, and of a watercolor, *Navajo Camp,* in the third annual exhibit of watercolors sponsored by the Foundation of Western Artists, represent Borg's final contribution to the associations of Western artists he had helped form.

In March 1936, Borg gave away many of the things he had not burned or sold—autographs, pictures and books—to the American-Swedish Historical Museum in Philadelphia. In that month, his friends, the Lorenzens, reported in *The Pacific Coast Viking* that "Carl Oscar Borg is preparing to leave for New York shortly. It is his intention to spend most of his time in that city, making occasional visits to Southern California during the winter months." An exhibition of paintings was scheduled in New York, and of prints in Boston. "California was," Borg was quoted as saying, "no longer what it was ten years ago. In Los Angeles-Hollywood there were formerly more artists than in the five times larger New York City," but now, "New York is the new world's art center."[6] Publicly Borg sounded as confident as always.

On April 23, a few days before his departure for New York, Borg attended a meeting of the Art Discussion Group at El Paseo, an informal artists' club to which Borg and a number of his good friends—the Boreins, the Vaughans, and Colin Campbell Cooper—belonged. Litti Paulding reported in the *Santa Barbara Daily News*: "Art history was really made when Carl Oscar Borg . . . showed the first copy off the press of his new book, a folio of etchings of the Southwest."

Borg's old friend, Everett C. Maxwell, the man who had hung his first picture in Los Angeles, had compiled a number of Borg's poems and pictures of the Southwest to make "a valuable addition to the tomes of California." *The Great Southwest*, edited and compiled by Everett C. Maxwell, with forewords by Leila Mechlin and Gustavus Eisen, was published in 1936. Lucia Vaughan read several of the poems aloud at that April meeting.

As Borg prepared for what he thought his final break from the life that had been his, all echo of fellowship gone, other poems were not heard.

> Where are the years?
> Where have they gone?
> All that I dreamed,
> All that I wanted to do!
>
> A cross leaning on a forgotten grave
> A cry in the wind that no one hears!
>
> The storm that was my life is over
> The sea is calm: nothing is seen of the wreck.
> The hardship was of no importance.
> The life was only mine.

I sit alone at the table
No guests are expected
What would anyone
At my lonely festival
Where the song is broken and still
And sorrow with sorrow is changing?

On May 4, 1936, Borg sat in the observation car of the Superchief, watching the great Southwest desert unroll before his eyes

barren and austere, serene and indifferent to the trains and puny beings that cross its magnificent expanses. How I have loved it and do yet. I can hardly bear to think that I may never see it again. The golden days and silvery nights I have spent under its skies are things that I shall always cherish. . . . all the old familiar stations and names. . . . there they lie under the spell of the drab desert. Corrugated iron sheds, starving cottonwood trees, Mexican and Indian children playing in the dust. But the horses that used to be so evident are gone and the country is littered with old Fords.

As the train moved on across the country into Kansas, Borg recorded

not a grass straw in sight . . . at noon one could see as far as a mile. . . . Farms and buildings looked deserted. The dreariest thing I have ever seen. The dark cement color covers everything. The sky the color of bleached-out khaki. . . . This country was America's, but I am afraid no more. Man sure makes a mess of everything he gets hold of, by that I mean white man. The farmers have killed the land for profit. Plowed up every natural grassroot, and now the soil is blowing away.

The reception given by New York critics to the exhibition of Borg's oils at the Grand Central Galleries deepened Borg's depression and confirmed his disillusionment. "Representational painting is currently out of favor," Malcolm Vaughn commented in the *New York American* on April 25. "Borg's representations of Southwestern mountains and plains are competent enough, but . . . he does not bring to his landscapes much originality of perception." The critic for the *Herald Tribune* perceived only "a simple picturesqueness in the landscapes." Although he admired the "broadly effective treatment of rugged mountain masses" in *Navajo Stronghold*, and thought that *Arizona Summer* gave "a good

Hopi Kachina Priest, drypoint etching.

impression of a dry desert valley," he felt that "these paintings . . . for the most part . . . are rather lifeless."[7]

Old friends in western and Swedish American newspapers gave highly favorable reviews. On April 28, the critic for the *Christian Science Monitor* applauded the "low key" of the pictures, citing "the dignity and mystery [in the] brilliant and personal scenes," and on April 29, Dr. Eisen reported in *SVEA* that Sweden had not had an artist of Borg's stature since Fahlcrants revolutionized the notion of color in landscape, and America had not had a greater nature painter since George Inness. "Carl Oscar Borg is the greatest nature painter of our time."

The Antelope Ruins, Canyon del Muerto, drypoint etching, 20.3 x 25.4 cm.

The two strongly favorable reviews from friendly sources did nothing to lessen Borg's discouragement. He commented that the New York reviews "could have been worse, but not much"[8]; the exhibition had been "all outlay and no income." A month later, Borg exhibited Southwestern drypoints and woodblocks in his "first Boston one-man show" at the Vose Galleries, but the favorable critical reception there did not alter his increasing sense of alienation from America and the "art game."

In New York he saw a few "very fine paintings and a mass of less worthy work," and concluded that "one cannot place New York on a higher level than other places in the country."[9] He lived at the Salmagundi Club and observed the other artists, "old fellows who once had a good reputation, but are too old to work much, have no income and are too proud to go on the Federal govern-

ment's dole." He found the situation "sad and quite hopeless." He was outraged by the publicity given a younger artist, Helen Wills Moody, the tennis player.

> The space given Mrs. Moody in the papers made me sick . . . and all because she is a well-known player. Several pictures sold before the exhibition. If she was not known as a tennis player, she would, at the utmost, have had five or ten lines in the papers. Such is art in the United States, and, I suppose, all over the world today—not a particularly pleasant outlook.

As disillusioned with prospects for himself as an artist in New York as he had been in California, he decided, in the summer of 1936, to sail for Sweden. He wanted to know whether Sweden was withstanding the pressures of modernism and whether he might call his native land "home" again. He did not think, he told Swedish reporters as he left the States, that art could become the "cheap business" in Sweden that it had become in America. The fine taste and long traditions of craft excellence would preserve Sweden from the ruder shocks of the age of mass production and mass marketing. He reiterated his desire to paint the Laplanders and their customs; they were still "out of the hands of the merchants."[10]

WINTER

Borg spent the summer of 1936 travelling through Scandinavia in the company of Mrs. Nilman. He had observed the devastating effects of land abuse and the ravages of the white man's greed as he crossed America by rail. Travelling in Sweden, through "one of the poorest provinces" where there were "certainly more rocks than soil," he was struck by the contrast. The country was green and fresh; the woods full of flowers; there were "beautiful and prosperous looking farms everywhere." Borg was comforted to see the meticulous preservation of the land, the care given even humble buildings, by the welcome given him by both family and strangers, and by his own deep response to his people's past.

The "great Indian painter" was honored by Dalsland artists, asked to exhibit with them in Brålanda, invited as guest of honor to the dinner celebrating the opening of the Raskogsstugan, an old house converted into a museum. Thousands of Dalslanders attended the opening. "It was a spectacle to stir a man's heart. The love of the land of their fathers is a thing they cherish above all things." That celebration of their common heritage moved Borg profoundly. He walked by himself from the museum to an old, abandoned church and stood alone inside, "The painted ceiling and the altar piece, the worn pews of pine . . . something gripped my heart. Here the simple people, the rich and the great, have mingled their voices; the whole a mute evidence of the frugality and severe living of this distant land. I could hardly tear myself away." When he returned home, his father and a small band of relatives stood out on the road in the light of the deep summer night waiting for him.

Borg sat with his father and listened as the old man played the concertina with his swollen fingers and sang all the old melodies he had heard as a child. He recorded the scene in a gouache. A friend sent a clipping, frail and yellowed by time—Pastor Nilman's farewell address to the people of Grinstad. Pastor Nilman was dead, but as he read the faded print, Borg "heard his voice. So it goes, a life's journey from cradle to grave, no knowing what is in store for us."

Borg lingered on in Sweden when the summer was over. He went to Stockholm and found Paul Engdahl repatriated, surrounded by a new group of friends, Swedish artists, writers, musicians, and actors. Borg was welcomed among them, "de bästa människor man kan träffa," (the best people one can meet). In October, the Utlandssvenska Museum exhibited a collection of sixty-two of Borg's watercolors, etchings, and woodblocks. The Gothenburg papers carried the photographs and stories of Borg's life and art. The "unique exhibition in Gothenburg," the collection of Borg's pictures with Indian motifs was a success. The Swedes, who "had grown up reading the novels of Cooper,"[1] were interested

Gustaf Borg, 1936, gouache, 31.8 x 24.8 cm. Privately owned.

in the Indians.

Borg gave every appearance in Sweden, as he had in America, of being the eminent, successful, confident artist. "I have had to hide my feelings many times or I should have gone under." Although he experienced richly peaceful moments in Sweden in 1936, he carried with him the loneliness and fatigue that for the past few years had been his almost constant companions in America, and as fall came on, he often thought and wrote of death. Sometimes he was sure of "other worlds and other beings," who dreamt his dreams of "peace and liberty, happiness and love." They too would "go to meet their foreordained fate, to die and be forgotten." In more hopeful moods he felt that

> Even if the tree is falling the forest remains.
> We are not from today, or yesterday.
> Some of our blood, our strong hands,
> Are an inheritance from humanity's cradle days.
> A hundred years from now we shall be dead.
> Still, something, maybe, has been left behind.

In his poems in the fall and winter of '36, he moved from fables of the gods, to the stories of men, to the simple song any mother might use for a lullaby. "Come, come, my child, said the Earth. Softly she bedded him down. Now all your sorrows are forgotten. Sleep child, sleep sweetly."

Canyon and Navajo, 1924, woodblock, 23.5 x 20.3 cm. Collection Mr. and Mrs. Jules Delwiche.

As the days became short, cold and dark, and Borg lingered in Gothenburg, his moods alternated between loneliness and melancholia, restlessness and irritation. "Sometimes I wish I had never returned to Sweden. Begin to think it was a mistake and am getting heartily tired of it." On November 13, 1936, he wrote one of his last poems in English and one of his most despairing.

THE SINGER
Sing, singer, sing!
Sing in the fading times.
Alone among the living dead—
Yes, alone, and drunk on loneliness.
True to thyself, like the swan,
Sing, sing . . .
To sing on earth is to be true
Against all temptations,
The desire of man to be himself.
Song on earth is loneliness,
Beyond gods—and all men—
Loneliness unto death.

In his poetry, Borg gave in to loneliness and hunted death; in other moods he hoped for life and happiness, an end to solitude. On the day that Borg wrote

The Singer, he sold two etchings from the Gothenburg gallery. "This afternoon Inez Byland came up with a friend of hers, Miss L. Lindstrand, who bought two etchings. Seems very intelligent, and, I thought, an interesting person. At least she knew what she wanted and did not take too long to decide. Hope I have a chance to see more of her." Borg did see more of her. He came to view her as his inspiration. Lilly Lindstrand became the source of a "new beginning" for Borg. She had appeared, Borg wrote, with more insight and prophecy than he knew, "as a thought in a summer night . . . a thought in my tired brain." "Where did you come from so full of light with your song in the winter night's rain?" and he had already answered his question.

The "winter night" of Borg's life was transformed by the interest and attention of the intelligent Swedish woman whose own life, until her meeting with Borg, had been absorbed in her family—her sisters and brother and their families lived in Gothenburg—and her interest in her own career as personal secretary for the head of Standard Oil in Gothenburg for whom she had worked for many years. She was a well-travelled, tall, beautiful, dark-haired, fair-skinned woman in her mid forties, capable and independent. Lilly had a trained voice and her speaking voice was full of music. She was not at all interested in loneliness or death; she was active, direct, and confident. Borg had observed a central aspect of her character when he wrote after their first meeting that "she knew what she wanted and did not take too long to decide." Like Borg, Lilly made intuitive assessments. They saw a good deal of one another during the winter of '36, and by the new year, had decided to marry.

Borg recorded a number of positive responses to Sweden, but it was his meeting and subsequent engagement to Lilly Lindstrand that provided the final impetus for his "permanent" return "home." His most compelling need had been for "someone to love me"; having found her, he would remain.

On December 13, 1936, his confidence restored, his isolation broken, he wrote *Why Was I Born*, concluding

> I was born to give expression to those powers the Creator gave me; to unfold and develop my talents, under the guidance of my reason, so as to find lasting happiness through worshiping the higher, the altruistic and spiritual impulses, and to fight the more brutal inclinations. I was born to try to find love and my own work, and through these—Freedom. In other words: the reason I was born was that I should be as GREAT as possible.

Lilly gave him the courage to believe in himself again, and he celebrated

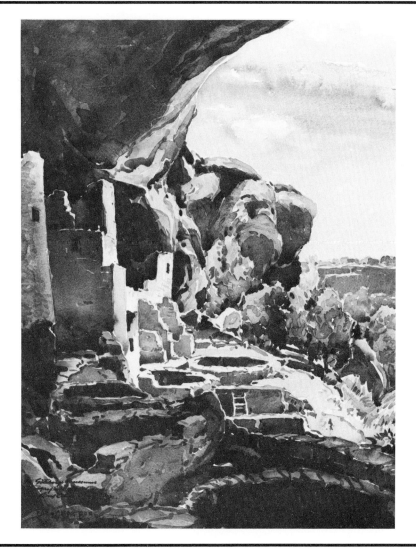

Cliff Palace Mesa Verde National Park, watercolor, 34.3 x 44.5 cm. Collection Gothenburg Ethnological Museum, Sweden.

her in the poems he now wrote in Swedish. She was his "Mona Lisa, all the world's women in one." He saw her in the moon's light, "silver black standing there in the evening's blue hour."

Hold fast, hold fast, you who wander without home or house. . . . Once I heard a star's song back in the heaven's dark deep! It was you . . . and now our love blooms endlessly. Mona Lisa! I hear a thousand silver tones ring. It is the power of the troll kingdom.

In the bookplate he designed for her in 1937, Lilly stands, a fairyland princess, her mouth open to sing, a songbook in her hand, in the midst of a spray of gigantic lilies, the moon and the stars overhead.

Borg was approaching his sixtieth year; his power of imagination was as strong as ever. He surrendered to his vision and absorbed Lilly in it. He celebrated Lilly the Flower, Lilly the Singer, Lilly the Madonna; his vision of her during their courtship left out Lilly the clear-headed, independent, strong-willed, capable manager. He urged her to return to America with him as he prepared his final move back to Sweden, but her "responsible job" kept her in Gothenburg.

By the time Borg returned to America in the spring of '37, he had the promise of a new beginning with Lilly and a certain celebrity in Sweden. In addition to several newspaper articles about Borg and his Indian art that appeared in the Gothenburg and Dalsland newspapers during the year, Stockholm's *Svenska Dagbladet* published a four-page article about the life and work of Carl Oscar Borg with eight photographs of his pictures and two of himself. The article appeared on April 4, 1937. On April 18, as Borg was about to sail—first class—for America aboard the *Gripsholm*, Swedish reporters interviewed the celebrity. He told them that he would "settle here and become Swedish again"; there were many Swedish-Americans involved in reverse migrations; he had seen Paul Engdahl in Stockholm. He didn't know if he would become a "Dalsland painter," but the "high, blue sky there was like Arizona's, the evenings beautiful." He had "just lived through one of the hardest winters and had found it so wonderful in its way" that he did not think he would miss the California climate he had enjoyed for thirty years.

Day of the Fiesta, Oraibi, oil, 50.8 x 50.8 cm. Collection Eugene B. Adkins.

LEAVING AMERICA

1937-1938

Borg intended to settle his affairs in America during the summer and fall and return to Sweden in time to celebrate Christmas with Lilly. At first his sense of beginning again, of a personal "spring" survived the distance.

Where I am there you are. . . . In the darkest night when I close my eyes you are there. . . . Dark winter is gone, all the trees are green. . . . The world is filled with small flowers, delicate and lily-white. Lilies of the valley with crowns so pure and angel like. . . . Life has called and now winter must wait.

But winter never waited very long for Borg. Soon, "not even all the happiness of the past year could make up for the pain that I have suffered since." The intended stay of a half year lengthened to a year, another year full of conflicting emotions, a mixture of success and pain, comradeship and acute loneliness. Borg was wafted by alternating moods of despair and joy; he longed for death but went hopefully on. Sometimes the "storm" of his life seemed imminently to drown him; as suddenly he found himself in the light of a clear day as buoyant as the white clouds that drew his eyes upward out of himself and made him want to paint again.

We are "all so alone, so alone," he lamented. "If I should cry in the still night, who would hear my cry or need"? He asked his "poor heart" why it wept: "Why do you weep so and lament and suffer your pain in the night, in sorrow's dark night." He had to remind himself to "look out, there, in the sunshine . . . there are the driving forces that shall break the chains. Look out, everything is determined for the best." His private, mental, emotional life played the counterpoint as he moved across the country from New York to Los Angeles and Santa Barbara and back to New York, efficiently, meticulously arranging his affairs.

Borg arrived in New York at the end of April and remained in the city through May and June, living again at the Salmagundi Club, checking in at the Grand Central Galleries, which continued to represent him in New York and where many of his canvases were stored. He contacted friends and supporters in the East; he ascertained that there was still "nothing doing" in the New York art market.

Gustavus Eisen had moved to New York and his was a welcome presence. Borg often visited the aged scholar in his apartment on Park Avenue. Although they had rarely seen each other since their travels together in Europe and North Africa, they had corresponded regularly and easily took up the old friendship.

Eisen was still publishing, but no longer working with his microscope or in biology. His interest in archeology persisted, but he had developed new interests in glass, bronze, and portraiture. When Borg saw him again, he was absorbed in the study of the earliest portraits of Christ, the apostles, and the evangelists. Sharing common interests, artist and scholar succeeded sometimes in putting present troubles behind them.

Osa Johnson, widow of photographer and explorer Martin Johnson, was planning yet another trip to Africa to film a life of Stanley. She wanted Borg to sign on as artistic director, but he refused. He was not interested in adventure anymore.

He accepted another offer, however, a commission from the Santa Fe for two oil paintings. The commission provoked the comment from Lilly that he "always had luck."

> Luck I have had. But it was through hard work that I got somewhere. As a boy I had a great goal in sight—to be a great painter. Now when I look back I can only laugh at everything—to be great is only an egotistical feeling and, as I now believe, not of much value.

He was lonely for Lilly and the possiblility of some years peace. He knew he seemed very independent to most people,

> and in way I am, but I need someone who loves me. As a matter of fact, I am very sensitive. Many times in defense, I show myself as another person from what I am, otherwise, I should have gone under long ago.

When Borg wrote Lilly that he had completed the canvases, she wanted to know if he were satisfied.

> I am never satisfied with anything I do; I try to do the best I can and never spare myself but still I always think something is missing, but when one does the best one can then it must be good. Nothing is complete, myself and my work least of all.

In August, the Portland Museum of Art in Portland, Maine, sponsored an exhibition of Borg's etchings of the Southwest. That exhibition, the exhibition of two oils at the Salmagundi Club in January 1938, and of *Summer Storm, Arizona*, at the National Academy in March were the only public exhibitions of Borg's work during what he thought to be his last year in America.

In July, Borg left New York for Los Angeles. He was interviewed by Alma May Cook upon his return to the city and on August 9, 1937, her article "Sweden

Honors California Artist" was published in the *Herald Express*. She described Borg's warm reception in Sweden, his plans to return there, and included photographs of Borg and three of his pictures, two of the Southwest and one of the room in which he was born.

Borg expected to find that Madeline had initiated divorce proceedings, but she had not. He was "determined to have everything cleared up" before returning to Sweden, and he remained in Los Angeles almost two months seeing to the divorce, disposing of "everything which binds or hinders me," getting his pictures ready for sale, or storage, or shipment to Sweden, taking care of extensive dental work.

In September, he left for a farewell visit to Santa Barbara. A wire reached him there from Cecil B. De Mille who was then producing and directing a new pirate film, *The Buccaneer*. De Mille, recalling Borg's work for Fairbanks in *The Black Pirate*, asked him to return to Los Angeles and join his art department for a month. The world seemed on the brink of another depression; the offer, four hundred dollars a week, the familiar theme, and the limited obligation were too attractive to refuse.

When his work for De Mille was finished, Borg's eyes were seriously strained by the studio lights and the unrelieved concentration on close work, often from eight in the morning until two the next morning. On his doctor's advice, he remained in a darkened room for a week. Someone sent him an Indian fetish, a pair of silver eyes. He never learned who the sender was, but he understood the wish, recognized the Hopi charm, and kept it with him. He had "gotten rid of" almost all of his various collections, but he did not sell his American Indian artifacts. Those he carefully wrapped and shipped to Sweden.

On November 3, 1937, after a final visit to Santa Barbara, Borg was aboard the Superchief heading East again. As he travelled through the country for what he thought would be the last time, he shared what he saw and felt with Lilly.

> We are in Arizona! The desert! My desert! The land with the red earth, the sunburnt vastness with its blue mountains. . . . This is a big, lonely country. . . . Here one is much nearer the creator of all. Most people hate it and are afraid of it because it is a hard country and the inhabitants know what hunger and thirst are. It is still burning warm here, but soon the frost will come and then it is just as cold as it was warm before. It is around 7,000 feet above sea level. There is something ethereal about it—sometimes it is blue, sometimes red, yellow or pure gold. But there is also the most impenetrable darkness; it is more than black and

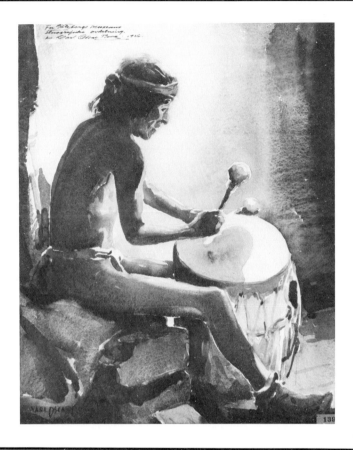

Indian Drummer, watercolor, 30.2 x 25.1 cm. Collection Gothenburg Ethnological Museum.

it seems to be as endless as the night sky. . . .Here one is so near the heart of nature, undefiled and pure as it was from the beginning of time.I have not seen a single one of my Indian friends, but I know that they are out there. On the blue summits at the edge of the horizon sits an old medicine man beating his drum. Monotonously, the melancholy sound goes out over the desert, perhaps a last goodbye to me, whom they called "kvachi," friend. . . . The white intruder will come nearer every year. Then. . . the mystery will disappear. Then the cars will come and hit the old Indians who cannot move out of the way fast enough. Then will come the buyers and sellers of land, as well as of souls. Then there is no speaking about the Great Spirit, but about gold and profits. One thing I know and that is that some of the world's primitive purity and simplicity will disappear.

Self-portrait of artist as a dog.

He thought he would probably never hear "the big strong pulse beat of nature, of the desert" again.

The next day the Indian country was far behind him. He crossed Kansas and told Lilly the story of that unvaried land.

> Here and there one can see big farms, some near the track, almost buried under the loose earth which the wind has blown around them. It is just like the snow in Sweden. In many houses the sanddrifts go up to the roof. They are empty and deserted.

He reiterated the thought that had struck him as he made his way east in 1934. It was "remarkable that the human being has almost ruined this wonderful country which had all they needed, just to make money and be richer than anyone else."

In his letters to Lilly, Borg described America and himself. Before leaving Los Angeles he had written what it was for him to be an artist. A cartoon illustrated his point (25 July, 1937).

> Generally I am not very much interested in painters. They are usually filled with too much self-esteem . . . at least the so-called modern artists, and it is because of that that their art isn't so much. They take Art very easily, but in reality it is some kind of religion, a worship of the

beauty in nature, something hung on, as you can see from my self-portrait . . . and because I have that feeling, I cannot live like other people—I have a feeling of responsibility. I am certain if I lost that which I have had all my life, it would be very hard for me. It has followed me everywhere and from it I have learned a great deal about people, the world and life. It is a great teacher, and makes one humble before the unsearchable, even if it is poor and looks like a tin can.

Borg was in New York as the year drew to an end. Lilly was disappointed that he would not be home for the holidays. Borg explained

> But, dear one, you mustn't be so downhearted. When once I leave freedom's (?) land, then it will be for all time. And as much as I wish to be with you at Christmas, I can't. . . . Have still many things to settle. . . . I will celebrate Christmas as I have so many other Christmases, in my own company.

He would not go to the Swedish church even though there was one in the neighborhood. "I think it's just cheap and absurd to stand and talk stupidities when the world is an endless battleground either on one territory or another." He would "rather rest, and go out in nature," but as the weather was "terrible," he would probably "sit in the library and read."

He spent Christmas 1937, alone in the "strong and interesting" library at the Salmagundi Club. He read the Greek philosophers.

> In Empedocles I found the following. "Through the earth in us we see the earth, the water through water, air through air and fire through fire. Love perceives love and hate hate." One meets the same idea in many primitives as well as in later philosophers. Goethe has given it the famous formulation: "Were eyes not radiant, they could never perceive the sun. If God's own strength lay not in us, how then could the divine transport us?"[1]

The poet and philosopher expressed Borg's ideas. He quoted their words to Lilly to tell her who he was, and in his own words, he gave news of more immediate interest. He was "up for a medal at the National Academy."

On March 14, Borg received word that his nomination to the Academy, "this country's highest honor for a painter," had been approved:

> I sat up at the Salmagundi Club bar until about eleven o'clock when several members came in and congratulated me on having been elected

by the biggest vote of anyone. As far as I remember, not a single vote against me. I had to stand drinks all around . . . and we made a night of it. It was five in the morning before we all got to bed.

Borg stayed on at the Salmagundi, waiting for the divorce papers, talking with interested prospective buyers at the Grand Central Galleries, contacting by letter one hundred and eighty individuals who might wish to buy his pictures before he left the country.

The pattern was interrupted the last week in May when Borg walked by Rockefeller Plaza, glanced up at the Swedish flag and was struck by the full import of his father's last letter. "You will all get to come home this summer, because I don't think I will live any longer. I saw Krestin, your mother. She beckoned to me." Borg went directly to the Swedish American Line office. Learning that a single first-class ticket had just become available, he booked passage on a ship sailing for Gothenburg the following week. He called on Dr. Eisen to bid him goodbye. "He was sad to hear the news, but said I was right to go." On June 3, 1938, even though the divorce was not final and everything was not "all settled" in America, Borg was on his way back to Sweden.

The sea was calm; the weather beautiful; the voyage uneventful. The only event Borg thought worthy of recording in detail was its conclusion.

The ship was anchored off the coast of Sweden at midnight. They were to dock in the morning. The bar was closed, but the passengers, forewarned, had purchased bottles of whiskey. They were gathered on deck. As it grew later and voices grew louder, one man's voice dominated the rest. To escape from the noise and the growing irritation he felt at the nonsense that was being spoken, Borg retreated to the shelter of a lifeboat where he lay looking at the sky.

It was an exquisite, a completely magical night and almost as light as day in spite of the fact that one saw neither moon nor stars. The mystery of the summer night [was] something like a dream. The sky was copper colored, interspaced overhead with flaming stripes of silver and blue, but towards the horizon everything darkened into the same uniform dark grey tone which lay like a veil over the sharp cliffs of the shore. The firmament was full of little clouds in a dark charcoal color with edges like polished silver. There was not the least movement on the water; it was like a blank mirror of light opal color, but the islands and the small islets which lay between us and the mainland were as black as coal. It was a Northern summer night like nothing else in the world.

Lured on by the initial beauty of the scene, Borg's mind soon trapped him in an anxious dream.

Near the horizon a nebulous, dark mass gradually took the form of an enormous female figure dozing on the sharp and naked cliffs, her feet by the shore, one hand relaxed at her side, the other on her knees. She was dressed in ancient Nordic costume, a long white skirt, a nursing bodice open to reveal her, white, milk-full breasts. A necklace with the emblem of the Folkhjemmet (People's home) set in jewels sparkled at her neck. As she nodded in her sleep, a crown gradually slipped down over one eye and ear "like the high hat on someone who in the cool of the morning stumbles home after a night of partying." The night deepened; the surf seethed, lapping the figure's feet. The vision grew demonic when Borg perceived that the whole scene was swarming with tiny figures, people. Some were on her arms, some on her chest, all clambered to get to her breasts, "life's source." Many hung on successfully; many fell. The scene was tumultuous, but the great figure dozed, indifferent. Thousands clambered out of the water striving to climb to her bosom. Nonchalantly she knocked them back into the sea, stepping on the hands that tried to grasp the shore, making them all bloody. The vision puzzled Borg until a voice behind him asked, "Ser du inte att detta är Svea, Sweden the Middleway, Folkhjemmet?" (Don't you see that it is mother Svea, Sweden, the Middleway, Home of the People?") The voice explained that those who swarmed near her breasts and were able to reach the source of nourishment were the children of her youth and vitality. Those swarming up towards her from the seven seas were children of her old age and fatigue whom she had cast from her. She hated them. Whether they had perished in foreign lands, or had succeeded and become famous and spread her name far and wide, "she hates them all the same."[2]

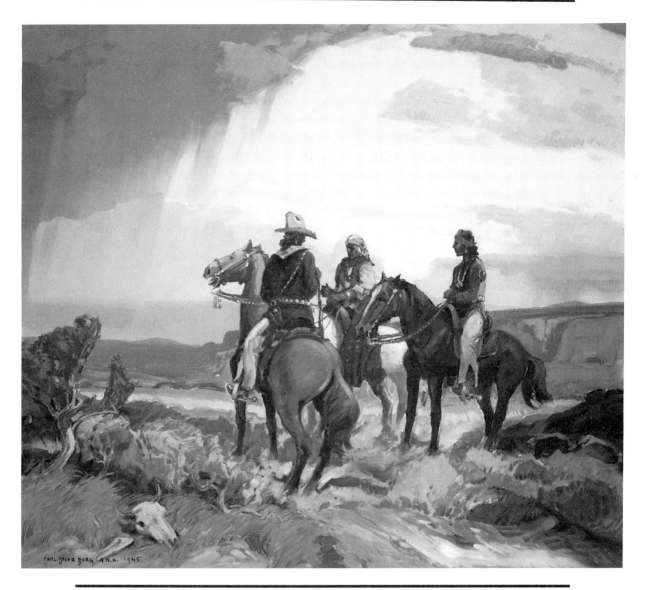

The Navajo Horsemen, oil, 91.5 x 101.6 cm. Collection Mr. and Mrs. Sydney Shoenberg.

SWEDEN

1938-1945

From the little town where he was born, Borg wrote Lilly that he was glad that he had come, but as he waited by his dying father's side, the sad vigil prompted sadder thoughts. America was no longer his home, and he was now not sure he belonged in Sweden. Certainly his dream told him he did not.

He sat out in the woods and wrote. He thought about life. He could see the door of the little red room where his father lay dying. He watched the nurse and the townspeople come and go and wondered why. They never came before. He thought there was "something macabre about it all, something sadistic, this coming just to see a man's pain and sickness." He was sure that many were worried that they wouldn't get to see the last minutes. He felt

more a stranger among my own than anywhere else. . . . I can understand them, but they can never understand me. All my life I have been a wanderer. There doesn't seem to be any peace anywhere. I have had many good friends out there in the world, but it was always something like it is here. I had to learn to understand them. However good a friend, I was still always a stranger. The fault is probably my own. I thought I was a wanderer—the eternally wandering Jew, who for his sins had to wander forever—not that I have any great sins or that even, strictly speaking, there are sins. No, with me, it has always been something else. It has been the unreachable which has been waving at me from over the peak of every mountain, waving with its bewitching smile, exhorting to new efforts. But as soon as one has come to it, there is always, a new peak, and so again, without end. Life, the biggest adventure, we sell for pottage and bread, like Esau, in other words, distinctions, honors, etc. It smells in our noses, the smell of pottage, and so we lose our first-born right. Then we look for truth, this ladder which is splintered into millions of fragments. Each one will have found one little fragment and believe himself to have found the whole, the secret of life, the way to meet unknown fate. . . . Inside, in the little room, a life is going out. Once it was strong and powerful and in its strength did many things which became sweet morsels of scandal for the town's gossiping tongues. But now the strength and pride are gone. Whether it takes a short or a long time, it still goes. . . . As the preacher says, "All is vanity." I am not complaining. We all have the same end. . . . Angels and idiots . . . do what nature bids them to do.

Death came to Dals-Grinstad on July 3, 1938. Released then from the bond-

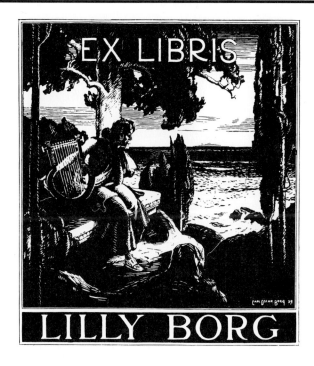

age of nightmare and introspection by Lilly's presence, Borg found the clouds so beautiful that he felt "the creator's joy and the desire to paint again." She was his "dearest Lilly," "beloved Lilly," "my Lilly," in the letters Borg wrote whenever they were apart for more than a day. "When I am with you I come to a peace, something I can call an eternal truth, something I can cleave to." He told Lilly, "It is not in my nature to be 'good'! But you know that for you I will even try to be 'good.'" He easily bent his will to hers. "So you are angry that I won't go to the theater. Don't be angry. I'll go."

Many of the friends he reported feeling such a stranger with wrote to him in the summer of '38, and he replied to them all, writing "one letter in English and another in Swedish, back and forth so that one really gets dizzy." In his ebullient mood he was grateful to and proud of them, telling Lilly that he had

friends there far away who are extraordinary. The best anyone can have. One says, for example, "If you stay in Sweden, then I will be very lonesome, but if you weren't interested in your own land, your people's land, then I wouldn't care about you." That's said like a real American, one of the "Pilgrims" who came to Plymouth Rock in 1620.

His sense of loss and isolation had almost broken him; now, during the late

summer and fall of 1938, he experienced a joyous interlude; he plunged again into life in the loving embrace of his Swedish Mona Lisa whom he was convinced would provide the safe harbor he sought. On August 18, Borg's divorce became final; on October 3—"everything important in my life has happened on the 13th, the 7th, or the 3rd"—Carl Oscar Borg and Lilly Lindstrand were married in a private ceremony in the Swedish church in Copenhagen. For romantic as well as practical reasons they had elected the quiet ceremony in Denmark where one of Lilly's sisters, Elsa Villadsen, and her husband lived.

The Borgs settled in Gothenburg. Because Borg "hated business of any kind,"[1] Lilly, who was "all business,"[2] took charge of financial matters. She had a good head for figures and enjoyed manipulating money, buying and selling stocks, bonds and real estate. They invested in a large, new, seven-story apartment house at 46 Gibraltargatan and bought a villa in Örgryte where they briefly lived. When they sold the villa, they moved into an apartment where Borg had a studio on the first floor and the couple lived on the second.

A neighbor's child, Gunnell Elfwing, often interrupted Borg at his work. Playing in the street in front of his studio, she called his name until he recognized her presence and threw coins and candies to her. He didn't mind the interruptions. He liked children and was gentle with them. When she was only two, Miss Elfwing was invited to be a dinner guest at the Borgs. They would have been thirteen without her.

From 1939 until 1945 while Borg lived in Gothenburg, his name and work, with a single exception—a photograph of Borg's *Catching Seals off Santa Cruz Island* published in the *Santa Barbara News Press*—did not appear in the American press. Swedish newspapers in Stockholm and Gothenburg and provincial newspapers from villages north of Gothenburg now reported Borg's more restricted activities and modest accomplishments.

During his earlier visits to Sweden, Borg had been regarded exclusively as a painter of the American Southwest and the Indians. Now that he had settled in Sweden again, he became a Swedish painter. "Am painting Swedish pictures now,"[3] he wrote friends in Santa Barbara. Fully confident, at first, in his decision to begin again, he joined the Dalslandgruppen of artists, the smallest art club in Sweden formed in 1938, the year of his return to the sparsely populated province of his birth.

He held only one major exhibition of his American pictures of the Southwest—sixty-four watercolors, oils, gouaches, etchings, and monotypes hung at the Gummeson Gallery in Stockholm in May 1939—but this "true and

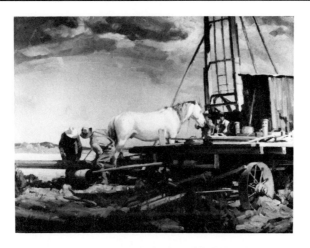

The White Horse, 1940, watercolor. Privately owned.

good child of Dal" exhibited frequently with the Dalsland group as an honored member.

California scenes appeared among the Swedish pictures. When the town of Mellerud held its first fine arts week in March 1939, with an exhibition of Dalsland painters, the reporter covering the event for the *Elfsborgs Läns Annonsblad* recounted an interesting detail from Borg's childhood in Grinstad. The artist could remember eating only one egg—"It was at Easter." The reporter commented that "nothing made by the hand of man"[4] could be more exquisite than Borg's *Gammel Cedar (Old Cedar,* Monterey, California).

Borg had an extraordinary gift for seeing, for sensing the spirit of the place where he was, the thing he looked at. He could comprehend the full sweep of an Arizona sky, the energy in a gnarled tree, the essence of a flower. He found the daisies and cornflowers in his native province

> the most beautiful flowers I know. I have seen most of the vegetable kingdom's splendor, the blue lotus flowers on the Nile and many others, but my youth's red clover fields with daisies and the rye fields with cornflowers are the sweetest I have ever seen. I admire these simple flowers as much as I admire simplicity in a human being.

Borg did not, after all, seek out the Laplanders. He remained close to home painting the ruins and sights that appealed to him: Viking graves, old churches, old fortresses, old barns, old houses, boats, and harbors. He painted the stream

Before the Storm, 1940, watercolor, 55 x 53.3 cm. Privately owned.

that ran past the wooden hut in which he had lived as a child and the fields blanketed with snow and with flowers. When his paintings were hung, reporters noted his "disinterest in the modern approach"; he was "an artist who could not be typed." He painted "nature as it appears to friendly people and not only to the artist's eye. The land looks as it really appears to people."[5]

Reporters were enthusiastic and friendly, but Borg observed that most Swedes were indifferent to serious art. "But we must hope that it will be better, that interest in art will be more usual than it is now."[6]

In the months preceding the outbreak of World War II, Borg did what he could to encourage that interest. He painted and exhibited scenes of Dalsland, a monumental historical painting, *Dalaborgs förstoring*, and a number of portraits, one of a nameless, archetypal Scandinavian, *Old Grandmother*, and another of an eminent citizen, Professor Vilhelm Lundström. Lundström was the founder of the Riksföreningen, an organization established to develop archives and to maintain contact with Swedes who had immigrated, an organization in which Borg was actively interested and to which he donated several paintings.

When Russia invaded Finland, Borg painted a political cartoon, donating the picture to *Göteborgs Morgonpost*. Copyrighted and published on December 14, 1939, reproductions were sold to benefit the Finnish cause. When war descended again on all of Europe, he sketched and painted the signs of it in Gothenburg: the crowds reading the extras posted on walls, the bomb shelters, the planes, the fishermen who risked their lives bringing refugees across stormy seas to safety in neutral Sweden. As activities and supplies became increasingly restricted, he

Old Grandmother, 1940, oil. Collection Gunnell Elfwing Menn. *Vilhelm Lundström,* 1940, oil. Collection Utlandssvenska Museum, Gothenburg, Sweden.

etched bookplates for friends and relatives, provided Axel Fredenholm illustrations for his book of poems, *Songs of the Desert.* (Like Borg, Fredenholm had lived with the Pueblo Indians early in the century.) Finally, lonely for them and the life they represented, Borg painted the Indians again.

He had moved into his new environment in Gothenburg with ease and high expectations. He had good friends in Gothenburg, among them: Stanley Reginald Lawson, the American consul, and his Swedish wife, Inga; Walter Kaudern, Director of the Gothenburg Ethnological Museum; Benkt Ake Benktsson, the enormously fat, brilliant actor and mask collector associated with the Gothenburg State Theater; Axel Fredenholm, the poet whose book he illustrated, and Vilhelm Lundström, the distinguished old professor, publisher, and statesman.

Borg was a prominent member of the community, the eminent Swedish American artist who had come home, but he was not at home in Sweden for long. The euphoria of the new beginning did not survive the climate, the confinement of the war, or the closer association with his bride.

Borg's joy in the fictional Mona Lisa of his own high craving could not last.

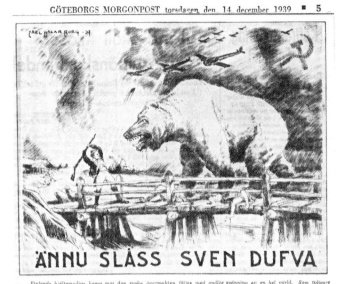

ÄNNU SLÅSS SVEN DUFVA

Finlands hjältemodiga kamp mot den ryska övermakten följes med andlös spänning av en hel värld. Som tidigare omtalats komma göteborgskonstnärerna att anordna en utställning till förmån för hjälp åt Finland. Den svensk-amerikanske konstnären Carl Oscar Borg deltar i denna utställning med en duk "Ännu slåss Sven Dufva", som han just i dagarna lagt sista hand vid, och till vilken GMP erhållit reproduktionsrätt.

Vi publicera här ovan ett foto av den märkliga duken. Här om någonsin kan det vara på sin plats, att använda den annars så nötta frasen, att "bilden talar för sig själv". Men vad konstnären här har skapat är en så suggestiv skildring av de ödesbetonade folkstormar från Asien i den ryska björnens skepnad som nu jaga fram över Finlands gränser, att alla kommentarer må anses överflödiga.

"Sven Dufva is still fighting."

In all marriages, sooner or later, the partner becomes revealed in his or her complexity, and Borg soon learned that Lilly was not only gifted, lively, intelligent, and beautiful, but also self-willed, determined, realistic, stubborn, and a manager accustomed to having her own way. Borg throughout his life moved up and down the social scale, was as much at home with cooks as scholars, beggars as millionaires. Lilly was more rigid, conscious of class and social position, interested in maintaining her special rank as wife of a famous artist. She was not one of the world's simple people whom Borg so admired. The very qualities in which Lilly and her family took pride, her managerial skills, her business sense, her ability to make money, became a source of disappointment. Money had always been needed, but was always essentially unimportant, not one of the things that really counted for Borg, but money interested his wife.

Less than a year after their marriage, a discerning critic writing in the *Elfsborgs Läns Annonsblad* commented that Borg's "charming wife seems . . . to be the finance minister and economic expert. One can almost believe that she is more enthusiastic for her husband's paintings than he is himself." With Lilly

Carl Oscar Borg in Gothenburg, Sweden, 1944.

as manager, Borg had no financial worries, but he came to resent being "paraded about like a trained bear."[7]

Less than two years after their marriage, Borg wanted to return to America. Lilly was willing, but it was too late. He had not taken the decisive step in time. War blocked them in Sweden.

An American citizen, not bound by Sweden's neutrality, Borg occasionally performed a service passing information from Pearl Buck's daughter in Czechoslovakia to the American Consul. But his life in Gothenburg was largely the settled and routine life of a family man bound by wife, relatives, and friends. On March 3, 1944, his sixty-fifth birthday, a poem written by "a friend of your art, one of many," was published in *Göteborgs Posten*. The author thanked Borg for all that he had been and done, and wished him luck now and for all eternity.

Borg enjoyed the good wishes and respect of friends and admirers; he enjoyed his extended family, but he resented routine, chaffed at confinement, and keenly felt his fall out of love. In letters written to his young Danish nephew, John Villadsen, his "little Indian," he called himself "Sitting Bull," and, much to the child's surprise, confided that he was very sad. He confided as much to friends in America, W. Edwin Gledhill and Harry Lorenzen. They were less surprised. Gledhill theorized that Borg's unhappiness lay in the fact that "Lilly and

Madeline were of the brittle objective-type beautiful. . . . If Borg, the Poet and Dreamer, had married a woman with these same qualities, he might have achieved real happiness."[8]

Borg did not communicate his feelings to his wife. Lilly had noted his extraordinary enthusiasm during their courtship. "So completely had he fallen in love that he lost his objectivity—something Borg rarely did—and laboured under the impression that he was going through an experience unique in the annals of mankind." Now she attributed the change she saw in him to the fact that he was "an explosive, footloose kind of man," and when he could not travel, he felt "a sense of claustrophobia," as though he were "in jail." His "hasty temper," and "fits of depression," made her think that the sculptor, David Edström, might have been describing her husband when he wrote in *Testament of Caliban*, "Just as a child in the dark is seized with terror, so I was driven into these moods at the slightest provocation. Ideas of persecution of every imaginable kind began to haunt me, and only my strong will made it possible to associate with others. I was mentally more desperately ill than I had ever been physically."

She thought that Borg was "very pleasant to live with," but during the long, cold winters when he became ill, as he often did with colds and rheumatism, he was "an extremely difficult man. . . . Nothing pleased him."[9]

He drank afternoon coffee with his wife and friends, put on weight, listened to the war news on the radio, and longed for California. He also drank the traditional drink of the Scandinavian winters, sometimes disguising it in a bottle of fruit juice, Pommac, so that his wife, who kept a firm hand on the bottles as well as the money, would not know. On at least one occasion, Borg and a friend sat in the kitchen together and were "both so loaded they didn't know in from out,"[10] when Lilly, hearing the sounds of their laughter, came rushing in. Her delight in seeing the "fruit juice" and her, "I told you you could have a good time without liquor!" added to the fun. One took one's pleasure as one could during the endless Gothenburg winters.

Friends wrote from California, sorry that he had not returned in time, aware that he was "overwhelmed by moments of longing and loneliness," adding, "The loneliness has always been with you. It is in your painting."[11]

Borg wrote that "nothing [was] more beautiful than California."[12] He worried that great changes had occurred during the years that he had been away, but he still hoped to return to California.

In the spring of 1945 when the war seemed about to end, Borg prepared to return to America. He had begun to make gifts of pictures to Swedish museums and institutions in the thirties; in December 1936 he gave seven water colors

and eighteen etchings of the Southwest to the Gothenburg Ethnological Museum; he gave an etching of the Navajos to the University of Lund, an oil painting, *On the Rim of the Grand Canyon* to the Vänersborg Museum, and an oil, a Dalsland landscape, to the Folkskola in Grinstad. The latter gift had been cause for celebration, a gathering of the townspeople, a prayer by the minister, a singing of the hymn *Härlig är jorden* (Beautiful Is the Earth), a violin solo, a poetry reading, and finally a talk by the artist himself who recounted amusing, fond anecdotes of his childhood in Grinstad.

Believing that the people of Sweden knew and cared more about the Indians than most Americans did, Borg presented a final gift to the National Ethnological Museum in Stockholm, a collection of approximately one hundred Indian artifacts—baskets, jewelry, blankets, pottery—collected in the Southwest from 1908 to 1930.

In June 1945, the prediction made by the Egyptian fortune teller thirty years earlier came true. The Royal Swedish Academy of Science awarded Carl Oscar Borg the Linné Medal in recognition of his gifts to Sweden. Borg was recognized for having provided—through his art, his verbal analyses, and the artifacts that he collected and presented to the Museum—a significant contribution for an understanding of the American Indian and the Southwest. The Swedes celebrated, momentarily at least, his achievements as artist, archeologist, and historian.

As so often in Borg's life, public success and honor walked on one level, his private life on another. The Linné Medal marked an extraordinary achievement for a poor boy from Grinstad, but the California of his youth inhabited his mind like the ghost of a benevolent past. Borg wrote friends in America that many honors had come to him in late years, but the greatest of all would be to be back in California. He moved from one dream to another, from the dream of love and home in Sweden to the dream of California, that utopian land in the sun. On the back of a watercolor sketch of a Western rider on a bucking bronco he wrote, "To my dear California, may she never die and may she never wake up from that 'state' which is California."

On July 17, 1945, alluding neither to honors nor utopias, he wrote to his old friend Edwin Gledhill in Santa Barbara:

> Dear Will—I was both surprised and glad to get your letter a short time ago. It takes such a long time for mail if it reaches one at all—well we have at least an end to the war, and slowly things will be better. We hope to get away sometime this year, and I hope that we will be in Califor-

On the Rim, Grand Canyon, **1932, drypoint etching, 32.7 x 30.5 cm. Collection Santa Barbara Museum of Art, California.**

nia before winter—I am sure I could never stand another European winter. . . . It was very interesting to hear about the property in Mission Canyon [Gledhill had purchased a home on Glendessary Lane.] I know of course where it is—and to think that you have gotten to be a collector of early American silver! Well, you know I have always collected something, even silver, sometimes it has paid, and sometimes not. But it has always been lots of fun! . . . I suppose I come back and find you in the Antique business! Well, maybe you can give me a job then—I am not so bad at that game as you know! or else I have to go back to house painting. According to the wages you mention, it would not be so bad.

Thank you for writing me. It is when one is far away that one appreciates to hear from an old friend. With the best of greetings. . . Always your friend, Carl Oscar Borg

On September 12, 1945, the Borgs sailed for America aboard the Swedish East Asia Company's freighter, *Tonghai.* Violent storms tossed the ship about like a "walnut." Lilly wondered if they would ever reach land. "We will soon find out. What is going to happen will happen," Borg reassured her, "and there is nothing we can do about it. Try to sleep; there is nothing to worry about."[13] Borg was not afraid of storms; they soothed him. "When nature is storming and howling then I feel comfortable myself."

THE LAST YEARS

1945-1947

On September 24, 1945, after an absence of seven years, Carl Oscar Borg was in New York again. As a married man, he could not stay at his club, the Salmagundi, but he filled out the newly required questionnaire for a nonresident membership. (The time of the independent, self-made man had given way to the age of regulated man.) He left blank questions regarding education and religion; in the spaces provided for degrees and art schools, he wrote a defiant "None"; to the question "under whom did you study" he penned a firm "Nobody." When asked what branches of art he practiced professionally, he had something to say: watercolor, oil painting, illustration, etching, instruction, and wood engraving. When asked to list awards and exhibitions, he had barely room on the page to fit them all.

Interviewed by Magda Måneskjöld for *SVEA* on his return to New York, Borg spoke of Sweden's experience of the war, of changes in New York, and of himself. He had no plans beyond returning to Santa Barbara and going back to his Indian paintings. Asked about the state of art now, he calmly observed, "The time of the old masters is finished."[1]

At the beginning of the thirties, Borg sustained the deep shocks that undermined his belief in his destiny as a great painter following in a hallowed tradition of master painters and his belief in himself as both worthy and capable of inspiring an enduring love. Inhabiting a changed, changing universe, he returned to his native land struggling to order his experience. Although his art remained essentially what it had been, ranging from the almost photographically realistic to the exquisitely simple, serene, deeply compassionate portrayal of man and nature, his poetry during the remaining years of his life recounted a spiritual odyssey, the counterpoint of the youth's early confident wanderings. He moved from despair and self-pity to extravagant hope, then to acceptance. When he returned to America he was not angry or defiant or despairing or even "ready to begin again." He was ready for death. He had seen "emptiness behind everything," but had drawn "strength from weakness" "and wisdom" too. At the age of sixty-six when Borg returned to California, he was estranged from the world that had evolved there—Santa Barbara was not, after all, Utopia, but a rapidly developing community full of cars and strangers—but at peace with himself.

During the enormously productive last year and a half of his life, although subject as always to lightning shifts of mood, he was prepared "to leave the one world, to see the other," ready "to meet the coming unknown." So many of his friends already had. Ed Borein had died during his absence, and William Wendt died soon after his arrival. He missed the "many old friends that have

passed away," but thought as he observed the society that had evolved that they "are happier than we are."

> These times are only for the young ones who don't know the time when the "machine" was of little importance and everybody worked by hand, and glad to have work. This is the age of gloves and don't soil your hands, but it has made no one happy! As far as I can see, there is far more unhappiness now than there was in my childhood. Then people had too much to do to be unhappy. Now time seems to be a burden for everyone.

Perhaps the superstitious adults were right that Christmas in Sweden; the child's vision of the horse-drawn carriage crossing before his eyes, his despair when he could not capture and hold the apparition may have been an omen. The horse and carriage did disappear in the course of Borg's life. Displaced by the machine, its passage could not be stayed. An adult, Borg did not weep at the loss, but he recorded his concern with and suspicion of the machine, the vision destroyer.

Early in the century he had been moved by the sight of an old Indian couple watching an airplane perform in the Los Angeles sky. Their extraordinary dignity touched something deep in himself. As the century progressed, he became increasingly concerned with the relationship of money, man and machine, with man's diminished self. The machine displaced the horse in the thirties; in the forties, Borg saw the danger of its displacing man.

> The machine age is no blessing for man. The progress of technological culture makes us more dependent on machines; in other words, we ourselves shall be drowned, and that is really dangerous.

Borg anticipated the day when the automobile, a vehicle of destruction, would come and "hit the old Indians who cannot move out of the way fast enough." In December 1945, less than a month after his return, the *Santa Barbara News Press* reported that Borg had been hit by a car while crossing the street. He was taken to the hospital "for treatment of a large cut on his head and for observation of other possible injuries."

There was a string in his heart, he wrote in *The Hospital,* "a string with a dizzy tone./It sings about everything." He was not afraid. "They say death is good./As yet I have courage—free./But who, in eternity, will be my friends?"

Borg was never really strong again. His heart weak, "mildewed through to the marrow of his bones"[2] by the long winters in Sweden, he was subject to colds and suffered attacks of pleurisy. He knew, and the knowledge brought no comfort to him who had dreamt of a perfect love, that his wife could manage without him, that she would not grieve long. Lilly had declared soon after their arrival that "even if [Borg] goes back to Sweden, I am going to stay here because I love it already."[3]

They bought a house on East Padre Street from Captain McGuire, Borg's friend from seal fishing days. Borg's studio was on the second floor. He did not need to paint for his livelihood; he was no longer interested in exhibitions, but he painted for his own ease and pleasure, to be alone with himself. He didn't venture forth on painting trips now, but worked from a file of sketches, using Ed Borein's old paints and brushes, enthusiastically sharing the results of a good day's work with his wife and neighbors. Sometimes a craftsman, a carpenter, or stone cutter who had helped him build his "Château" on the Mesa in 1918 would come for a visit, and they would settle down in the privacy of Borg's studio-retreat to talk about the old days.

In the last year of his life, in a Swedish prose as eloquently simple as his small watercolors of Sweden, Borg began to write his autobiography. He brought it to the year 1908. It begins with an Old Swedish saying: "Jag vill vara som jag är, sade igelkotten när älvan ville göra en gräshoppa av honom." (I want to be what I am, the porcupine said when the elf wanted to change him into a grasshopper.) In English, he wrote a final poem; he dreamt of himself as a heavy-eyed Buddha by a singing stream, "a figure of stone with only a thousand years' smile for life's births and deaths, its sorrows and pains."

On April 10, 1947, he wrote a "Dear friend of the long ago," Eva Lummis DeKalb, to tell her that he had had a hard time since November; he was unhappy; he could not go on further; he had heard from Turbesé, his "medicine man," a few days ago. "Please send her my love. . . . Tell her her medicine will reach me." He hoped before he "pan[ned] to regions unknown," that they would meet again.

On April 14, Inga and Stanley Lawson (then American consul in Copenhagen) came for an extended visit. On May 6, they suggested a trip to San Francisco. Borg urged Lilly to go, but he wanted, he said, to remain in Santa Barbara "to rest, to be alone, to paint."[4] Lilly pressed to know if that were the only reason he would not join them. He paused, then slowly answered, "No, everyone I knew in San Francisco is dead, and I don't want to go there."

On May 7, as the taxi taking the travellers to the station pulled away from the house, "Lilly looked back and waved, wanting to go back, feeling that she should." She did not, however, in spite of the fact that a recent attack of pleurisy had left her husband "weakened and debilitated and his heart, which was not good, was now worse than ever."[5]

That night, alone, as he said he preferred to be, and depressed, Borg paid a visit to Lucille Borein. As the two old friends sat together in the familiar living room, full of mementos of earlier, happier days when Ed was alive and life full of promise for them all, Borg confided that "he was so unhappy that he was considering a divorce."[6]

He spent the following day, May 8, painting in his studio. In the evening, dressed in his now customary heavy tweed jacket, cowboy boots, and felt cowboy hat, he walked down to the Casa de Sevilla to eat his favorite Spanish food. He was stricken with a massive heart attack in the restaurant and died in the ambulance on the way to the hospital.

A simple memorial service was held, according to Borg's wishes, in a little chapel near the Biltmore Hotel in Santa Barbara. A minister recited a Swedish child's prayer, "God who loves his children all, watch o'er me who am so small. Wherever I may wander, still I am in God's hands"; a violinist played early Spanish folk songs.[7] He had asked that his ashes be given to the wind and the dust in the Grand Canyon, and they were. There he joined his God and the spirits of the Native Americans who had made the same migration for ages.

THOUGHTS

Dead, but the sun still shines,
Dead, but the spring wind
Rustles in the trees,
Pairs of lovers wander
Up the paths.
The world goes on.
Many cry and suffer.
Lilacs in the spring's
Warm air smell
Divine through the open window.
The smell comes into the room
Where my writing desk stands
Full of yellow paper,
Old books,
Thoughts from my life's day.

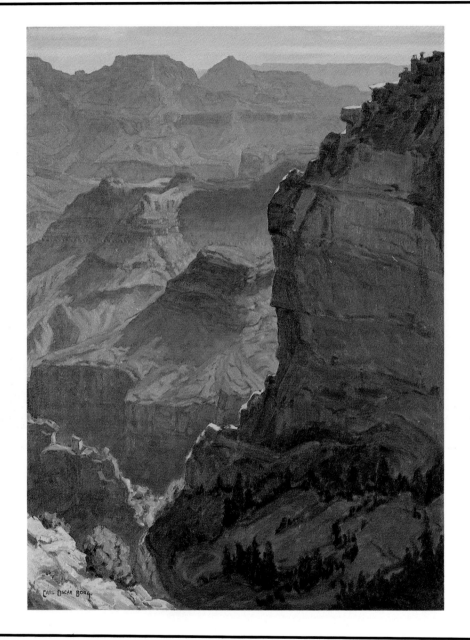

Grand Canyon, oil, 101.8 x 76.5 cm. Collection The National Museum of American Art, Smithsonian Institution.

El Cerro, 1909, oil, 71.1 x 91.4 cm. Privately owned.

The Lone Rider, 1920, oil, 45.7 x 60.8 cm. Paul R. Maybury Purchase Prize. Collection The Museum of History, Science and Art, Los Angeles.

.end

.end

Landscape, Santa Barbara, 1907, oil, 49.5 x 75 cm. Collection Gallery 29, Wisconsin.

Wagon and Sand Dunes, Santa Barbara Islands, **1907, oil, 40.6 x 58.4 cm. Privately owned.**

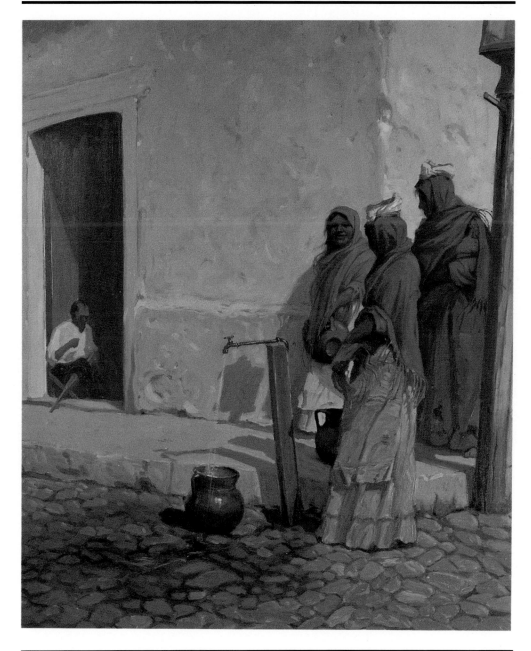

Street Scene in Tegucigalpa, Honduras, 1909, oil, 91.4 x 71.1 cm. Collection Lowie Museum of Anthropology, University of California, Berkeley.

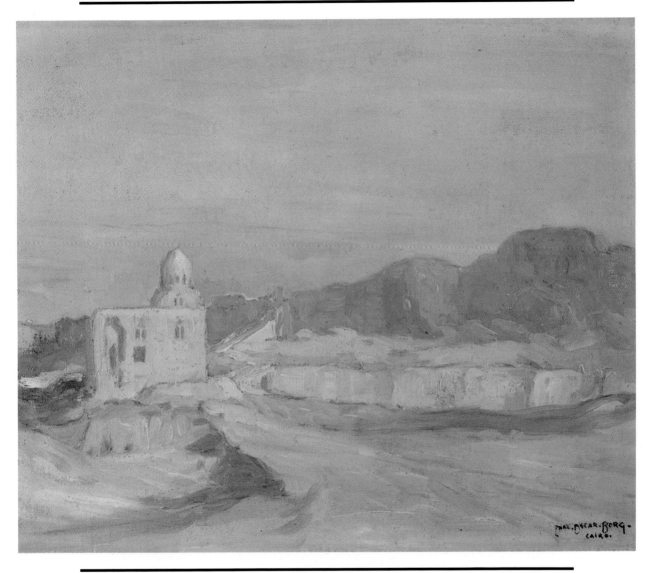

Hills of Mokattam, Cairo, 1911, oil on board, 25.4 x 32.4 cm. Collection Gallery 29, Wisconsin.

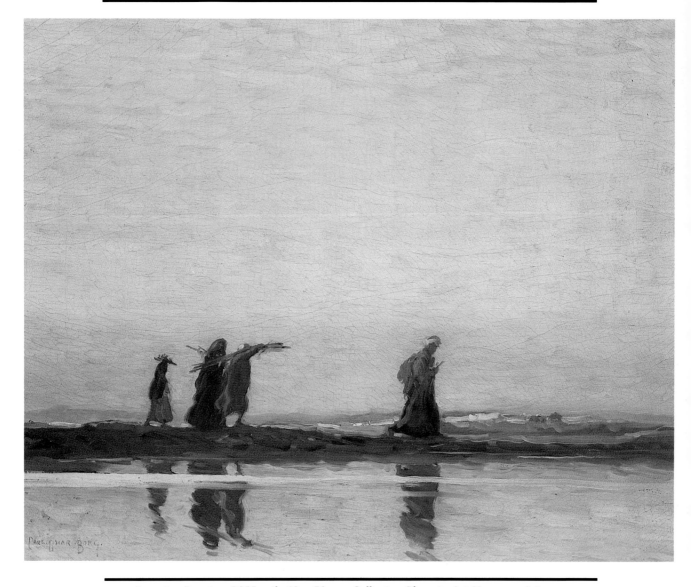

Egyptian Evening, 1911, oil, 40 x 50 cm. Collection Phoenix Art Museum, Arizona.

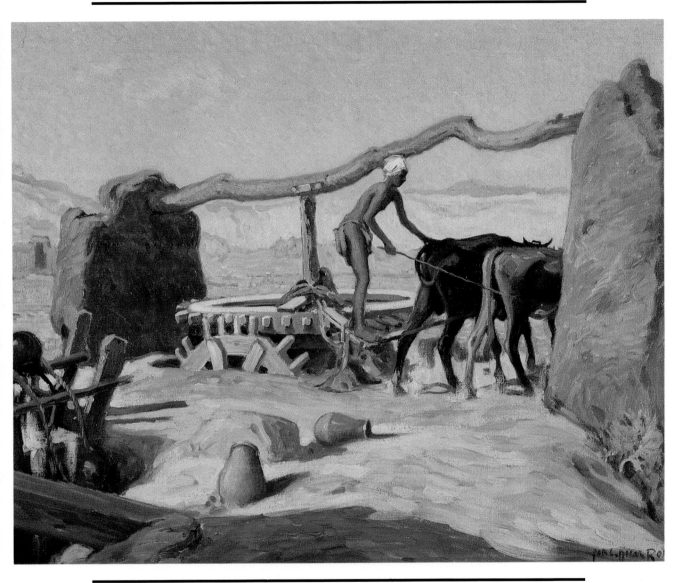

The Waterwheel, Egypt, 1911, oil, 61 x 81.3 cm. Collection Gallery 29, Wisconsin.

Egyptian Village, Luxor, 1912, oil, 91.5 x 119.4 cm. Collection Lowie Museum of
Anthropology, University of California, Berkeley.

Dance at Walpi (Festival in HopiLand), 1918, 63.5 x 76.2 cm. Black Prize for best picture in
nonlandscape category. Collection Los Angeles Athletic Club.

Left: *Ed Borein on Rancheros Ride,* 1946, gouache, 35.6 x 25.4 cm. Collection Earl C. Adams
Right: *Grand Canyon*, oil, 48.2 x 34.4 cm. Collection Katherine Haley. Below: *The Niman Kachinas*,
1920, oil, 119.4 x 132.1 cm. The Anschutz Collection.

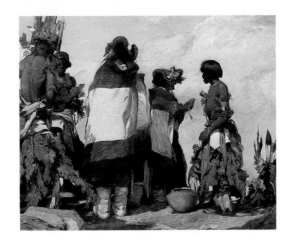

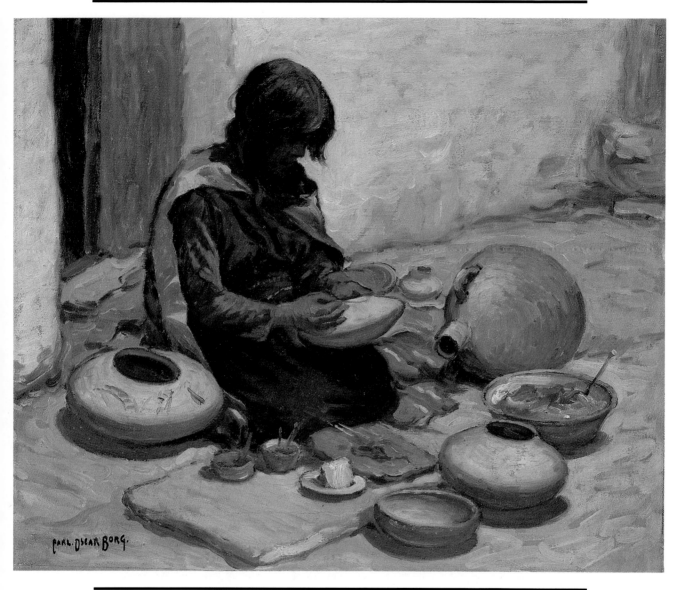

Hopi Potter, Nampejo, 1920, oil, 38.1 x 44.5 cm. Collection Jess La Dow.

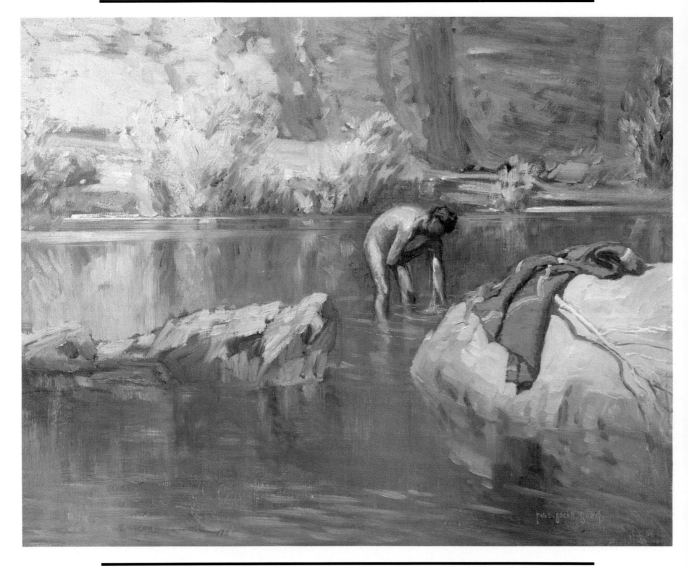

Indian Bather, oil, 40.6 x 50.8 cm. Collection Charles M. Russell Museum, Montana.

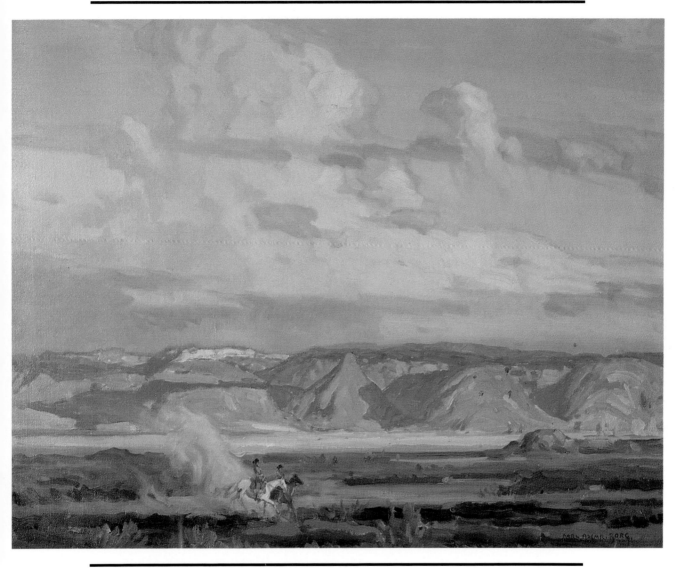

The Badlands, Arizona, 1924, oil, 63.5 x 76.2 cm. Silver Medal Painters of the West.
Collection Earl C. Adams.

Pueblos, oil, 40.6 x 50.8 cm. Collection National Cowboy Hall of Fame and Western Heritage Center, Oklahoma.

The Rainmakers, 1928, oil, 96 x 102 cm. Collection William Cushing Whitridge.

Navajos, gouache, 76.2 x 101.6 cm. Collection Mr. and Mrs. Jules Delwiche.

Canyon de Chelly, oil, 124.5 x 101.6 cm. The Anschutz Collection.

The Red Rock Wall, Canyon de Chelly, oil, 76.2 x 86.4 cm. Collection
Mr. and Mrs. Martin Kodner.

California Landscape, Santa Ynez near Santa Barbara, oil, 75 x 101 cm. Collection Helen and
David Laird.

On the Edge of the Desert, Tuba, Arizona, oil, 70.0 x 76.2 cm. Collection
Howard Woodruff family.

Desert Sunset, pastel, 17.8 x 24.1 cm. Collection Philip W. Johnson.

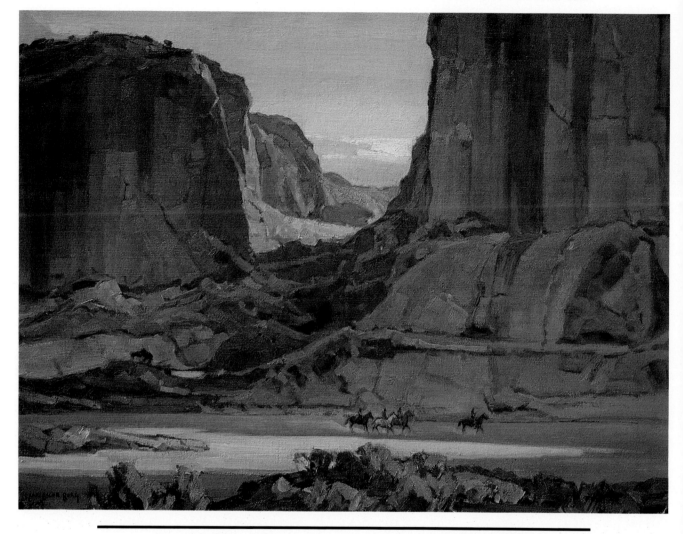

Canyon de Chelly, 1932, oil, 76.2 x 101.6 cm. Collection John Villadsen.

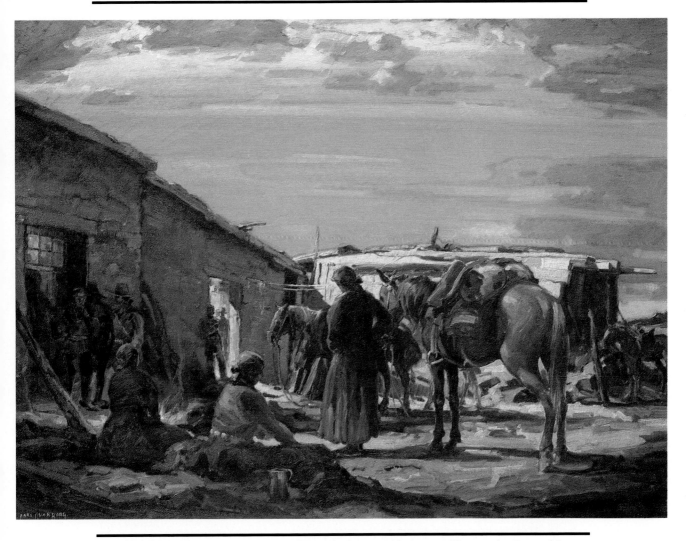

Navajo Trading Post, Ganado, 1932, oil, 76.2 x 101.6 cm. Collection the Honorable
Barry Goldwater.

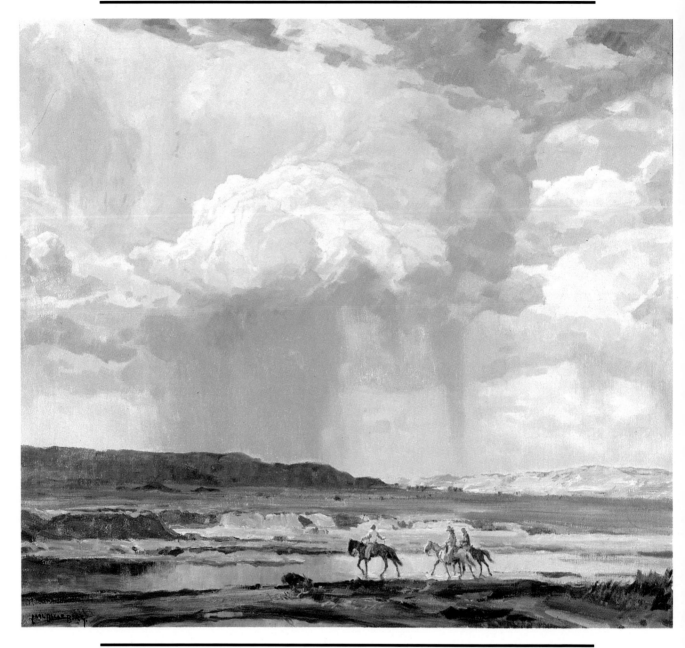

Summer Storm, Arizona, 1934, oil, 91.4 x 101.6 cm. Collection Helen and David Laird.

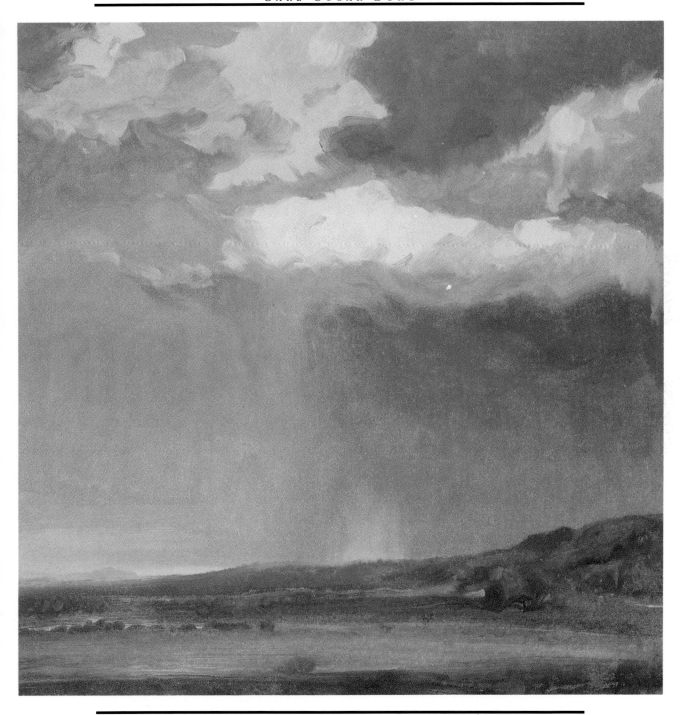

Spring, Cimarron, New Mexico, 1935, colored monotype, 25.4 x 25.4 cm. Privately owned.

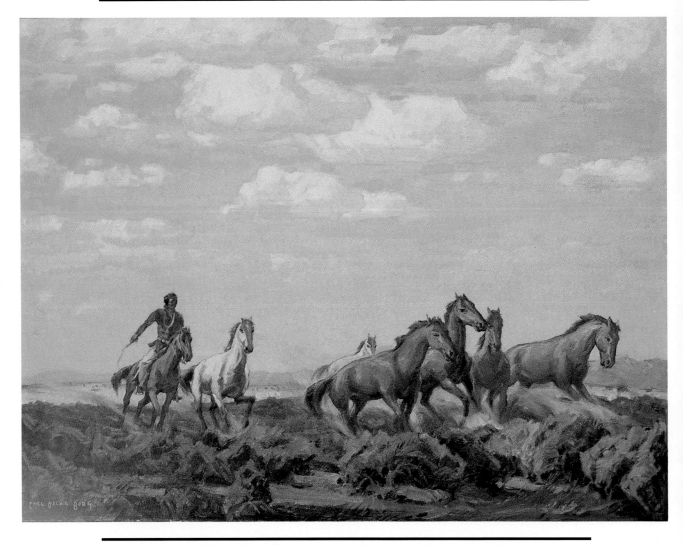

Navajo with Wild Horses, 1946, oil, 76.2 x 101.6 cm. Collection Jules Delwiche, Jr.

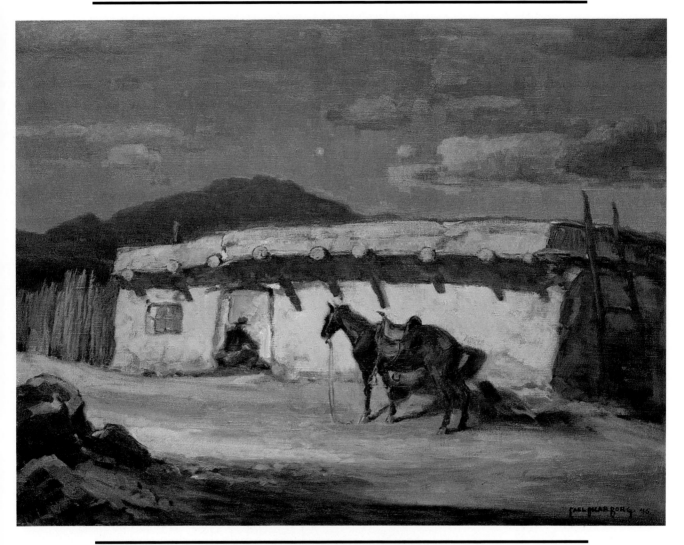

Indian Trading Post (Arizona Night), 1946,
76.2 x 101.6 cm. Collection Mr. and Mrs. Jules Delwiche.

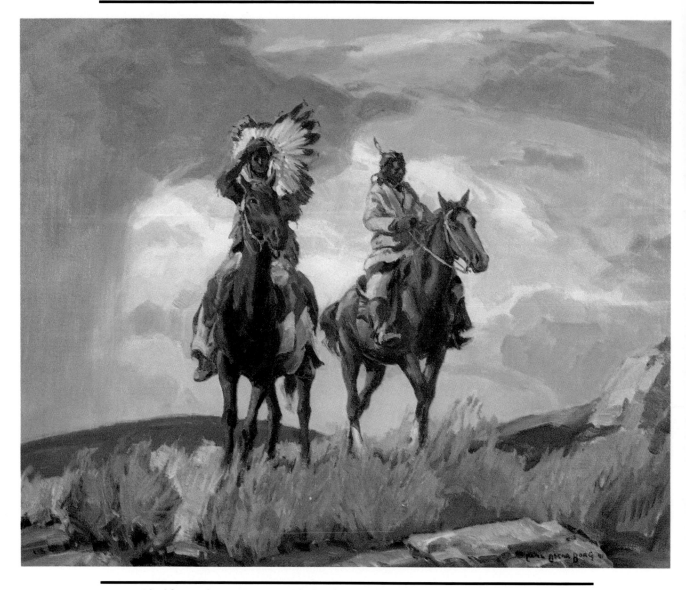

Blackfoot Indians, Montana, 1945, oil, 63.5 x 76.2 cm. Gallery 29, Wisconsin.

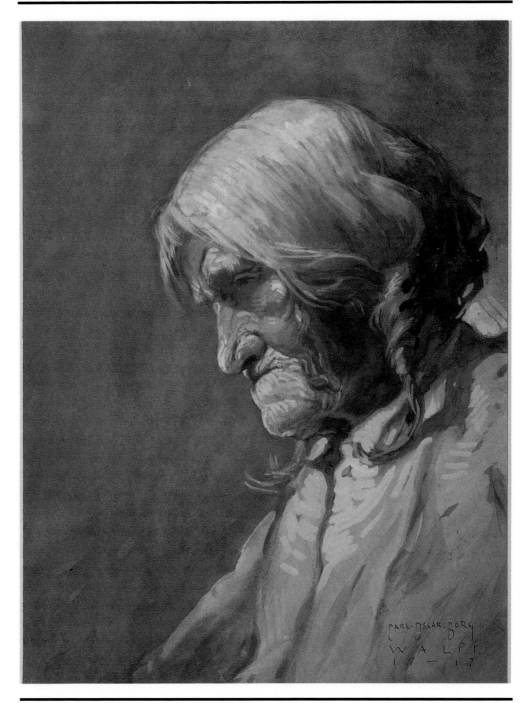

Sa-la-ko, 1917, oil, 55.9 x 43.2 cm. Collection Lowie Museum of Anthropology, University of California, Berkeley.

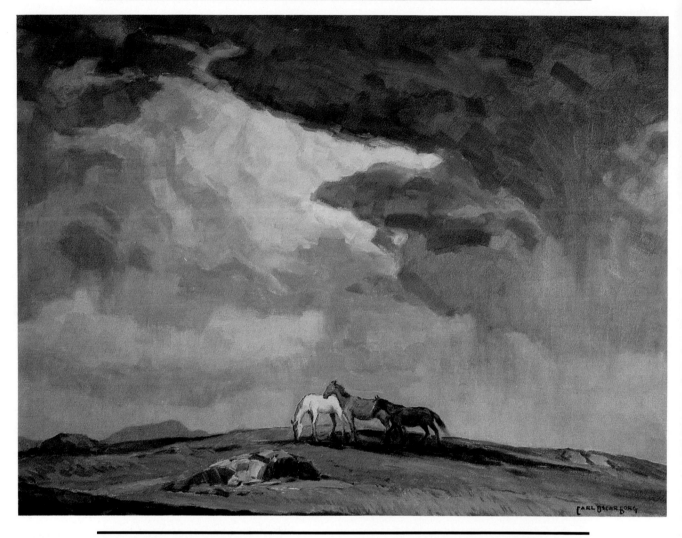

Wild Horses, Nevada, 1946, oil, 76.2 x 101.6 cm. Collection John Villadsen.

NOTES

Major Sources

Quotations in chapters 1 through 4 dealing with Borg's childhood and youth are from the manuscript (MS.) of Borg's uncompleted autobiography. Author's translation. Author's possession.

Quotations from Borg's diaries are from Ms. Lilly Borg Elmberg, "Carl Oscar Borg, The Wanderer." Author's possession.

Quotations from Borg's poetry are from MSS. Author's translation—where necessary. Author's possession.

Quotations from Borg's essays are from MSS. Author's possession.

Quotations from Borg's letters to Lilly Lindstrand are from MSS. Author's translation. Author's possession.

Quotations from Hugh Gibson's letters to Mary Gibson and to Carl Oscar Borg are from MSS. in the archives of the Hoover Institute. Quoted by permission of Michael Gibson.

Quotations from Borg's letters to Hugh Gibson are from MSS. in the archives of the Hoover Institute. Quoted by permission of Lilly Borg Elmberg.

Quotations from Borg's letters to Phoebe Hearst are from MSS. in the Bancroft Library of the University of California, Berkeley. Quoted by permission.

Quotations from Phoebe Hearst's letters to Carl Oscar Borg are from MSS. formerly in possession of Lilly Borg Elmberg. Quoted by permission of Lilly Borg Elmberg.

Quotations from Gustavus Eisen's travel notes and letters to Phoebe Hearst are from MSS. in the Bancroft Library of the University of California, Berkeley. Quoted by permission.

Quotations from Charles Lummis's letters to Carl Oscar Borg, and Borg's letters to Lummis are from MSS. in the Library of the Southwest Museum. Quoted by permission.

Quotations in Chapter 12 are from the oral history of Saimi Lorenzen. Quoted by permission.

Quotations from newspaper articles are from clippings in Borg's scrapbooks. Author's translations—where necessary. Author's possession. Most dates, where available, are cited in the text. A few quotations are from unidentified newspaper clippings. The rigorous regard for chronological order that Borg maintained

in his scrapbooks enabled the author to draw on these sources with confidence as to their proper sequence.

Quotations not otherwise indentified are from unpaginated Borg MSS. in the author's possession.

Completed citations are located in the bibliography.

CHAPTER TWO

1. From David Edström's introduction to George Liebling's Cantata, *Nuestra Señora. La Reina de Los Angeles*, n.d., cited in *Los Angeles Evening Herald*, October 24, 1930.

CHAPTER THREE

1. Robert Louis Stevenson, quoted on title page of *Twelve Good Men and True*.

2. Mary Austin, *California, the Land and the Sun*, p. 32.

3. Ralph Waldo Emerson, *Miscellanies*, p. 319.

4. William Lees Judson, "The Dawn of the Spiritual Era," *Arroyo Craftsman*, October 1901, p. 55.

5. Austin, op. cit., pp. 38-40.

6. Mary Gibson was the driving force behind the first bill successfully sponsored by the California Federation of Women's Clubs. The bill, signed into law in 1901, exempted the meadowlark as a game bird. In the book plate he executed for the Gibsons, Borg included symbols documenting their history: the covered wagon by which they traveled West; the bear, symbol of the state; the California black oak, *Quercus kelloggi*, named for Mrs. Gibson's uncle who discovered and classified the tree; and the first notes of *The Song of the Lark* in recognition of Mrs. Gibson's efforts to preserve the bird. The notes, do-si-la-mi, carry a message. Birds and books were "docile(s) ami(s)" for Mary Gibson and her friends.

7. Charles Lummis, motto for *Out West* magazine.

8. Letter from Eva Lummis to Lilly Borg Elmberg, MS., Lilly Borg Elmberg, "Carl Oscar Borg, the Wanderer," p. 67.

9. Turbesé Fiske and Keith Lummis, *Charles F. Lummis: The Man and His West*, p. 166.

10. Elmberg, p. 67.

11. MS. letter from Charles Lummis to Carolyn Severance, February 24, 1908, Severance Collection, the Huntington Library.

12. MS. letter from Lummis to Severance, October 1, 1908, Severance Collection, the Huntington Library.

CHAPTER FOUR

1. Antony Anderson, *Los Angeles Times*, December 16, 1906.

2. *L.A. Times*, November 18, 1906.

3. Hector Alliot, *Los Angeles Examiner*, November 16, 1906.

4. Alma May Cook, *William Wendt and His Work*, n.p.

5. MS., Borg autobiography.

6. *Mary S. Gibson, Pioneer,* anon., publication of the Friday Morning Club, p. 20.

7. *Los Angeles Express,* January 11, 1908.

8. *The Evening News,* April 1908.

9. Everett C. Maxwell, "The Structure of Western Art," in *Art in California,* p. 34.

10. Ibid., p. 36.

11. John Borglum, "An Artist's

Paradise," *Land of Sunshine,* May 1895, p. 106.

12. MS. W. Edwin Gledhill, diary and journal, April 23, 1955, p. 6.

13. Everett C. Maxwell, "Southern Republics Abuse Monroe Doctrine," unidentified newspaper clipping in Borg's scrapbook.

14. Alma May Cook, *L.A. Express,* clipping from Borg's scrapbook, n.d.

15. Antony Anderson quoting Borg in the *L.A. Times,* Borg's scrapbook, n.d.

16. Elizabeth Waggoner, "Art Notes," unidentified clipping, Borg's scrapbook.

17. Turbesé Lummis to Lilly Borg Elmberg, Elmberg, p. 72.

CHAPTER FIVE

1. MS., Phoebe Hearst to Carolyn Severance, July 9, 1912, Severance Collection, The Huntington Library.

2. MS. letter Phoebe Hearst to Orrin Peck (undated), Peck collection, The Huntington Library.

3. Eva Lummis to Lilly Borg Elmberg, Elmberg, p. 71.

4. MS. Turbesé Lummis, "Recollections of Carl Oscar Borg, n.d., Keith Lummis Collection, quoted with his permission.

5. MS. Turbesé Lummis.

6. Turbesé Lummis to Lilly Borg Elmberg, Elmberg, p. 72.

7. Eisen explored the Pacific Coast from Guatemala to Canada. He described ancient sculptures in Guatemala, worms in Canada, and the Indians of the Santa Barbara Islands. He helped develop the raisin and fig industries in California; was honored in Sweden, receiving the Commander of the North Star award, and in America, where, in recognition of his role in the creation of the Sequoia National Park, a mountain in the Great Western Divide was named Mount Eisen.

CHAPTER SIX

1. MS. letter from Mrs. M. K. Swingle to the author, March 1976.

2. Charles Terrasse, *French Painting in the XX Century,* p. 18.

3. Marshall Davidson, ed. *The Artist's America,* p. 303.

4. The term *modern art* has shifted in meaning. Gorecki used it in the sense that all critics used it in the first two decades of the century to refer to a contemporary, living artist, rather than to a school of art. Borg, who hated "modern art," was often referred to as "one of the best of our modern artists."

5. Hugues Balagny, *Le Chroniquer de Paris,* 20 juin, 1913.

6. *The Christian Science Monitor,* December 8, 1913.

CHAPTER SEVEN

1. *The Sunday Sun,* February 28, 1915.

2. Elmberg, p. 94.

3. Michael Williams, "The Pageant of California Art," *Art in California,* p. 52.

4. Everett C. Maxwell, "The Structure of Western Art," *Art in California,* pp. 33-36.

5. *Sunset Magazine,* August 1915, pp. 325-26.

6. Mary Austin, "Art Influence in the West," *The Century Magazine,* April 1915.

CHAPTER EIGHT

1. Lannie Haynes Martin quoting Borg in *L.A. Examiner,* February 29, 1920.

2. Idah Meacham Strobridge, *Miner's Mirage Land,* p. 42.

3. Some twenty years before Borg's admission to the Hopi Snake clan, Fernand Lungren, another Western artist, was admitted to the Snake

and Badger clans. Although Borg knew and admired the older artist's work, they were not personal friends. The two men had a good deal in common, however. Lungren was of Swedish descent, Lummis's contemporary and good friend; he was a member of the Garvanza circle and lived on Avenue 41 before moving to Santa Barbara in 1906. He too was a mystic and an idealist for whom the pantheistic nature worship of the Pueblo Indians was as meaningful and natural as it was for Borg. Theodore Roosevelt hung Lungren's pictures in the White House. Had the city of Santa Barbara located a home for them, the paintings in Lungren's own collection would now be available for the enjoyment of the people of Santa Barbara to whom he bequeathed them.

4. *Manes*—in the Roman religion, spirits of the dead. The Romans placated the manes with offerings at the graves of the dead. Obviously, the Indians did not know the Roman custom or term. Borg used the adjective to describe the symbol and function of the cane used by Indians.

5. Borg followed in a tradition of Western poet-painters. William Keith, "California's early day painter-poet and mystic," wondered "What true artist is not a poet?" Like Borg, Keith was an admirer of Swedenborg and a close personal friend of Lummis's. He was a member of the Board and contributor to the *Land of Sunshine* and *Out West* magazines. It was "up in the Sierras" that the older artist had heard "every sound of nature. That's where the music comes from." (See California Art Research Project W.P.A. 2874, v. 11, pp. 1-16.)

6. *San Francisco Examiner*, March 5, 1917.

7. Elizabeth Taft, "In the Studios and Galleries," *Everywoman*, April 1917.

CHAPTER NINE

1. Oral history, Saimi Lorenzen.

2. *The Daily News and Independent*, January 2, 1918.

3. *Santa Barbara Morning Press*, February 2, 1919.

4. Letter from Collier to Borg cited in Elmberg, p. 116. Collier was appointed Commissioner of Indian Affairs in 1933.

5. Amy Dudley, "Carl Oscar Borg's Pictures," *The Federation*, June 1922, p. 12.

6. *San Diego Sun*, June 17, 1919.

7. *American Magazine of Art*, December 1921, p. 414.

8. Thurman Wilkins, *Thomas Moran: Artist of the Mountains*, p. 239.

9. MS. W. Edwin Gledhill, Diary and Journal, April 23, 1955, p. 5. Keith Gledhill Collection.

10. Harold Davidson, *Ed Borein: Cowboy Artist*, p. 108.

CHAPTER TEN

1. Perley Poore Sheehan, *Hollywood as a World Center*, p. 112.

2. Borg became a member of the Academic Society of International History, Paris, in 1925.

3. Douglas Fairbanks, *Making Life Worthwhile*, p. 41.

4. Vachel Lindsay, *The Art of the Moving Picture*, p. 222.

5. Sheehan, pp. 90-91.

6. *California Sports Magazine*, January 1926.

7. Mordaunt Hall, "The Screen," *New York Times*, 1926.

8. Kevin Brownlow, *The War, the West and the Wilderness*, p. 245.

9. "Rating Film Entertainment

Values," *Film News,* November 12, 1927.

10. Alva Taylor, "The Black Pirate," *Liberty,* April 24, 1926.

11. MS. letter from Lummis to Borg, June 27, 1927, the Southwest Museum.

12. The 52"x60" oil is a larger and slightly modified version of the *Festival in Hopi Land* Borg exhibited in Los Angeles in 1918. The painting, now called *Dance at Walpi,* is in the permanent collection of the Montclair Art Museum, Montclair, New Jersey.

13. Ralph Hancock, Lelitia Fairbanks, *The Fourth Musketeer,* p. 220.

CHAPTER ELEVEN

1. Sloan's etching *Indian Detour* (1927) has as its theme the Harvey Bus Tours. Buses and a brainless mob of tourists dwarf the Indians performing their rites and the desert.

2. Walter Leighton Clark, *Leaves from an Artist's Memory,* p. 268. Clark, a friend of James T. Farrell, Andrew Carnegie, and Henry Pullman, held the patents on machinery to mass produce rifles and built factories which turned out $52 million worth of armaments during World War I. After the war, he turned to the artist-poets. "Their vision was deeper than science, unbounded by time and space."

3. Harry C. Bentley, "Foreword," *A Private Collection of Paintings by Some of the Living Artists of Southern California,* Fine Arts Association, Tucson, Arizona, n.d., p. 7.

4. Other artists present were: John Frost, Paul Lauritz, Colin Campbell Cooper, Orrin White, Theodore Van Soelen, Walter Ufer, Maurice Braun, and Gattardo Piazzoni.

5. Arthur Millier, *L.A. Times,* December 2, 1934.

CHAPTER THIRTEEN

1. Roosevelt's speech and other quotations from Lummis's "sermon" are from Charles Lummis, *Stand Fast Santa Barbara,* pp. 3-13.

2. Everett C. Maxwell, *Overland-Out West,* November 1932, p. 263.

CHAPTER FOURTEEN

1. Esaias Tegner, *Poems by Tegner,* p. 41.

2. "Dalslänningen malar Indianer at U.S.A. och dekorationer at Doug," *Provinstidningen Dalsland,* 29 juni 1934.

3. "Southland Art History Set Forth in Foundation Show," *L.A. Times,* August 5, 1934.

4. "Western Painters Make Bow in Museum Exhibit," *L.A. Evening Herald and Express,* January 6, 1935.

5. "May Show at Biltmore Salon," *Allied Artists,* Los Angeles, May 1935.

6. "Ökenmålaren Drar At Öster," *SVEA,* March 26, 1936.

7. Carlyle Burrows, "Notes and Comments on Events in Art," *Herald Tribune,* April 26, 1936.

8. Borg discounted another favorable review. Charles Offin (*Brooklyn Daily Eagle,* April 26, 1936) thought the frankly realistic pictures "excellent pictorial records of one of the most interesting sections of our country."

9. Måneskjöld, "Litteratur och Konst," *SVEA,* 10 juni, 1936.

10. Ibid.

CHAPTER FIFTEEN

1. Oral history, Saimi Lorenzen.

CHAPTER SIXTEEN

1. Borg quoted Goethe in German. "Wär' nicht das Auge sonnenhaft, Die

Sonne könnt' es nie erblicken. Läg' nicht in uns das Gottes eigne Kraft, Wie könnt' uns Göttliches entzücken?"

2. Widén, *Carl Oscar Borg, ett konstnärsöde,* pp. 146-48.

CHAPTER SEVENTEEN
1. Elmberg, p. 164.
2. Ms. W. Edwin Gledhill, p. 6.
3. Ms. letter to Reginald Vaughan, Santa Barbara Historical Society.
4. "Melleruds Första Konstutställning," Elfsborgs Läns Annonsblad, 7 Mars 1939.
5. "Konstutställningen," *Amåls-Tidningen,* 6 November 1939
6. Sixten Strömbom, Chief Curator, Department of Paintings, National Museum, Stockholm, objected not to the Swedish indifference to art, but to their "oft mentioned indifference to our fellow countrymen who have immigrated." In 1928, on a visit to the United States, he had "heard Borg's name mentioned with admiration in art circles around the country." Strömbom regretted that few Swedes were aware of Borg's achievements. "His name ought not to be forgotten among the immigrants who have brought honor to the Swedish nation." (Elmberg, p. 168.)
7. Oral history, Saimi Lorenzen.
8. Ms. W. Edwin Gledhill, p. 7.
9. Elmberg, pp. 164-68.
10. Oral history, Gunnell Elfwing.
11. Elmberg, p. 166.
12. Elmberg, p. 166.
13. Elmberg, p. 171.

CHAPTER EIGHTEEN
1. "Carl Oscar Borg Tillbaka i Amerika," *SVEA,* October 4, 1945.
2. Oral history, Saimi Lorenzen.
3. Litti Paulding, *Santa Barbara News Press,* November 1945.
4. Elmberg, p. 174.

5. Elmberg, p. 173-75.
6. Ms. journal of W. Edwin Gledhill, p. 6.
7. Lummis introduced Borg to the Spanish songs which Lummis collected and published under the title *Spanish Songs of Old California.* Borg passed out subscriptions for the book in Santa Barbara, and on November 2, 1923, Lummis wrote to thank him. "Thanks for the subscriptions to *Spanish Songs of Old California.* I am so happy in the hope that I shall be able to bring out a similar book next year—and perhaps two more later—so that I shall eventually have saved a pretty handsome bunch of these Flowers of our Lost Romance."

Lummis had named old friends, the artists William Wendt, Maynard Dixon, and Carl Oscar Borg, honorary pallbearers at his funeral. A violinist played a liturgy of old Spanish songs then. Almost twenty years later, at Borg's own memorial service, the music recalled the past they had shared in Los Angeles, that corner of the Magic Region, where, for a while, the romantic spirit lingered into the twentieth century.

BIBLIOGRAPHY

BOOKS

Ainsworth, Ed. *Painters of the Desert.* Palm Desert, California: Desert Magazine Publishers, 1960.

Anderson, Antony. "William Wendt, Painter of California Landscape," *William Wendt and His Work.* Los Angeles: Stendhal Art Galleries, 1926.

Austin, Mary. *California, The Land of the Sun.* London: Adam and Charles Black, 1914.

_____ . *Country Without Rain.* Boston and New York: Houghton Mifflin, 1903.

_____ . *Earth Horizon.* Cambridge and New York: Houghton Mifflin, 1923.

_____ . *Land of Little Rain.* Boston and New York: Houghton Mifflin, 1903.

_____ . *Love and the Soul Maker.* New York: D. Appleton and Company, 1914.

_____ . *Starry Adventure.* Boston and New York: Houghton Mifflin, 1931.

Bancroft, Hubert Howe. *Retrospection, Political and Personal.* New York: The Bancroft Co., 1912.

Bandelier, Adolph Francis Alphonse. *The Delight Makers.* New York: Dodd, Mead and Co., 1890.

_____ . *Final Report of Investigations among the Indians of the southwestern United States. Papers of the Archeological Institute of America, American Series III, IV.* Cambridge, Mass. J. Wilson and Son, 1890-92.

_____ . *The Romantic School in American Archeology.* New York: Trow's Printing and Bookbinding Company, 1885.

Berger, John A. *Fernand Lungren.* Santa Barbara: The Schauer Press, 1936.

Berry, Rose V.S. *The Dream City: Its Art in Story and Sign.* San Francisco: W. N. Brunt, 1915.

_____ . *What Do You Know About American Art?* New York: The Club Corner of Scribner's Magazine, 1928.

Bingham, Edwin R. *Charles F. Lummis: Editor of the Southwest.* Los Angeles: The Huntington Library, 1955.

Binns, Henry Bryan. *A Life of Walt Whitman.* New York: E. P. Dutton & Co., 1905.

Bonfils, Winifred Black. *The Life and Personality of Phoebe Hearst.* San Francisco: John Henry Nash, 1928.

Borg, Carl Oscar. *Cross, Sword and Gold Pan.* Los Angeles: Primavera Press, 1936.

_____ . *The Great Southwest Etchings.* Santa Ana: The Fine Arts Press, 1936.

Brinton, Christian, ed. *Exhibition of Paintings by Ignacio Zuloaga.* New York: Redfield-Kendrick-Odell Co., 1916.

_____ . *Impressions of the Art at the Panama Pacific Exposition.* New York: John Lane Co., 1916.

_____ . *Modern Artists.* New York: Baker & Taylor Co., The Trow Press, 1908.

Brownlow, Kevin. *The War, the West and the Wilderness.* New York: Alfred A. Knopf, 1979.

Burdette, Robert J. *Los Angeles & Southern California.* Chicago: The

Lewis Publishing Co., 1910.

California Art Research. "William Keith." 1st Series, Volume 2, Abstract from W.P.A. Project 2874 O.P. 65-3-36-32; pp. 27-56.

Clark, James Albert. *A Theosophist's Point of View.* Washington D.C.: The Theosophical Society, 1901.

Clark, Walter Leighton. *Leaves from an Artist's Memory.* Camden, New Jersey: Haddon Craftsman, Inc. 1937.

Clover, Samuel Travers. *Constructive Californians.* Los Angeles: Saturday Night Publishing Co., 1926.

Collier, John. *The Indians of the Americas.* New York: W. W. Norton & Co., 1947.

_____. *On the Gleaming Way.* Denver: Sage Books, Allen Swallow, 1949.

Cook, Alma May. "William Wendt the Artist's Friend. *"William Wendt and his Work.* Los Angeles: Stendhal Art Galleries, 1926.

Cooke, George Willis, ed. *The Poets of Transcendentalism.* New York: Houghton Mifflin Co., 1903.

Cornelius, Brother, F.S.C., M.A. *Keith: Old Master of California.* New York: G. P. Putnam's Sons, 1942.

Cox, Kenyon. *Old Masters and New: Essays in Art Criticism.* New York: Fox, Duffield & Co., 1905.

Dash, Norman. *Yesterday's Los Angeles.* Miami, Florida: E. A. Seaman Publishing Co., 1976.

Davidson, Harold. *Ed Borein: Cowboy Artist.* New York: Doubleday & Co., 1974.

Davidson, Marshall B., ed. *The Artist's America.* New York: American Heritage Publishing Co., 1973.

De Bary, Richard. *Land of Promise.* New York: Longman, Green & Co., 1908.

Demarest, Phyllis Gordon. *Hollywood Gold.* New York: The Macaulay Co., 1930.

Dos Passos, John. *Henry Ford and William Hearst: Or, Tin Lizzie and the Poor Little Rich Boy.* San Francisco: Sherwood and Katherine Grover, 1940.

Doyle, Helen MacKnight. *Mary Austin: Woman of Genius.* New York, 1937.

Eastman, Charles A. *From the Deep Woods to Civilization.* Boston: Little Brown & Co., 1916.

_____. *Indian Boyhood.* New York: McClure, Phillips & Co., 1904.

_____. *The Indian Today.* New York: Doubleday Page & Co., 1915.

_____. *Red Hunters and the Animal People.* New York: Harper & Brothers, 1904.

Eisen, Gustavus. *The Great Chalice of Antioch.* New York: F. Kouchakji, 1933.

_____. *Portraits of Washington.* New York: R. Hamilton & Associates, 1932.,

Elder, Paul. *California the Beautiful.* San Francisco: Paul Elder & Co., 1911.

Emerson, Ralph Waldo. *Essays.* New York: Hurst & Co., 1885.

_____. *Miscellanies: Nature, Addresses and Lectures.* Boston: Phillips, Sampson, & Co., 1856.

_____. *Representative Men.* London: John Chapman, 1850.

Enoch, Reginald C. *The Great Pacific Coast.* London: Grant Richards, 1909.

Fairbanks, Douglas. *Making Life Worthwhile.* New York: Britton Publishing Co., 1918.

Fiske, John. *Through Nature to God.* Boston and New York: Houghton Mifflin, 1899.

Fiske, Turbesé Lummis, and Keith Lummis. *Charles F. Lummis: The Man and His West.* Southwest Museum Limited Edition: University

of Oklahoma Press, 1975.

Five Essays on the Art of Ignacio Zuloago. New York: The Hispanic Society of America, 1909.

Five Years of Theosophy. London: Theosophical Publication Society, 1894.

Fox, Charles Donald. *Mirrors of Hollywood.* New York: Charles Renard Corp., 1925.

Fryxell, Fritiof Melvin. *Thomas Moran, Explorer in Search of Beauty.* East Hampton, New York: East Hampton Free Library, 1958.

Garnett, Porter. *The Green Knight. A Vision.* Bohemian Club, San Francisco: Paul Elder & Co., 1911.

Gaston, Edwin W., Jr. *The Early Novel of the Southwest.* Albuquerque: University of New Mexico Press, 1961.

Gibson, Hugh. *A Journey from our Legation in Belgium.* New York: Doubleday Page & Co., 1917.

Gibson, Mary. *A Record of Twenty Five Years of the California Federation of Women's Clubs:* 1900-1925. Los Angeles: The California Federation of Women's Clubs, 1927.

Goddard, Pliny Earle. *Indians of the Southwest.* New York: American Museum Press, 1921.

Gordon, Dudley. *Charles F. Lummis, Crusader in Corduroy.* Los Angeles: Cultural Assets Press, 1972.

Grave, Friedrich. *Chaotica Ac Divina eine Metaphysische Schau: Schriftenreihe zur Neubegrundung der Naturphilosophie.* Jena: Eugen Diedericks, 1926.

Graves, J.A. *My Seventy Years in California.* Los Angeles: The Times-Mirror Press, 1927.

Grey, Zane. *An Autobiographical Sketch.* New York and London: Harper Brothers, 1928.

_____. *The Man of the Forest.* New York and London: Harper Brothers, 1920.

_____. *The Vanishing American.* New York and London: Harper Brothers, 1925.

Grierson, Francis. "La Révolte Idéaliste" in *Modern Mysticism.* London, 1899.

_____. *The Invincible Alliance and Other Essays.* New York: John Lane Co., 1913.

Hagstotz, Hilda Boettcher. *The Educational Theories of John Ruskin.* Lincoln: University of Nebraska Press, 1942.

Hancock, Ralph and Letitia Fairbanks. *The Fourth Musketeer.* New York: Henry Holt & Co., 1953.

Hassrick, Peter. *The Way West.* New York: Henry N. Abrams, Inc., 1977.

Hay, Emily Parkin Babcock. *William Keith as Prophet Painter.* San Francisco: Paul Elder and Co., 1916.

Hedin, Sven. *Grand Canyon.* Stockholm: Albert Bonniers Forlag Boktryckeri, 1925.

_____. *My Life as an Explorer.* Garden City, N.Y.: Garden City Publishing Co., 1925.

Hegeman, Elizabeth Compton. *Navajo Trading Days.* Albuquerque: The University of New Mexico Press, 1963.

Heindel, Augusta.*The Birth of the Rosicrucian Fellowship.* Oceanside, Ca.: The Rosicrucian Fellowship, 1923.

_____. *Mysteries of the Great Operas.* Oceanside, Ca.: Fellowship Press, 1921.

Heller, Nancy, and Julia Williams. *The Regionalists.* New York: Watson Guptill Publications, 1976.

Holls, Fredrick William, ed. *Correspondence Between Ralph Waldo Emerson and Herman Grimm.* Boston & New York: Houghton Mifflin and Co., 1903.

Hugh Gibson 1883-1954: Extracts from

his Letters and Anecdotes from his Friends. New York: Belgian American Educational Foundation, Inc., 1954.

Jacobs, Lewis. *The Rise of the American Film.* New York: Harcourt Brace & Co., 1939.

James, Edward, ed. *Notable American Women: 1607-1950.* Cambridge: Belknap Press Harvard University, 1971.

James, George Wharten, ed. *The California Birthday Book: Prose and Poetical Selections from the Writings of Living California Authors.* Los Angeles: Arroyo Guild Press, 1909.

————. *California, Romantic and Beautiful.* Boston: The Page Co., 1914.

————. *Living the Radiant Life.* Pasadena, Calif.: The Radiant Life Press, 1916.

————. *Through Ramona's Country.* Boston: Little, Brown & Co., 1909.

————. *What the White Race May Learn from the Indian.* Chicago: Forbes & Co., 1908.

La Follette, Suzanne. *Art in America.* New York: Harper & Brothers, 1929.

Lange, Charles, Carroll Riley, ed. *The South West Journals of Adolphe Bandelier.* Albuquerque: The University of New Mexico Press, 1966-1970.

Leadbeater, Charles Webster. *An Outline of Theosophy.* Los Angeles: Theosophical Book Concern, 1916.

Lillard, Richard G. *Eden in Jeopardy.* New York: Alfred Knopf, 1966.

Lindsay, Nicholas Vachel. *Adventures While Preaching the Gospel of Beauty.* New York: The Macmillan Company, 1916.

————. *The Art of the Moving Picture.* New York: The Macmillan Co., 1922.

Los Angeles. Los Angeles: The Frank Meline Co., 1929.

Los Angeles County Pioneer Society Historical Record and Souvenir. Los Angeles: Times-Mirror Press, 1923.

Los Angeles: What to See and How to See It. Los Angeles: Los Angeles Chamber of Commerce, 1915, 1917.

Lummis, Charles Fletcher. *Flowers of Our Lost Romance.* New York: Houghton Mifflin Co., 1929.

————. *The Land of Poco Tiempo.* New York: Charles Scribner's Sons, 1893.

————. *Mesa, Cañon and Pueblo.* New York: The Century Co., 1925.

————. *Spanish Songs of Old California.* Los Angeles: Lummis, 1923.

Lungren, Fernand. *Some Notes of His Life.* Santa Barbara: Santa Barbara School of the Arts, 1933.

Mahurin, John H. *History of Santa Barbara County.* ed. Owen H. O'Neill. Santa Barbara: Harold McLean Meier Pub., 1939.

Maeterlinck, Maurice. *Le Grand Secret.* Paris: Bibliothèque Charpentier, 1921.

Maxwell, Everett C., Bruce Porter, et. al., ed. *Art in California.* San Francisco: R. L. Bernier, 1916.

Meline, Frank. *Los Angeles, The Metropolis of the West.* Los Angeles: Francis H. Webb, 1929.

Mills, George. *Navajo Art and Culture.* Colorado Springs: Taylor Museum of the Fine Arts Center, 1959.

Moure, Nancy Dustin. *Art and Artists in Southern California.* Glendale, Ca.: Dustin Publications, 1975.

————. *William Wendt: 1865-1946.* Burbank, Ca.: T.L.C. Services, 1977.

Munk, Joseph A. *Arizona Sketches.*

New York: The Grafton Press, 1905.

Nash, Roderick. *Wilderness and the American Mind*. New Haven: Yale Univ. Press, 1967.

_____. *The Call of the Wild*. New York: George Braziller, 1970.

Neuhaus, Eugen. *History and Ideals of American Art*. Stanford, Ca.: Stanford University Press, 1931.

_____. *William Keith: The Man and the Artist*. Berkeley: The University of California Press, 1938.

Older, Fremont. *The Life of George Hearst*. San Francisco: John Henry Nash, 1933.

Powdermaker, Hortense. *Hollywood, The Dream Factory*. London: Secher and Warburg, 1951.

Powell, Lawrence Clark. *California Classics*. Los Angeles: The Ward Pitchie Press, 1971.

Rather, Lois. *West is West: Rudyard Kipling in San Francisco*. Oakland, Ca.: The Rather Press, 1976.

Remington, Frederic. *The Way of an American Indian*. New York: Fox, Duffield & Company, 1906.

Rolle, Andrew. *The Golden State: a History of California*. New York: Crowell, 1965.

Roosevelt, Theodore. *An Autobiography*. New York: Macmillan Co., 1913.

_____. *Ranch Life and the Hunting Trail*. New York: The Century Co., 1902.

Russell, Charles M. *Trails Plowed Under*. Garden City, N.Y.: Doubleday Page & Co., 1927.

Salsbury, Stephen, ed. *Essays on the History of the American West*. Hinsdale, Illinois: The Dryden Press, 1975.

Sheehan, Perley Poore. *Hollywood as a World Center*. Hollywood: Hollywood Citizen Press, 1924.

Southern California Writers' Project of the Writers' Project. New York: Hastings House, 1941.

Southworth, John R. *Santa Barbara and Montecito*. Santa Barbara: Orena Studios, 1920.

Spaulding, Edward Sheldon. *A Brief Story of Santa Barbara*. Santa Barbara: The Santa Barbara Historical Society, 1964.

Starr, Kevin. *Americans and the California Dream 1850-1915*. New York: Oxford University Press, 1973.

Stein, Roger B. *John Ruskin and Aesthetic Thought in America, 1840-1900*. Cambridge: Harvard University Press, 1967.

Stelzig, Eugene L. *All Shades of Consciousness*. Paris: Mouton the Hague, 1975.

Stoller, Leo. *After Walden*. Stanford, Ca.: Stanford University Press, 1957.

Strobridge, Idah Meacham. *The Land of Purple Shadows*. Los Angeles: The Artemesia Bindery, 1909.

_____. *The Loom of the Desert*. Los Angeles: Baumgardt Pub. Co., 1907.

_____. *Miner's Mirage Land*. Los Angeles: Baumgardt Pub. Co., 1904.

_____. *Stories from the Land of Sunshine*. Los Angeles: The Artemesia Bindery, 1898-1900.

Taft, Robert. *Artists and Illustrators of the Old West*. New York: Charles Scribners & Sons, 1953.

Tegner, Esaias. *Frithiof, a Norwegian Story from the Swedish of Esaias Tegner*. trans. R. G. Latham. London: T. Hookham, 1838.

_____. *Poems by Tegner*. New York: The American-Scandinavian Foundation, 1914.

Terrasse, Charles. *French Painting in the XX Century*. Trans. Evelyn Byam Shaw. London, Paris, N.Y.:

The Hyperion Press, 1939.

The Theosophical Movement 1875-1950. Los Angeles: The Cunningham Press, 1950.

Three Papers on "Modernist Art." New York: American Academy of Arts and Letters, 1924.

Tompkins, Walker A. *Santa Barbara Yesterdays.* Santa Barbara: McNally and Loftin, 1962.

Townsend, Francis G. *Ruskin and the Landscape Feeling.* Urbana: University of Illinois Press, 1951.

Twelve Good Men and True. Los Angeles: Times Mirror Printing and Binding House, 1928.

Villasenor, David. *Tapestries in Sand: the Spirit of Indian Sand Painting.* Healdsburg, Ca.: Natureograph., 1963.

Walker, Franklin. *A Literary History of Southern California.* Berkeley: University of California Press, 1950.

The Westerners Brand Book Los Angeles. Los Angeles: The Westerners,

Widén, Albin. *Carl Oscar Borg. Ett Konstnärsöde.* Stockholm: Nordisk Rotogravvr. 1953.

Widén, Albin. "Carl Oscar Borg 'Indianmålaren'" in *De Röda Krigarna Indianklubbens Arsbok.* Stockholm: Ab Lindqvists Forlag, 1964.

Wilkins, Thurman. *Thomas Moran: Artist of the Mountains.* Norman: University of Oklahoma Press, 1966.

PAMPHLETS

Bentley, Harry C. *A Private Collection of Paintings by Some Living Artists of Southern California.* Tucson: The Fine Arts Association, 193?.

The California Art Club Bulletin. Los Angeles, December 1928.

Catalogue of Paintings by Ignacio Zuloaga. New York: The Hispanic Society of America, 1909.

Collier, John and Charles F. Lummis. *The Indian and Religious Freedom.* San Francisco: The Indian Defense Association of Central and Northern California, July 2, 1924.

Eisen, Gustavus. *Account of the Santa Barbara Indians of Southern California.* Prague: Royal Bohemian Society of Sciences, 1904.

_____. *On Some Ancient Sculptures from the Pacific Coast of Guatemala.* San Francisco: California Academy of Sciences, 1904.

_____. *Notes during a Journey in Guatemala.* Bulletin of American Geographic Society.

Lummis, Charles Fletcher. *Humanizing the Sciences of Man.* Washington, D.C.: Government Printing Office, 1917.

_____. *Stand Fast Santa Barbara.* Santa Barbara: Community Arts Association, 1923.

Fernand Lungren, 1857-1932. Some Notes on His Life. Santa Barbara School of the Arts, 1933.

Gibson, Mary S. *Caroline M. Severance, Pioneer 1820-1914.* Los Angeles: The Friday Morning Club, 1925.

Mary S. Gibson, Pioneer. Los Angeles: The Friday Morning Club, 1930.

Middleton, Charles O. *Western Artists and Their Pictures.* Los Angeles: Charles Middleton, 1927.

A Portfolio of Landscapes by Twelve Noted California Artists. Los Angeles: Automobile Club, 1929.

The Quarterly Bulletin of the Museum of History, Science and Art, Department of Fine and Applied Art. Los Angeles, October 1920.

PERIODICALS

American Swedish Monthly. June 1936.

Austin, Mary. "Art Influence in the West." *The Century,* Vol. 89, April 1915.

Baligny, Hugues. "Salon des Artistes Français." *Le Chroniquer de Paris,* 5 juin, 1914.

Berry, Rose V.S. "The Club Art Program." *The Ladies Home Journal,* May 1923, pp. 104-108.

"Block Printing in the United States." *American Magazine of Art,* April 1923.

Bonnell, Ben-Franklin. "The Transcendentalists." *Overland Monthly,* vol. 42, September 1903, p. 267.

Borg, Carl Oscar. "Hopi Patriarch." Etching, *Overland Monthly,* January-February 1932, p. 2.

_____. "Land of Mystic Shadows, Grand Canyon." Cover reproduction *Progressive Arizona,* vol. XI, no. 13, December 1931.

_____. "Land of the Navajo." Cover reproduction, *Southern California Alumni Review.* October 1931.

_____. "Lo, the Poor Indian: Block Prints by Carl Oscar Borg." *Touring Topics,* May 1926.

_____. "The Province of Tusayan." *Touring Topics,* November 1929.

_____. "Yellow Leaves." *Laguna Life,* December 2, 1921.

Brown, Howell C. "Block Printing in the United States." *The American Magazine of Art,* April 1923, pp. 202-207.

Borglum, John Gutzon. "An Artist's Paradise." *Land of Sunshine,* vol 11, no. 6, May 1895, p. 106.

Bulletin of the Museum of History, Science and Art, Department of Fine and Applied Art, Los Angeles, vol. 11, no. 1, 1920.

"Carl Oscar Borg Issue." *Noticias, Quarterly Bulletin on the Santa Barbara Historical Society,* Summer 1965.

"Carl Oscar Borg, Painter." *The Westerner,* July 26, 1919.

Carpenter, Edwin H. "A Sagebrush Westerner: Idah Meacham Strobridge," *The Branding Iron of the Westerners,* Los Angeles, June 1955.

Clarke, E. P. "Growth of California Cities." *Overland Monthly,* vol. 88, no. 10, p. 303.

Clover, Madge. "Art." *Saturday Night,* Los Angeles, August 27, 1932.

"Colman Conquers Castles in Spain." *Motion Pictures Classic,* January 1927.

"Den Svenske Indianmålaren." *Levande Livet.* 1943, pp. 6, 7, 34.

Dudley, Amy. "Carl Oscar Borg's Desert Pictures." *The Federation Magazine,* July 1919.

Dudley, Amy. "Carl Oscar Borg's Pictures." *The Federation Magazine,* June 1922.

Forbes, B.C. "Cities in the Making." *Overland Monthly and Out West Magazine,* vol. 89, nos. 8 & 9, August-September 1931, pp. 305, 318.

Fowler, Frank. "The Field of Art." Scribner's Magazine, vol. XI, July-December. 1906, p. 512.

Gorecki, Thadée de. "Carl Oscar Borg." *L'Art et les Artistes,* Avril-September 1913, pp. 268-74.

Harada, Jio. "The Panama Pacific International Exposition and Its Meaning." *The Studio,* vol. 65, no. 269, p. 187.

Hessby, Robert. "Carl Oscar Borg, Portrayer of American Indians." The *American-Swedish Monthly,* January 1935, pp. 7-9.

Hoffman, Eugene. "Exposition de Carl Oscar Borg." *Le Journal des Arts,* 25 January 1913.

Hoffman, E. "Le Paysage au Salon des Artistes Français." *La Revue des*

Beaux Arts. 8 juin 1913.

"How Theosophy Came to the Golden West." *Scenic America,* June 1910, p. 6.

"Indianmålåren, Carl Oscar Borg." *Allsvensk Samling,* Oktober 1936.

"In the Studios and Galleries." April 1917.

Ingalls, J. K. "A Word-Weary World." *The Thumb Tack,* February 1926, pp. 5-9.

James, George Wharton. ed. *The Basket: The Journal of the Basket Fraternity, or Lovers of Indian Baskets and Other Good Things.* Vols. 1 & 2, 1903-1904.

————. "Los Angeles, a Moral City." *Out West,* March-April 1913, pp. 109-209.

————. "William Lees Judson, painter." *Out West,* May 1913, pp. 243-54.

Jerome, Lucy Baker. "California Sunshine." *Sunset Magazine,* Vol. XI, no. 1, May 1903, pp. 64-66.

J. M. "Les Expositions." *Masques et Visages,* 15 February, 1913.

Judson, William Lees, Hanson Puthuff et. al. "The Dawn of the Spiritual Era." *Arroyo Craftsman Quarterly Magazine,* October 1909, pp. 55-59.

Kolp, Belle Axtell. "Bullying the 'Quaker Indians.'" *Out West,* July 1903, pp. 47-55.

"Los Angeles 1781-1981. A Special Bicentennial Issue of California History." Spring 1981.

Lewis, Frank D. "The Warner Ranch Indians." *Overland Monthly,* August 1903, pp. 171-73.

Lilius, Aleko. *"En Svensk Konstnär Som Douglas Fairbanks' Artistika Högra Hand." Film Journalen,* 17 April, 1927 .

Lindgren, Raymond F. *"The Wanderer." American Swedish Historical Foundation Yearbook,* 1962, pp. 68-77.

Lummis, Charles F., "The California Lion." *Land of Sunshine,* April 1985, pp. 80-85.

————. "In the Lion's Den." *Land of Sunshine,* November 1901, p. 370.

————. "In the Lion's Den." *Out West,* vol. 22, 1905, pp. 420-27.

————. "In the Lion's Den." *Out West,* vol. 25, no. 3, September 1906, p. 275.

————. "In the Lion's Den." *Out West,* vol. 24, no. 5, May 1906.

————. "The Making of Los Angeles." *Out West,* vol. 30, nos. 2, 3, 4, March 1909, pp. 227-57.

———— . "The Mother Mountains." *Land of Sunshine,* vol. 3, no. 3. August 1895, pp. 119-25.

————. "The Right Hand of the Continent." *Out West,* vol. 18, no. 1, January 1903, pp. 3-34.

————. "The Southwest Museum." *Out West,* vol. 26, no. 5. May 1907, pp. 389-412.

————. "In Western Letters." *Land of Sunshine,* vol. 15, no. 4, October 1901, p. 239.

MacDowell, Sye. "Behind the Scenes." *California Sports Magazine,* January 1926.

Maxwell, Everett Carroll. "The Adventurous Art of Carl Oscar Borg." *Progressive Arizona,* December 31, 1931, pp. 12-23.

————. "Art and Artists." *The Graphic,* March 26, 1910.

————. "The Art of Jean Mannheim." *Overland Monthly and Out West Magazine,* vol. 91, no. 7, September 1933, p. 125.

————. "Filling a Long Felt Need in the Field of California and Western Art." *Overland Monthly-Out West Magazine,* Vol. 9, no. 4, May 1933, p. 75.

————. "Painters of the West" *Progressive Arizona,* December

1931, pp. 11-13, 23-24.

_____. "Personal Art of Max Wieczorek." *Overland Monthly-Out West Magazine,* vol. 91, no. 5, pp. 90-92.

_____. "Progress of Western Art and Drama." *Overland Monthly-Out West Magazine* vol. 90, no. 10, December 1932, pp. 305-308.

_____. "Saga of the Desert Indian." *Overland Monthly-Out West Magazine,* February 1934, p. 45.

_____. "The Value of Western Art." *Overland Monthly-Out West Magazine,* vol. 90, no. 9, November 1932, p. 263.

_____. "Western Art Foundation Launched." *Overland-Out West,* vol. 91, no. 3, April 1933, p. 58.

Miles, Harold. "Architecture in Motion Pictures." *Pencil Points,* vol. 8, no. 9, September 1927, pp. 535-45.

Patterson, James Wm. ed. "William Keith." *Fine Arts Journal,* June 1913, pp. 367-78.

Reisner, George A. "Egyptian Excavations of the University of California: Work in Egypt through the Munificence of Mrs. Phoebe Hearst." *Overland Monthly,* vol. 12, August 1903, pp. 99-104.

"Rating Film Entertainment Values." *Films News,* November 12, 1927.

"Salon des Artistes Français." *Le Chroniquer de Paris,* 5 juin, 1914, pp. 9-15.

Sayre, Ann H. "Borg's Conservative Oils of the Southwest." *The Art News,* April 1936.

Sayre, F. Grayson. "California Artists and Their Colonies." *California Graphic,* November 15, 1924, p. 12.

Scenic America, Southern California Exposition Number. 1915.

Schallert, Edwin, "Yo, Ho, and a Bottle of Rum!" *Picture-Play Magazine,* February 1926.

Selkinghaus, Jessie A. "The Art of Carl Oscar Borg." *The American Magazine of Art,* March 1927, pp. 144-47.

Starr, Kevin. "Painterly Poet, Poetic Painter." *California Historical Quarterly,* Winter 1977-78, pp. 290-309.

Taber, Louise E. "California Artists: Across the Painted Desert with Carl Oscar Borg." *The Wasp,* February 16, 1918, p. 14.

Taylor, Marian. "Joaquin Miller, Poet." *Overland Monthly,* vol. 63, no. 2, February 1914, pp. 108-109.

Teylor, Alva. "The Black Pirate." *Liberty,* April 24, 1925.

"Three Recent Paintings of Interest." *Touring Topics,* July 1924.

The Thumb Tack. Vol. 8, no. 2, 1926, p. 8.

Tolerton, Hill. "The Art of Maynard Dixon." International Studio, May 1915, pp. xcii-xcv.

Touring Topics. May 1926.

"Under the Skylights, the Borg Monotypes." *The Pacific Outlook,* January 19, 1907.

Waterhouse, Alfred. "In the West." *Sunset Magazine,* May 1903, pp. 64-66.

Wells, William Bittle. "Our Point of View." *Pacific Monthly,* vol. 10, 1903.

Williams, Michael. "Western Art at the Exposition." *Sunset Magazine,* August 1915, pp. 317-26.

Wilson, L.W. "Santa Barbara's Artist Colony." *The American Magazine of Art,* December 1921, pp. 411-14.

NEWSPAPER REFERENCES FROM BORG'S NOTEBOOKS.

L'Adriatico. (Venice) 23 Aprile, 1912.

Älvsborgsbygden. (Vänersborg) 3 Juli, 1934.

Amåls-Tidningen. (Amåls) 3 mar.

1939-11 Juni, 1945.
The Boston Herald. May 10, 1936.
Boston Sunday Post. May 10, 1936.
Brooklyn Daily Eagle (New York) April 26, 1936.
California Veckoblad. (San Francisco) 1915-1935.
Christian Science Monitor. 1913-1936.
Dagens Nyheter. (Gothenburg.) 1939-1945.
The Daily News and Independent. (Santa Barbara) 1918-1919.
Dalslänningen. 1934-1945.
Elfsborgs Läns Annonsblad. 1934-1944.
The Evening Herald. (Los Angeles) 1923.
The Evening News. (Los Angeles) 1906-1908.
Le Figaro. (Paris) 1913-1914.
Gil Blas. (Paris) 1913.
Göteborgs Aftonblad. 1913.
Göteborgs Handels-Och Sjöfars-Tidning. 1934-1937.
Göteborgs Morgonpost. 1936-1946.
Göteborgs Posten. 1938-1945.
Göteborgs Tidningen. 1936-1944.
The Herald Tribune. 1934.
Hollywood Citizen News. 1933.
Hollywood Daily Citizen. 1927.
Laguna Life. 1921.
La Liberté. (Paris) 7 mai, 1913.
La Libre Parole. (Paris) 1913-1914.
Long Beach Press-Telegram. 1928.
Los Angeles Examiner. 1906-1927.
Los Angeles Evening Herald and Express. 1923-1937.
Los Angeles Express. 1906-1908.
Los Angeles Herald. 1903-1925.
Los Angeles Times. 1908-1936.
The Los Angeles Tribune. 1914.
Il Messaggero. (Rome) 4 Guigno, 1912.
Morgonstidningen. 1934-1940.
The Morning Press. (Santa Barbara) 1919-1935.
The New York Times. 1926-1927, 1947.
New York Telegraph. 1927.
Ny Tid. 1934-1941.
Pacific Coast Viking. (Los Angeles)

1936-1943.
The Roman Times. 14 Aprile, 1912.
The San Diego Sun. 1917.
The San Francisco Call and Post. 1926.
San Francisco Chronicle. 1909.
San Francisco Examiner. 1910-1918.
Santa Barbara Daily News. 1923.
Santa Barbara Press. 1913-1945.
Snallposten. 22 Okt. 1937.
The Sun (New York) Feb. 28, 1915.
The Sunday Star. (Washington D.C.) Nov. 11, 1934. *SVEA* (Worcester, Massachusetts) 1934-1945
Svenska Amerikanaren. (Chicago) 1927-1941.
Svenska Dagbladet. (Stockholm) 1927-1941.
Svenska Morgonbladet. (Stockholm) 1939.
Syracuse Post Standard. (New York) 1925.
Le Temps. (Paris) 29 Sept., 1913.
La Tribuna. (Rome) 28 Marzo, 1912.
Vestkusten. (Oakland, San Francisco) 1913-1941.
The Washington Post. 1934.

MANUSCRIPTS

Austin, Mary. MSS. all boxes 1, 8, 9, 11, 14-16. The Huntington Library.
Borg, Carl Oscar. MS. Autobiography 1879-1908. Author's possession.
————. MS. Letter to Eva Lummis DeKalb, April 10, 1947. Keith Lummis Collection.
————. MSS. Letters to Lilly Lindstrand 1936-1939. Author's possession.
————. MSS. Letters from Phoebe Hearst 1909-1920. Photocopies in author's possession.
————. MS. Letter to W. Edwin Gledhill. Keith Gledhill.
————. MSS. Scrapbooks. Author's possession.
————. MSS. Poems and essays

1908-1947. Author's possession.

_____. MSS. Letters to Hugh Gibson. The Hoover Institute, Stanford University.

_____. MSS. The Pasadena Historical Society.

_____. MSS. The Santa Barbara Historical Society.

Eisen, Gustavus. MSS. Letters and Travel Notes to Phoebe Hearst, 1909-1913, the Bancroft Library of the University of California, Berkeley.

Elmberg, Lilly Borg. MS. "Carl Oscar Borg, the Wanderer." Author's possession.

Falvy, Albert. MSS. The Santa Barbara Historical Association.

Francisco, J. Bond. MSS. WI 458, WI 511, The Huntington Library.

Gibson, Hugh. MSS. The Hoover Institute, Boxes 15, 29-41, 51, Stanford University.

Gibson, Mary. MSS. The Friday Morning Club.

_____. MSS. The Hoover Institute, Stanford University.

Gledhill, W. Edwin. MS. Journal, April 23, 1955, pp. 5, 6. Keith Gledhill Collection.

Hearst, Phoebe. MSS. The Bancroft Library, Berkeley.

Lapsley, Arthur. MS. HM. 23861. The Huntington Library.

Lockley, Fred. MSS. Boxes 1, 11, 14, 15. The Huntington Library.

London, Jack. MSS. JL. 6882-6888. The Huntington Library.

Lummis, Charles F. MSS. JA. 581-600. The Huntington Library.

_____. MSS. HM. 44807-44933. The Huntington Library.

_____. MSS. 19815-19817. The Huntington Library.

_____. MSS. The Southwest Museum.

Lummis, Turbesé. MS. "Recollections of Carl Oscar Borg," n.d., Keith

Lummis Collection.

Lungren, Fernand Harvey. MSS. The Huntington Library.

_____. MSS. The Santa Barbara Historical Society.

_____. MSS. The Southwest Museum.

Peck Collection. MSS. The Huntington Library.

Russell, Charles. MSS. The Southwest Museum.

Russell, Nancy. MSS. The Southwest Museum.

Severance Collection. MSS. Boxes 18, 20. The Huntington Library.

Swingle, Mrs. M. K. MS. Author's possession.

Wendt, Julia Bracken. MSS. The Southwest Museum.

INDEX